Nicolas de Staël

Paris, Galeries Nationales du Grand Palais 22 May–24 August 1981
London, The Tate Gallery 7 October–29 November 1981

An exhibition arranged by the Musée Nationales d'Art Moderne
Centre Georges Pompidou, Paris

ISBN 0 905005 28 7
Published by order of the Trustees 1981
for the exhibition of 7 October – 29 November 1981
Copyright © 1981 The Tate Gallery

Organising committee

Alan Bowness
Pierre Granville
Isabelle Monod-Fontaine
Ruth Rattenbury
Françoise de Staël
Germain Viatte

Designed and published by the
Tate Gallery Publications Department
Millbank, London SW1P 4RG
Printed by Balding + Mansell, Wisbech, Cambs

Contents

Cover
Les musiciens, souvenir de Sidney Bechet 1953

Acknowledgments

Firstly, we must thank Mrs Françoise de Staël for her unstinted and warm-hearted help, and Mr and Mrs Pierre Granville for their active collaboration throughout the preparation of this exhibition.

We must also thank Mr Hubert Landais, Directeur des Musées de France and Mrs Germaine Pélegrin, Administrateur des Galeries Nationales du Grand Palais who gave us hospitality.

Mr Alan Bowness, Director of the Tate Gallery, showed interest in our project from the beginning. We are overjoyed that such an exceptional gathering of works should be shown in another European Museum. Ruth Rattenbury, Deputy Keeper of the Department of Exhibitions and Technical Services, has been in charge of every problem connected with organising the London exhibition. We wish to record here our gratitude to them. We are also warmly thankful to Mrs Geneviève Asse and MM. Jean Bauret, Patrick Bongers, Jacques Dubourg, Jean-François Jaeger, Pierre Lecuire, Rainer Michael Mason, Peter Nathan, Théodore Schempp, for their attention to our work and our research as well as to Mr James MacLaughlin, Director of the Phillips Collection for the considerable loan of works he has granted us.

This exhibition could not have been achieved without the generosity of numerous foreign and French museums, galleries, and private owners to whom we have applied:

Antibes, Musée Picasso
Berne, Kunstmuseum
Colmar, Musée d'Unterlinden
Cologne, Museum Ludwig
Dijon, Musée des Beaux Arts (Donation Granville)
Düsseldorf, Kunstsammlung Nordrhein-Westfalen
Liège, Musée de la Boverie
London, Tate Gallery
Minneapolis, Walker Art Center
Oslo, Sonja Henie & Niels Onstadt Foundations
Paris, Musées nationaux (Donation Pierre Lévy)
Saint Paul de Vence, Fondation Maeght
Toronto, Art Gallery of Ontario
Washington, The Phillips Collection
Zurich, Kunsthaus
Galerie Jacques Benador, Genèva
Galerie Jeanne Bucher, Paris
Galerie Louis Carré, Paris
Monsieur Louis Clayeux
Monsieur et Madame Jacques Dubourg, Paris
Monsieur et Madame Paul Dufrien, London
Monsieur Hubert Fandre
Gimpel-Hanover Galerie, Zurich
Gimpel Fils, London
Mr and Mrs F. R. Hensel
Hulin Trust Company
Sidney Janis Gallery, New York
Monsieur Michel Laval
Monsieur Jacques Matarasso, Nice
Mr and Mrs Paul Mellon, Upperville, Virginia
Dr Peter Nathan, Zurich
Madame Françoise de Staël
Madame Vieira da Silva, Monsieur Arpad Szenes, Paris
Madame Suzanne Tezenas, Paris
Baron Thyssen-Bornemisza, Lugano
Monsieur Igor Troubetzkoï, Paris
Mr and Mrs Oscar Weiss, London
Dr Nigel Weiss, London

We also wish to thank here the lenders who have preferred to remain anonymous.

4

Introduction

Perhaps we may define Nicolas de Staël's itinerary as an unresolved quest for unity. It is true that different aspects appear during the creation and maturing of an oeuvre and again when, as is today the case, it is reassembled; nor can any such aspect claim to be definitive.

Nicolas de Staël's art remains the sign and symbol of an era. One of them, at all events: the hope for a pure lyrical vision – devoid of blemish.

Pontus Hulten
Director, Musée National d'Art Moderne, Paris

None of those who saw it will ever forget the exhibition that Nicolas de Staël had at the Matthiesen Gallery in London in February 1952. For the artist himself it was his most important exhibition to date, and the first of any consequence outside France. Apart from a group of 15 drawings, and the woodcuts for René Char's *Poèmes*, there were 26 oil paintings, representing the range of his art from 1946 to 1952, including several of his largest works.

The catalogue introduction was written by the art historian and collector, Denys Sutton, who had met Staël in Paris in 1948, and, greatly admiring his work, had come to know him well. The painter and his wife came to London for the exhibition; writing in 1956, Mr Sutton said:

> He was satisfied with the result: the press was generous. After we had read the notices and gone over what everyone had said, he leaned back in the armchair with the words 'Voilà nous sommes arrivés'. It was true.

At the time of the 1952 London exhibition Staël was considered by many to be the most significant new painter to emerge in post-war Europe. Several British artists fell immediately under his influence: his thick impasto and sensuous handling of the paint were imitated, and the kind of abstract painting that his work of 1948–52 represented seemed to offer an example that was particularly relevant to those younger British painters then on the verge of abstraction but also reluctant to lose all contact with nature and the figure.

Unfortunately, though he retained his popularity with British collectors, some of the painters and critics were disappointed by the more thinly painted and more figurative paintings of 1954 and 1955. I remember that Staël's tragic suicide was seen as an indication that a certain kind of painting could no longer be practised. The Whitechapel exhibition of 1956 – a reduced version of the Paris memorial exhibition – left one with a sense of finality about Staël's achievement. It also happened to coincide with the first major showing of New York painting in London at the Tate Gallery. Thus began that significant re-orientation of modern painting away from Paris and towards New York which has transformed the art scene in the second half of the twentieth century.

After 25 years it seems an opportune moment to look at the painting of Nicolas de Staël again. He was certainly a major figure in the art of his time. Was he in fact the last great painter of the Ecole de Paris as is often claimed? Are there not qualities in the European art of the 1940s and 1950s that have been too lightly disregarded as a consequence of our infatuation with the vigour and exhilaration of American painting? Only a major exhibition such as this can resolve these questions.

We are therefore particularly happy at the Tate Gallery to be able to show in London – as happened in 1956 – a slightly reduced version of the Paris exhibition, conceived and planned by our friends and colleagues at the Musée National d'Art Moderne. To them, and to the lenders – many of them faithful friends of the artist, and members of his family – go our grateful thanks. If I may single out two names, I would particularly like to thank Isabelle Monod-Fontaine, who has selected the paintings and drawings, and Madame Françoise de Staël, who has lent so generously and shown such interest in the exhibition of her husband's work coming to London.

The original French version of this catalogue carried a most interesting biography, interleaved with long quotations from Staël's own writings, and also an anthology of mainly French critical writing on Staël. Hetty Einzig has produced an English equivalent of the biography, using some new and different material. In place of the critical anthology, Denys Sutton has kindly given us permission to reprint the earliest substantial piece of writing on Staël that has appeared in English – his own introduction to the London exhibition of 1956. To this Mr Sutton has added a short postscript and we are most grateful to him for his help and his interest in the exhibition.

Alan Bowness, Director, The Tate Gallery

Staël après
un quart de siècle

Conter l'homme, commenter l'œuvre, c'est tout un. In-sé-pa-ra-bles. Assurément, c'est le destin de tout homme, de celui qui fabrique, qui tisse, qui forge, qui maçonne. Mais avant tout le destin du créateur d'un art, s'il est véritablement créateur – en ce sens que né de parents d'adoption et cheminant plus ou moins rapidement à grandes enjambées – finit par se dévoiler en trouvant une voie personnelle, une voie dominée par l'esprit et par une main qui conduit à travers une mêlée d'intuition et de ratio cette volonté conquérante d'un empire qu'il façonne. Rencontrant quelquefois l'insuccès, le plus souvent victorieux de sa peine tragique, il surpasse ses limites, et aboutit à une certitude affirmant l'Oeuvre dans le temps à venir.

Introduire son visiteur à Nicolas de Staël par un discret trou de serrure où le regard attentif perçoit, partant d'une même origine, deux lignes divergentes dont l'angle s'évase de plus en plus vers un horizon où le poids de clarté paraît être aussi grand que celui de sa nuit, le phénomène n'est pas aussi courant que certains le croiraient eu égard au créateur pris en tant que tel. Un point de départ un peu hésitant comme celui d'Oedipe au croisement de plusieurs chemins, est précisément le fait de ces créateurs-novateurs dont l'élan et la visée se cherchent, se définissent et se limitent en quelques années ramassées qui font bloc. Ce n'est pas le cas de nombre d'artistes finissant par amollir la fulgurance de leur départ, en étant persuadés que ce qu'ils avaient 'trouvé' en leur appareillage devait demeurer la signature reconnue de leurs ouvrages. A contrario, nous voyons l'aventure – pas celle de l'anecdote, si troublante qu'elle soit – du Caravage qui passe brillamment de ses débuts de réalisme dans la clarté à un réalisme de chiaroscuro dans la foudroyante percée de quelques années, ce qui ne va pas sans effrayer ses contemporains habitués à plus de sagesse renaissante. Ainsi de Van Gogh qui en une décennie passe des 'Planteurs de pommes de terre' de Nuenen au 'Vol de corbeaux' d'Auvers après avoir quelque peu hésité sur le chemin qui le conduisait à l'impressionnisme du jour, s'il ne s'en était pas détaché avec éclat, puisqu'il ressentait en ses profondeurs un besoin d'expression n'appartenant qu'à lui-même. Et tout cela dans un raccourci qui fait que l'unité totale de l'œuvre est préservée et possède autant de vérité criante dans le Borinage qu'à Arles, Saint-Rémy et enfin Auvers. Quelle que soit la latitude et quel que soit le cru de l'année, Van Gogh persistera dans son être, tout comme Nicolas de Staël va paver un chemin qui sera sien, de 1945 à 1955, sans que l'ombre d'autres vienne s'y projeter.

Etre 'à soi-même', comme l'a écrit Odilon Redon, affirmer son existence par des faits qui se contredisent et qui pourtant conservent leur unité, c'est bien là le fil conducteur d'une vie volontairement écourtée. Mais laissons à la notice biographique le soin de faire connaître le déroulement de la petite histoire d'un homme, afin de pouvoir mieux tenter d'éclairer la psyché de l'être adossé continûment au roulis balancé de la vie et de la mort. Son action vitale paraît ainsi se situer en équilibre instable, tant dans son quotidien affamé d'interrogations hâtives que dans son geste pictural, tous deux liés l'un à l'autre dans un incessant questionnaire. La peinture est pour lui force vitale n'ayant de cesse de se mouvoir à l'égal du brassage bouillonnant de son existence. En définitive, il paraît impossible de détacher l'allure de l'homme d'une traduction peinte au moyen d'un couteau, de la brosse ou du pinceau. Nous l'avons dit: in-sé-pa-ra-bles.

Ce qu'il y a lieu de souligner, c'est la mutation accentuée de son hérédité. Car, que reste-t-il dans son acte de peindre de l'héritage slave? Seulement une certaine attitude – mais pas une inquiétude – devant le négatif de l'existence qu'est la mort.

Cela, sans que son obsession fut maladive, comme certains l'avanceraient. En effet, Staël parait à l'aise en jouant avec elle et sérieusement dès l'adolescence, comme le chat avec la souris. L'obsession se sacralise dans la volonté finale, parfaitement consciente, sans équivoque, avec toute la puissance du coffre de sa poitrine et de ses bras noueux. Toutefois, en deçà du sentiment profond de l'autre face de l'existence, on n'aperçoit nullement dans la peinture de Staël la moindre trace de ce qu'un Munch, par exemple, signifie comme angoisse de la mort. Chez le scandinave comme chez l'espagnol Goya, elle est présente et leur geste de peindre ne va pas sans une haute affirmation de l'alternative métaphysique de la vie. A l'opposé, la plastique picturale de Staël dit avec force, dans une composition parfaitement raisonnée, une joie d'exister pour elle-même, sans que celle-ci soit pour autant une pure jouissance de la matière. Avant tout, son organisation se rattache à la pensée contraignante de la raison. Par là, l'éducation, la formation de sa sensibilité, son frottement intellectuel à un 'milieu' français, font que son art est beaucoup plus proche par l'esprit de celui d'un Braque que de celui, très distant, d'un Soutine. Il peut apprécier ce dernier par le goût qu'il a, pour un temps, de la matière épaisse et de ses sortilèges, mais en fin de compte il reste plus proche, toute théorie éliminée, d'un Robert Delaunay dont la clarté formelle est typiquement française. Il n'en reste pas moins qu'au travers de ses préoccupations purement plastiques, Staël aborde son spectateur par une émotion directe prise sur le vif, même si elle se dissimule derrière l'apparent rideau du non-figuratif.

Mais on peut bien se moquer de la non-représentation formelle d'un être ou d'un objet, Staël ne s'en privait pas: que l'on se souvienne de sa boutade – 'le gang de l'abstraction-avant' – allusive au gang de la traction-avant qui défrayait la chronique d'alors. La non-représentation n'est pas un acte arbitraire du pur intellect, tel un traité de géométrie, elle s'enfante du domaine du senti où l'émotion provoquée est un starter infaillible.

En pénétrant dans le vif charnel de l'œuvre de Staël, on voit comment progressivement il se détache d'une formulation plus ou moins géométrisante où il subit d'assez loin l'influence d'un Magnelli – dont le voisinage à Grasse, entre 1941 et 1943, était pour lui plutôt une stimulation amicale qu'une manière à suivre – puisque déjà là sa recherche graphique, qui domine avec la fraîcheur d'un coloris enjoué, tient bien plus du dessin éphémère inscrit par des danseurs de ballet que de figures géométriques. Ici donc, le sensible du peintre, discerné naguère dans l'effigie étirée de Jeannine, apparaît sous-jacent dans l'attente d'un éclatement tragique qui brisera des frontières trop intellectuelles. C'est en effet dans les années qui vont de 1946 à 1948 que le peintre va s'acharner à créer un 'nouvel espace', mais le sien, étant donné que la formule est dans l'air du temps et particulièrement depuis l'invention datant de 1939 par Lapicque d'une 'ossature bleue' s'opposant à la perspective classique d'Alberti. Cependant ce 'nouvel espace' chez Staël est traité de la manière la plus personnelle en y incluant toute la force impétueuse de son débat intérieur. Les titres, presque exigés à la demande de son marchand d'alors, Louis Carré, sont à cet égard révélateurs non pas tellement de la traduction *a posteriori* d'une sensation ou d'un sentiment, mais bien plus une expression de grande allure poétique du drame – au sens grec du mot – qui se joue à travers une musculature aussi bien physique que morale, se défoulant à plein et défiant le monde qu'il combat dans le noir avec la fulgurance de particules de couleurs déchirées: voyez comment ces titres tels que 'Ressentiment', 'Porte sans porte', 'La vie dure', 'Bâtons rompus', 'Barrière', 'Lance-pierres', 'Brise-lame', 'Hommage à Piranèse', 'Espace à Crans', 'Eau-de-vie' et autres 'collent' à la peinture, bien qu'inventés après coup. Il n'empêche que durant la même période et plus tard de nombreuses 'Compositions' se font jour. Ce mot passe-partout, courant à l'époque, ne recouvre pas moins chez Staël une réalité née de la chair et du sang de son auteur; le forceps des mots exprimant son émotion devient alors négligeable.

Staël, a quarter of a century later

The story of a man and the account of his work form a whole – the two are inseparable. Such is the destiny of every man who is a maker – who weaves, who welds, who builds. But above all the destiny of a creator of art, if he is a true creator – that is, as though born of adoptive parents, he advances comparatively swiftly in great strides – is revealed through the discovery of his own individual path, a path dominated by the spirit and by a hand that leads the conquering will through the conflicts of intuition and rationalisation in the shaping of his empire. Meeting at times with failure, but more often victorious over his painful tragedy, he transcends his limits and reaches a certainty which is conferred on and thus affirms the oeuvre in time to come.

To introduce the visitor to Nicolas de Staël by a discreet keyhole where the attentive eye may perceive two rays that, having the same point of departure, diverge ever more widely towards a horizon where the weight of light seems to be as great as that of darkness, is to show him that the phenomenon is not as common as some would believe it in consideration of the creator taken only as such. A rather hesitant point of departure, such as Oedipus's at the crossroads, is precisely what characterises these creator-innovators whose momentum and aim find themselves, define themselves and limit themselves within the concentrated block of a few years. This is not the case for a great many artists who end up softening their initial fire and inspiration, persuaded that what they 'discovered' during the period of establishing themselves should remain the recognised signature of their work. On the contrary, we see here the adventure of Caravaggio (not that of the anecdote, however disturbing it may be) who passed brilliantly from his early realism filled with light to a realism of chiaroscuro in the astonishing space of a few years, not without frightening his contemporaries used, as they were, to a more renaissance sense of moderation. Likewise Van Gogh, who within ten years went from the 'Potato Eaters' at Neunen to the 'Flight of Crows' at Auvers, and after taking his first hesitant steps toward the impressionism of his day, suddenly abandoned it as he felt within himself the need for a way of expression entirely his own. And all this via such a short and direct route that the total unity of the oeuvre is preserved and has as much passionate truth in the Borinage period as in Arles, Saint-Rémy and finally Auvers. Whatever the scope or the locality of the year Van Gogh remains true to himself just as Nicolas de Staël, between the years 1945 to 1955, was to pave a way for himself entirely his own without the shadow of others' influence.

To 'be one's own self', in the words of Odilon Redon, to affirm one's existence through acts that contradict themselves yet conserve their unity – it is this that constitutes the guideline of a life voluntarily cut short. But let us leave to the biographer the task of recounting the worldly details of a man in order to better concentrate on our attempt to throw light on the psyche of this being, swung continuously on the balanced pendulum of life and death. His vital action seems thus to be found in an uneasy balance, as much in his daily hunger for inquiry as in his painter's hand, both bound one to the other by their incessant quest. Painting is for him a life force whose groundswell is irremediably linked to the rhythms of his own seething existence. In short, it does seem impossible to detach the character of the man from his translation into painting whether by means of the palette knife or by brushes. As has already been said the two are inseparable.

What one must underline is the radical departure from his heritage. For what trace of Slav inheritance remains in his

painting? Only a certain attitude – but not an anxiety – before death's negation of existence. This did not, as some would suggest, lead his obsessiveness to become morbid. In fact since his adolescence Staël seemed at ease in his game with death, like a cat with a mouse. And this obsession, embodied with all the power of his sturdy frame and wiry arms, is sacralised in the final, perfectly conscious, unequivocal act of will. Nevertheless, despite this profound awareness of the other side of life, one by no means finds in Staël's painting the slightest trace of that anguish of death so significant in Munch for example. Death is present in the work of the Scandinavian as in that of the Spaniard, Goya and the act of painting is for both directly linked to an exalted affirmation of the metaphysical alternative to life. In contrast to this, Staël's pictorial aesthetic, within perfectly reasoned compositions, affirms forcefully the joy of simply living, without this becoming just an enjoyment of the material aspects of painting. Above all, his method of organisation is dependent upon the controlled thought processes of reason. In this – his education, the formation of his sensibility, his intellectual contact with a French 'milieu' – his art is closer to the spirit of a Braque than that of a Soutine. His short-lived taste for density of paint and its magical effects attracted him to the latter, but in the last analysis he remained, regardless of theory, much closer to the typically French clarity of form of Robert Delaunay. The fact remains though, that through his preoccupation with pure composition, Staël approaches his spectator through direct emotion drawn from life, concealed though this may be by the apparent curtain of the non-figurative.

A certain amusement at the conscientious non-representation of a being or object is all the more legitimate when one recalls Staël's witticism – 'the forward-abstraction gang' – alluding to the 'forward-traction gang' which were in the news at the time. Non-representation is not an arbitrary act of pure intellect, such as a geometrical treatise; it is the offspring of feeling and the emotion inspired is invariably the starting point.

When we penetrate the vivid sensuality of Staël's work we become aware of his progressive detachment from more or less geometrical formulations, in which he was under the now distant influence of Magnelli (a neighbour at Grasse between 1941 and 1943 he was more stimulating in friendship than in actual artistic influence) for Staël's graphic researches were already filled with the impact of bright colour and owed far more to the patterns ephemerally traced by ballet dancers than to geometrical figures. Here then, the sensitivity of the painter, already to be found in the elongated effigy of Jeannine, constitutes an underlying force in anticipation of a tragic impulse that will break through the barriers of over-intellectuality. It was indeed during the years 1946 to 1948 that the painter got down to the task of creating a 'new space' of his own; for this formula corresponds to the mood of that time, particularly after Lapicque's invention in 1939 of a 'blue framework' that opposed Alberti's classical perspective. However, Staël's treatment of this 'new space' is extremely personal and expresses the impetuous force of his inward struggle. In relation to this, the titles – practically demanded of Staël by his then dealer Louis Carré – do not so much pertain to an *a posteriori* translation of sensation or feeling, as to the highly poetical expression of the drama – in the Greek sense of the word – played out as much in physical as in moral terms: a storming self liberation effected against the dark force which he combats with flashing strokes of colour. Once can see how titles such as 'Ressentiment', 'Porte sans porte', 'La vie dure', 'Batons rompus', 'Barrière', 'Lance-pierres', 'Briselames', 'Hommage à Piranèse', 'Espace à Crans', 'Eau-de-Vie', and others, 'fit' the painting, even though invented afterwards. All the same, numerous 'Compositions' appear during this period and later. This cover-all word, much used at the time, does, in relation to Staël, no more than cover up a reality born of the author's flesh and blood; no longer does the forceps of words seem necessary to express his emotion.

Ce grand combat dans les noirs et les gris, il le poursuit jusqu'à l'apaisante clarté qui naît peu à peu d'un trou obscur à partir de 1949. Il faut voir en cela que la respiration de la peinture est l'écho même de la respiration de l'homme. Les grandes plages nues, recouvertes par d'autres plages, laissent apparaître les franges de la précédente avec un souci majeur de faire moduler musicalement les valeurs tout autant que la toniturance soudaine de la couleur, et reflètent une sorte de grand calme après une agitation tempétueuse. C'est tout au long de sa brève carrière que Staël se refuse, non par système mais par besoin de renouvellement, à tout maniérisme. La volonté percutante du peintre de se défaire de sa 'trouvaille' antérieure, va précisément le pousser à voir dans la nature non pas un motif mais l'excitant propre à aiguiser un regard neuf, autrement dit à s'extérioriser en sortant de son propre abîme.

Dès ce moment, il éclate en Staël une sorte de joie de vivre contrastant avec la lutte qu'il avait menée contre lui-même. Aussi, le voit-on penché de la fenêtre de son atelier sur la structure des moellons qui bordaient jadis le fond de l'impasse où il habitait. Et de ces moellons il finit par construire tout l'étagement d'une ville qui appelle, sans qu'on le cherche, l'évocation d'un titre : 'Les toits de Paris'.

Cependant et du même coup Staël ne se contente pas de ce qu'il aperçoit de sa fenêtre, puisque devant une même fenêtre intérieure il s'accoude sur la barre d'appui de l'amitié fervente fiancée à celle de la poésie et ce sont les admirables bois taillés dans le buis de bout, le plus dur, qu'il entame avec le burin pour associer définitivement deux noms du mi-temps du siècle, le poète René Char et le peintre Nicolas de Staël.

Mais la peinture poursuit son maçonnage, selon une imagination tenue en bride, dans le grand atelier enfin à sa mesure. Il va quêter au dehors, en banlieue, à Gentilly, ou plus loin en allant visiter son ami Jean Bauret, de possibles vérités qui sont à l'opposé de tout réalisme. Mais l'étendue au printemps d'un champ de colza jaune, d'une pièce de luzerne verte et d'une terre de labour, suffisent à déterminer un paysage que l'on reconnaît tout en n'étant pas identifiable. Cette approche du 'vécu' va soudainement éclater en une nuit de mars 1952 : après avoir assisté au match de football France-Suède, il établit en quelques heures nocturnes sur une toile qui aurait servi à un tout autre motif le grand 'Parc des Princes', où la mêlée n'est pas à proprement parler le sujet, mais le prétexte à une composition de larges pans lisses de peinture qui s'articulent les uns aux autres dans un dynamisme laissant le spectateur haletant. Toutefois ce serait une erreur de considérer 'Les footballeurs' comme une césure dans l'œuvre. Même s'il y a révélation – pour lui-même et pour nous – il n'y a pas là coupure ou si l'on préfère divorce dans un opus dont la continuité paraît si évidente. Cela, jusqu'à son achèvement, sans que l'on puisse parler de non-figuratif et de figuratif.

Le plus flagrant paradoxe se découvre surtout à ce point crucial : plus le labeur avance comme cheval au galop, soit Nus, soit Fleurs (aiguillonné que fût Staël à la vue du 'Vase de roses' par Van Gogh présent à l'Orangerie des Tuileries lors de l'exposition de 'La nature morte' en 1952 'moi aussi je vais en faire des fleurs . . .' oui, des fleurs qui ne sont pas des fleurs, mais au-delà de leur capacité de vivre, un jaillissement qui se dresse par touches calculées et éternisant des pétales qui ne se faneront pas, car Staël y fait découvrir le parfum d'une primauté de la peinture avant son existence propre), soit 'Paysages de Sicile' dont le lieu n'implique pas une situation géographique, mais seulement l'assimilation violente d'une architecture que le peintre cale dans l'invention d'une haute gamme, soit une simple 'Route d'Uzès' où le sens de la synthèse se limite au dépouillement de quelques lignes et de quelques plans, soit 'Les bouteilles dans l'atelier' où les choses les plus familièrement nécessaires à son labeur deviennent un monde de personnages dont la signification transcende leur phénomène, plus le travail est en progression, plus on ressent combien Staël, par son approche dévorante de la réalité, devient fondamentalement abstrait, comme tout peintre sachant dominer le réel afin d'en faire une réalité autre.

L'altière statue-bloc de Staël dominait efficacement les êtres de rencontre. Certains le craignaient ou n'ont pas su l'aimer, c'est-à-dire le comprendre. Car son orgueil racé n'était pas fait de mépris, mais de la conscience qu'il avait de multiples voies de la création : obstinément il se refusait de tomber dans le procédé. Il fuyait le redite et même quand le motif avait exercé sur lui une espèce de fascination transposée – voyez le 'Parc des Princes' ou 'Les footballeurs' – il s'en détachait rapidement sans jamais y revenir. C'est pour cela que l'on ne trouve pas à travers l'ensemble de l'opus ce que l'on appelle couramment dès séries dont l'obsession fait parfois du créateur un esclave. Staël domine donc physiquement par sa personne, sa distinction, son nez aquilin et ses narines ouvertes qui palpitent ; mais aussi le grave de sa voix de basse russe se répercutant dans la hauteur de son atelier, qui lorsqu'il se mettait à rire montait en contraste à un diapason aigu. Cependant, il fallait voir l'altière statue-bloc s'accroupir dans la position d'un danseur russe, ses yeux se plissant alors pour jeter un regard critique sur le travail en cours : une toile qu'il avait posée debout à 10 mètres de lui après l'avoir travaillée couchée à même le sol comme une femme heureuse sur laquelle il appliquait, caresse déroulée sur une autre caresse, la plaque d'acier dont il se servait pour étendre sensuellement un aplat rouge sur le précédent aplat jaune dont il laissait déborder les franges au hasard. On voit ainsi l'image de l'homme en son entier, qu'il soit à l'atelier, sur une avenue de la grande cité où la mort l'avait un jour frôlé de près par la grâce d'une moto dont la vitesse la rendait invisible, sur une route de campagne où son compas humait autant que ses narines le parfum indéfinissable que répandent les herbes de la garrigue, sur la terrasse d'une maison sans âme d'où son regard plongeait à l'infini dans le miroitement de la mer traversée de navires plus fantômatiques que réels, ou encore dans l'espace cisaillé de mouettes aiguisant l'air de leurs cris dont la vitalité est si proche d'un à pic virtuel. Voici donc l'altière statue-bloc en son unité impossible à desceller, depuis l'enfance et les tourmentes passées, de la vision captée par un enfant de la forteresse Pierre et Paul que son père commandait en général à St Pétersbourg, jusqu'à la vision rationnelle en étoile du Fort Vauban d'Antibes, à travers une forêt de mâts plantés sur un bassin d'eau.

Et n'est-ce pas une magnifique survie de son orgueil que de bâtir 'Ma cathédrale', comme il l'a exprimé sciemment et non pas *une* cathédrale, édifice arcbouté de sa puissance pour s'y enfermer à jamais. L'unité parcourt l'être et chacun n'a plus qu'à regarder pour voir dans la justification de sa courbe la cohésion de son œuvre.

Si la personne et la création issue d'elle forment un couple unique à la tâche, c'est de façon privilégiée dans le domaine le plus intime que cette unité se révèle : en deux éléments graphiques, non pas associés, mais vivant conjugalement et exprimant la totalité de l'être avec un punch imparable.

D'une part les lettres où un style martelé dit avec force, quel que soit le correspondant, le fond d'une idée, la moelle verbale d'une peinture à faire ou en train de se faire, dans le raccourci d'un direct et avec toujours l'éclair poétique qui en concrétise l'idée. Combien il serait heureux de voir réunie toute la correspondance du peintre, et cela sans commentaires alors qu'elle est aujourd'hui éditée séparément par les soins de certains de ses destinataires. On aurait ainsi comme pour Van Gogh une image fidèle de l'homme sans que l'on puisse la défigurer.

D'autre part, le graphisme proprement dit du dessin a sa spécificité. Le dessin de Staël n'est pas approche tâtonnante de sa peinture ou étude en vue de camper la composition d'une toile à naître. Bien qu'un nombre limité de dessins aient été utilisés comme schéma d'une peinture à une autre échelle, la retenue de tels dessins est pour Staël l'élection par un œil aiguisé d'un seul parmi des centaines de feuillets. Les techniques employées sont méditées selon l'époque, l'humeur, et la découverte enthousiaste d'un nouveau procédé en provenance

He carried on this great battle with blacks and greys until a peaceful clarity began to emerge out of the dark depths from the year 1949. From this we should understand that the breath of the painting is the very resonance of the breath of the man. He superimposes large empty planes such that a fringe of the plane beneath appears with great care to modulate the tones harmoniously just as much as he uses the counterpoint of the sudden blare of colour – the reflection of raging turmoil succeeded by utter calm. Throughout his brief career Staël refused any form of mannerism, not through any system but through a constant need for self-renewal. It is precisely the painter's incisive desire to free himself from each previous discovery that impelled him to consider nature not as a motif, but as the stimulant necessary to the sharpening of his new vision, in other words, to externalise himself by emerging from his own inner abyss.

From this time onwards a kind of 'joie de vivre' broke out in Staël that contrasts with the struggle that he had been waging against himself. So one finds him leaning out of the window of his studio to look at the structure of the stone wall that closed off the cul-de-sac where he lived. And from these stones he built the successive layers of a town which calls so naturally for its evocative title: 'Les Toits de Paris'. Staël did not however content himself with the view he had from his window, nor with that which imagination could fashion within the confines of his enormous studio, at last one on his own scale; it was outside, on the outskirts of Paris, at Gentilly, or further still, when visiting his friend Jean Bauret that he searched for possible truths that are the total opposite of all realism. But the spread of a field of yellow colza in Spring, of a patch of green lucern or an area of ploughed land are enough to suggest a landscape one can recognise without being strictly identifiable. This approach to lived experience became a revelation suddenly one night in March 1952: after having watched the football match between France and Sweden he set out, in the space of a few nocturnal hours, on a canvas already begun, the great 'Parc des Princes', in which the match is not strictly speaking the subject matter but the pretext for a composition of large, smooth, flat surfaces of paint, articulated together with a dynamism that leaves the spectator breathless. It would however, be a mistake to consider 'Les Footballeurs' as a break in his work. For even if it is for him, as for us, a revelation, there is no rupture or divorce in the evident continuity of the opus. And this remains true right up to the end of his work, without the question of figurative or non-figurative art being relevant.

It is at this crucial point that the most evident paradox appears: the faster the work advances – whether it be nudes or flowers (Staël was spurred on by Van Gogh's 'Vase de Roses' which he saw at an exhibition devoted to still life held at the Orangerie in 1952 – 'I am also going to paint flowers . . .' – yes, flowers that are not flowers but, beyond their capacity for life, are fountainheads erected by calculated touches eternalising petals that will not wither and the perfume of which resides in the primacy of the painting's own existence) or Sicilian landscapes where the place implies no geographical exactness but rather the violent assimilation of an architecture that the painter slots into the invention of a more vivid colour scheme, or the simple 'Route d'Uzès' where synthesis is achieved by a few austere lines and planes, or 'Les Bouteilles dans l'atelier', where objects that constitute the most necessary and familiar part of his work become a world of characters whose significance transcends their physical entity – the more the work progresses, the more one feels how much Staël, through his voracious grasp on reality, becomes fundamentally abstract, just like every painter who knows how to dominate the real in order to make from it another reality.

Staël's proud stature easily dominated all encounters. Certain people feared him, or were incapable of loving, that is, understanding him. For his aristocratic pride sprang, not from contempt, but from an awareness of the many possible avenues of artistic creation: he consistently resisted any temptation to fall into a routine. He fled repetition, and even when the fascination of a motif maintained its influence by a kind of transposition, as, for example in the 'Parc des Princes' or 'Les Footballeurs', he would quickly detach himself and never go back to it. For this reason one doesn't find in Staël's work what are commonly known as series, the obsessive quality of which seems at times to make a slave of their creator. Staël thus dominates physically by his presence, his distinction, his aquiline profile and his wide quivering nostrils; but also the resonance of his deep Russian voice which would echo in his high studio and which, in contrast, rose to a high pitch when he laughed. But one must also try to visualise this monolithic statue of a man crouching down like a Russian dancer and screwing up his eyes to cast a critical glance at the work in progress: a canvas that he would prop up about 10 metres away after having worked on it flat on the floor like a contented woman on whom he would lavish, caress following caress, the steel blade which he used to spread a red plane on top of the preceding yellow one with sensual disregard of their haphazardly over-flowing edges. So we have now a complete image of the man: whether in his studio, or in the avenue of a city where death had grazed him in the form of a motorcycle rendered invisible by its speed, or on a country road, directed as much by his pace as by his nose towards the indefinable perfumes of the herbs of the Provençal hills, or on the terrace of a soulless house, his gaze fixed on the infinite, glittering expanse of sea, itself crossed by ships that seemed more phantom-like than real, or again in that space criss-crossed by the flight of seagulls whose cries sharpen the air with a vitality so close to a virtual fall. Here then, is this proud statue of a man, of an unshatterable unity that has its roots in past torment and childhood experience: from the child's vision of the Peter and Paul Fortress at Saint Petersburg which his father had commanded as a general, to the more rational vision of the star-like Fort Vauban seen through a forest of masts rising out of the port of Antibes. And is not a magnificent triumph of his pride to have created 'Ma Cathédrale' (and not *a* cathedral) as he so knowingly expressed it, an edifice buttressed with its power to enclose him within forever. Unity runs through his being and one has only to observe in the continuity of the curve of his life the cohesion of the work as a whole.

in the act, a single entity, it is only in the most intimate and privileged way that this unity is revealed: that is, when two unassociated graphic elements come together to express the totality of the man with the force of a punch not to be parried.

On the one hand we have the letters in which, regardless of the correspondent, he communicates, with a lapidary and pithy style, the essence of an idea, the verbal substance of a painting to be started or in progress, while always a poetic clarity illuminates and makes these ideas concrete. What a pleasure it would be to see the painter's correspondence collected, and without commentary, whereas its publication has been under-taken separately by the various recipients. We would then have, as we do for Van Gogh, a true and undistorted image of the man.

On the other hand Staël's drawing itself possesses its own specificity. The graphic work is not a hesitant approach to the painting or a study for the composition of the next canvas. Although a certain number of drawings were used as pre-liminary sketches for paintings of another scale, the keeping of a particular drawing represents the choice of Staël's discriminat-ing eye of one out of hundreds. The techniques used are thought out according to the time, his mood, or by the happy discovery of a new medium from the United States – the felt-tip pen. Although the style he obtained by this means seemed to Staël from the start to contain new resources, and despite the superb results, unfortunately felt-tip pen does not withstand the light. It is the duty of the owner of such works to preserve in their physical fragility the strength of spirit from which they rose.

Indian ink, washed on or sprayed out in fine strokes; the pen, unhesitant and without pentimenti, heightened with water-

des Etats-Unis, à savoir le stylo-feutre. Si le graphisme des feuilles ainsi réalisées lui paraît dès l'abord un apport de nouvelles ressources, convenons que, malgré ses superbes réussites, le stylo-feutre ne résiste pas à la lumière. Le possesseur de telles œuvres a le devoir de sauvegarder une fragilité si bien armée par l'esprit au départ.

L'encre de chine, grasse ou jaillissante en gerbe, la plume, sans accrocs ni repentirs, rehaussée d'aquarelle par taches et non par plages, laissant jouer le blanc du papier, enfin le fusain au service des grands 'Nus' ou des 'Natures mortes', inspirées par le peuplement de la table de travail, jettent une lumière diffuse sur les œuvres de la fin: toutes ces démarches écrites claironnent, quel que soit le format, une individualité dont aucun trait n'est gratuit. Chacun d'eux fait corps avec une exigence de synthèse. En ce domaine d'une double écriture donc, l'être Staël aimante dans un ordre voulu une limaille dispersée.

En effet, telle la complexité unique de l'homme, il n'y a pas à considérer la trajectoire de l'œuvre, une diversité banalisée ou pis encore un éclectisme à références. Il y a seulement des phases courtes qui s'enchaînent logiquement les unes aux autres dans un lent mûrissement et de telle sorte que la parabole achevée, la courbe apparaît véritablement sans rupture, sans saccades. Historiquement, il est plutôt facile de parler 'périodes' pour la commodité des choses, mais le regard de celui qui est à même de suivre le projectile en mouvement n'aperçoit pas de discontinuité.

La gamme de sa palette et sa sonorité, que fait valoir parfois le noir, ne contribuent pas peu à la liaison de ces moments traversés de difficultés à surmonter.

Mais parlons musique en pensant à ce peintre si attentif, non pas seulement en tant que fervent du 'Domaine musical' qu'il fréquentait assidûment au Petit Marigny, non pas seulement à l'Opéra de Paris d'où il revenait avec enthousiasme, source des deux toiles des 'Indes galantes', mais encore et avant tout à la recherche consciente et inconsciente d'une transposition musicale en peinture, par le rapport des tonalités comme par le rythme de la composition. Combien de fois ne l'ai-je pas entendu dire, après un long silence de réflexion et la pause d'un regard aigu sur la toile en train de se parachever: 'Cela sonne bien . . .' ou bien rien, ce qui lui faisait reprendre un large pan du tableau dans une orientation ou dans un ton différent. Oui, il fallait que 'cela sonne', c'est-à-dire que l'accord, au point d'équilibre, soit juste et que la répartition des surfaces soit organisée dans un contrepoint et une harmonie, tout comme dans une partition orchestrale.

Staël éprouvait longuement ses toiles en cours. Difficile pour lui-même, il n'était pas facile pour les autres et cela sans médisance. Ses dilections pour les grands maîtres du passé – à ses débuts en 1942, sa peinture évoquait Le Greco alors qu'il réalisait 'con amore' le portrait de Jeannine Guillou, sa première compagne, artiste d'un talent si personnel qui, par la vente de sa peinture, permit au couple et à leur enfant de survivre à Nice durant ce temps de misère noire et qui enfin, la première, eut foi dans le pouvoir novateur de Staël – Zurbaran et Vélasquez redécouverts en compagnie de Pierre Lecuire lors du second voyage en Espagne à l'automne 1954 – mais aussi bien d'autres avec Bonington et Delacroix, sinon Courbet dont une exposition à Lyon lui fit faire un voyage éclair depuis Antibes à seule fin de goûter les épaisseurs sensuelles du maître d'Ornans dont le peu d'esprit ne le mettait pas en cause à ses yeux – Van Gogh, dont la correspondance fut son livre de chevet au temps de son voyage de jeune homme au Maroc en 1937 et dont il copia hardiment 'Le zouave' d'après une reproduction – enfin, parmi les contemporains les plus notoires, son admiration évidente pour Matisse dont les gouaches découpées laissent entrevoir l'empreinte parmi certaines de ses dernières peintures, alors qu'il se sent si éloigné de Picasso, parce que la part d'expressionnisme que ce dernier intègre sans le vouloir dans son art l'exaspère au point de l'écarter de son champ visuel – toutes ces réjouissances picturales alimentent

insatiablement l'appétit de Staël (n'oublions pas son 'Hommage à Hercules Seghers' dont des éléments d'eau-forte suscitèrent en lui une inspiration renouvelée dans la pureté du trait), et pourtant nulle de ces dévotions ne l'aura marqué d'un sceau, si bien que l'on peut affirmer que Staël reste attaché à son fond d'authenticité.

En paraphrase, on est en droit de s'interroger si tel qu'en lui-même un quart de siècle ne l'aurait pas changé? Certes non. Mais l'exposition qui se tient aujourd'hui semble prouver que le coup de poing saisissant que la foule des visiteurs de l'exposition du Musée National d'Art Moderne en 1956 reçut comme l'éclatement d'un météore ignoré jusqu'alors, demeure perceptible. Car la place de Staël dans notre temps écourté reste à l'origine d'une tentative dont les épigones ou les suiveurs essuient les plâtres, en France comme à l'étranger. Mais ce n'est point là le plus sérieux de l'affaire: il s'agit de la permanence du choc et de la stabilité de l'œuvre, persistantes au-delà des ans que nous vivons. D'emblée, on ne démontrerait pas mieux que la fausse querelle du figuratif et du non-figuratif, régnant depuis la fin de la dernière guerre et au long des années cinquante, relève des Trissotins de l'époque. Et les deux termes tombent vraiment en désuétude. On ne peut que redire que la peinture, si elle ne succombe pas au piège de la littérature, est déjà en soi une abstraction, objet à deux dimensions et non pas trompe-l'œil. Cette fausse distinction n'a plus cours que pour ceux qui picorent dans l'œuvre de Staël à travers ses différentes phases, n'étant pas à même de réussir la superbe synthèse que Staël avait accomplie avec comme seul guide et seul souci d'être en plein accord avec soi. Quant à la critique, du moins celle de l'époque, on ne peut guère lui appliquer le sens étymologique du mot grec, car elle n'était pas à même de suivre la création en mouvement perpétuel, tel le fleuve d'Héraclite. C'est ainsi hélas que nombre de ces critiques – dont il faut excepter la clairvoyance des Roger Van Gindertaël, Pierre Courthion, Pierre Lecuire, Georges Duthuit, Denys Sutton, Guy Dumur, André Chastel – ne sont eux aussi que des séparatistes arrêtés çà ou là par l'impossibilité de saisir la chose poursuivant une révolution, dans le sens où la terre tourne autour du soleil.

Cette exposition prend toute son importance en 1981: depuis 1956 nulle exposition officielle n'avait eu lieu à Paris et il faut songer que tous ceux qui sont nés autour de ce millésime n'ont pu avoir connaissance de l'œuvre de Staël que par bribes ou pas du tout. Le domaine de l'art est aujourd'hui plus confus que jamais. Où se diriger à travers une forêt dont les troncs et les branches s'entremêlent? A nos yeux, les générations nouvelles doivent ressentir comme une nécessité la pose du regard sur un œuvre projetant son éclat dans un ciel où des nuées obscurcissent le chemin à suivre. Mais pour beaucoup de jeunes qui se destinent au dur labeur de créer, dans l'actuel désemparement où les jette une tour de Babel de l'Art dont les multiples langages se heurtent sans se comprendre, il ne peut être question de refaire du Staël, il s'agit seulement de prendre exemple sur une récente authenticité vie et d'art mêlés: avec d'autres moyens être soi-même et à soi-même.

Staël est loin de tous ceux qui tentent de l'approcher pour le surprendre, plus encore pour le 'piger'. Il s'est déterminé seul et jusqu'au bout. Son acte final est un inachèvement, tout comme 'Le grand concert', dont le gros œuvre en carénage est mis à flot avec une frappe sonore comme une enclume. Ainsi Staël va plutôt que de l'existence à la non-existence du non-existant à l'existant. Dans une œuvre de telle clairvoyance, ne plus être, c'est continuer à bâtir.

Pierre Granville
Conservateur de la Section d'Art Moderne et Contemporain au Musée des Beaux-Arts de Dijon.

colour laid on in patches rather than larges planes, allowing the white paper to play its part, and then the charcoal of the great nudes and still lifes inspired by his full and lively work table cast a diffused light on the late works: each of these creative processes, whatever the format, declares its individuality without a single gratuitous mark; each is fully expressive within a rigorous composition. Here, where spirit and act are fused, Staël forges the dispersed particles into a voluntary order.

For, such is the unique complexity of the man, that when one considers the development of the work, one sees that there is no falling into a trivialised diversity or, worse still, referential eclecticism. Rather, there are short phases that link up logically with one another in a slow gathering of density in such a way that, when once the parable is completed, the curve of his development appears smooth and uninterrupted. Historically, it makes things easier to talk in terms of periods, but he who is capable of following the projectile in movement perceives no discontinuity. The range of his palette and its sonority, often enhanced by black, plays no small part in the linking up of those moments beset with difficulties to be overcome. But it is fruitful to talk of music with regards to this painter who was so sensitive to it, not only as an ardent follower of the 'Domaine Musical' at the Petit Marigny, not only at the Paris Opera from which he would return full of enthusiasm – the source of the two paintings: 'Les Indes Galantes' – but above all in the conscious and unconscious search for musical transcription in painting through tonal relationships as much as through the rhythm of composition. Many were the times I heard him say, after a long reflective silence while pausing to look intently at a painting nearing completion: 'That rings true . . .' or else nothing, in which case he would alter the sense of a whole area of the painting or find a new tonality. Yes, it had to 'ring true' – that is, the relationships at the crucial points had to be right and the organisation of the surfaces had to be both contrapunctal and harmonious, just as in an orchestral score.

Staël suffered for long hours over his canvases. We may, with all respect, say he was not always appreciated by others, for he was as exacting of them as he was of himself. His affections were for the great painters of the past: in his early years, around 1942, his style is reminiscent of El Greco when he painted, 'con amore', the portrait of Jeannine Guillou, his first companion and an artist of great personal talent; it was she who supported the couple and their child during the period of dire poverty in Nice through the sale of her paintings, and it was she who was the first to have faith in Staël's radical talent; – Zurbaran and Velázquez, rediscovered with his friend Pierre Lecuire on his second trip to Spain in the autumn of 1954, but also many others, including Bonington and Delacroix, also Courbet, an exhibition of whose work tempted him to make a lightning trip from Antibes to Lyons with the single aim of delighting in the sensual paint surfaces of the master of Ornans untroubled by his lack of spirituality; – and Van Gogh whose correspondence was his bible during his trip to Morocco as a young man in 1937, and whose 'Zouave' he boldly copied from a reproduction; and lastly, amongst his most famous contemporaries, his evident admiration for Matisse, whose gouache paper cutouts left their mark on some of the later paintings; whereas he felt distanced from Picasso because of the element of expressionism that the latter unconsciously incorporated in his art which exasperated Staël to the point that he banished him from his own visual world. All these pictorial pleasures nourished Staël's insatiable appetite (and one must not forget his 'Hommage à Hercules Seghers' whose etchings stimulated a renewed interest in the purity of line) – yet none of his admirations left their stamp on him, so much so that Staël undeniably remains faithful to his own deep authenticity.

To summarise, one may reasonably ask whether, such as he was, a quarter of a century might not, after all, have changed him? No, not at all. But the present exhibition seems proof that the exciting shock felt by the crowd of visitors to the exhibition at the Musée d'Art Moderne in 1956, that had the effect of an exploding meteor unknown until now, continues to be felt. For Staël's place in our fleeting century remains the point of departure for those descendants or followers, who are working in a language they did not originate, both in France and abroad. But the important issue is rather of the permanence of the work's impact and its stability in years to come. First of all there could be no better proof that the false debate between figurative and non-figurative which has been at the forefront of discussion since the end of the last war and throughout the fifties was replete with Trissotin pretention. For the two terms have really fallen into disuse. One can but repeat that, providing it does not fall victim to literature, painting is inherently abstract, existing in two dimensions and not as *trompe l'oeil*. This false distinction is only made by those who pilfer his work right and left, unable to come to grips with the superb synthesis that Staël achieved with the sole criterion and guide of being completely true to himself. As for the critics, those of the period at least, they hardly merit the etymological sense of the Greek word, for they were incapable of discerning creation in perpetual motion, such as the flowing rivers of Heraclitus. It is in this way that most of these critics, apart from Roger van Gindertaël, Pierre Lecuire, Georges Duthuit, Denys Sutton, Guy Dumur and André Chastel, are once again merely separatists hindered at various stages by their inability to grasp what follows each revolution, in the sense of the earth turning round the sun.

This exhibition gains its full significance in 1981: there has been no official exhibition since 1956, and one must remember that all those born around this date can have had only a very fragmentary knowledge of Staël's work or none at all. Today the art world is in a worse state of confusion than ever. How can one make one's way through a forest where the trunks and branches intermingle? In my opinion, the new generation cannot but feel the necessity of coming to terms with a body of work offering in the murky atmosphere of today a decisive and radiant illumination. But for the many young people who intend to take up the hard creative life, there can be no question of imitating Staël, in the confusion they feel at the fruitless conflict of languages of the Tower of Babel of Art. They can only take the authenticity of Staël's art and life as example, and find other means to be themselves and to be true to themselves.

Staël is immune to all attempts to find him out or to 'dig' him. From beginning to end he is his own man. His final act is an act of non-completion, as is 'Le grand concert', a work launched from its dry-dock with the deep thud of an anvil. So Staël goes not from life into death but proceeds from non-existence into being. The clairvoyance of his work assures us that beyond existence it continues to create.

Pierre Granville
Conservateur de la Section d'Art Moderne et Contemporain
au Musée des Beaux-Arts de Dijon

Nicolas de Staël

Nicolas de Staël was a man of legend even in his own life time. The force of his personality, the quality of his vision and the originality of his technique, made him one of the most influential artists of recent years and his position was, if anything, enhanced by the subterranean nature of his reputation. His name became known to more than a small circle only towards the end of his short career. However, almost from the outset this circle was international.

To start with, it consisted of those who were captivated by Staël's personal charms as much as by his painting. Staël was not a man to be passed over in any company. He possessed the almost invincible Slav appeal and that unexpectedness that can prove, as it did in his case, so winning. His moods could be quicksilver but they never degenerated into a display of temperament for its own sake. His long lean humorous face, which had something about it of a shy colt, was frequently lit up by a smile both sincere and cynical. Although his huge movements were those of a giant, his sensitivity was revealed in the cut of his face and his palpitating nostrils.

Not the least fascinating of Staël's qualities was his power of leadership. He was a man of authority, one determined to pursue a specific course whatever the consequences. His sense of mission did not exclude, however, a belief in the concept of noblesse oblige. His independent nature meant, moreover, that he refused to accept hypocrisy: he was ruthless in what he said not because he was malicious or a trouble maker, but because he adhered to absolutes. This faith in principles, this determination to make himself heard, brought him, on occasion, into conflict with smooth and less candid personalities. It was, I think, the Northerner in him that made him so sincere, so suspicious of 'finessing' unless justifiable in artistic terms.

Staël could thunder when the need arose. Characteristic of his attitude to life and of his deep sense of personal honour – as of his respect for traditional virtues – was his fury with a critic who had suggested, in all good faith, that his father had fled from Russia at the time of the Bolshevik revolution. Staël could not stomach the implication that the General had deserted in the face of danger: it seemed to him quite unthinkable that this should be so. He stormed up and down his studio in a towering rage. His voice, powerful at the best of times, swelled with operatic volume: it ranged from note to note, tasting each phrase, each syllable. 'Mon père,' he declaimed, literally shaking with fury, 'était un soldat . . . UN SOLDAT.' He did not run away, Staël went on, but was escorted, old and ill, to the frontier by his men who then bade him farewell.

The tempestuous side of his nature was not, as far as I am aware, vented on his friends. Not that friendship was altogether easy with so alert and demanding a personality and several of his companions took offence at his direct approach. Yet although one always felt that he might occasionally explode and in doing so deal one a stern blow, his nature was marked by an extreme delicacy of sentiment. Nor was he ever so convinced of his own personal importance as might have been the case in view of his gifts, as to remain indifferent to the problems and minor efforts of his friends. Nicolas was immensely affectionate; he responded; he would enter into one's own troubles; he wanted to know what was happening, and to be informed about one's life, down to the smallest details and his own sensitivity made him particularly able to understand the reasons for a bout of depression, as to enter into the joys of the moment. His comprehension of life arose from a broad experience of it: he had known and suffered much himself.

I first met Staël in 1948 through a colleague at Unesco, Jean-Jacques Mayoux, and the experience of coming across such a creative artist, one so original and positive, after the false values enshrined at the Hôtel Majestic was vivid and stimulating. After my return from the United States in the summer of 1949 we were in constant touch and he was very pleased when I mentioned his painting in one of the last issues of *Horizon* in 1949. I used to look forward to the arrival of his letters in which his use of a washpen awarded his writing the quality of a calligraphic design, to his telephone calls from Paris or, better still, to the occasions when we met either in London or in Paris.

Some of his most amusing and brilliant remarks were made over the dinner table. For Nicolas shone when he was enjoying a splendid feast. He was no dreary fellow content with a crust and a bit of sausage. He loved and understood food, just as much as he cherished and tended his palette. It gave him immense pleasure to dine out. We would often go to a little restaurant, Chez Henri in the rue Fossé St Benoît, which although giving every appearance of being a casual bistro, was actually a connoisseur's haunt. The food, simple but admirable, was washed down with 'un petit Sancerre' and a lively Beaujolais imported by the owner direct from source. No less a trencherman than Nicolas, I would help him to clear the table with glee and on such occasions bottles would succeed one another with pleasing regularity. The gaiety of these evenings was increased by his flair for turning an ordinary dinner into a feast. That some of his most effective sallies and revealing confidences were made in such circumstances meant – as such things should be – that they are now forgotten.

More often than not, we would finish such jollifications by returning to his home in the rue Gauguet, in the Alesia quarter. His studio was reached by way of a small ante-chamber which contained a couch, a large table littered with letters, papers, drawings and often the pulls of his lithographs or his illustrations, as those for René Char's volumes of poems. A drawing or a painting might be casually stuck up on the wall. The studio itself was vast and reminiscent of a hangar: it was sufficiently commodious to be able to accommodate his largest pictures. It testified to his immense activity: not only might one come across those major works on which he was often engaged (I saw, for instance, the 'Les Indes Galantes' in its formative stages) but innumerable smaller paintings. These were of all sizes and included those vivid colour notes that were elaborated in his finished compositions. These minute, heavily charged *pochades* glowed with an intense colour. Colour, rich and striking or subtle and discreet, was worshipped in this immense silent workshop and Staël's passionate research into its properties was evident in his accumulation of palette knives, brushes and tubes and buckets of paint. As requires small emphasis Staël was a gourmand for paint, always priding himself on the quality of his materials as borne out by the size of his account at the colour merchant.

To descend from the studio to the living-room was like entering the cabin of a ship. Here the captain would take his rest while waiting for six bells to sound. It was snug and separated from the outside world – a simple room, with a large couch, a bookcase, a framed lithograph dedicated to Françoise; while next door was the room in which her three children would sleep. Staël was greatly attached to children and was especially fond of Anne, his daughter by Jeannine: she was a tall, graceful and poetical girl and stays in the memory like some wistful figure from a fairy tale and she was devoted to her father. Here, sprawling on the couch, enjoying his ease after a long day's work Nicolas would round off the evening with us. There was usually much laughter. Nicolas was always laughing so it seems to me when I think back. His laughter was quite amazing. His was neither a creased smile nor a guarded snigger: he had a belly-ache of a laugh, a Homeric peal. He would bend forward, starting slowly and carefully, testing his laugh to secure, as if he were a musician, the correct range of notes and then it would come moving from a high scream to a warm bellow. 'Mon cher Denys?' his rolling sea-shanty voice would go, 'C'est fou, c'est

tordant. Il m'a acheté une toile pour trois cent mille mais il n'a rien compris. Mais RIEN, ABSOLUMENT RIEN.' And then the laugh would break.

Nicolas was a brilliant and witty talker. He displayed great style in his choice of words and turns of expression. He had an observant eye for all that went on around him and, as so often with Russians, enjoyed a passion for analysis. He delighted, for instance, in examining the problems of artistic success. He knew that for a painter to succeed it was not only necessary to paint well but to plan ahead and to consider the complex machinery of critics, art dealers and museum officials that form the art world. He went the whole way and had a general's eye for strategy and was well aware when he had to consolidate some small critical position or move in to capture a major redoubt, throwing his entire nervous sensibility and passionate enthusiasm into the battle. He would dispatch urgent letters to his henchmen (for that we were) with orders to execute this or that move on the chess board. At times the various pieces were moved with the stealth and rapidity that should accompany the most important cloak and dagger affair. His letters read – as one peruses them again – as if they were written to Ashenden.

In this connection, he was always amused by the story I told him of a well-known London collector who had sold a painting by Modigliani to M. Rosenberg for a handsome sum. Gratified by the large profit, and eager to re-invest the money in another painting, he asked him what he should buy now. 'Il faut,' replied Rosenberg, 'acheter Staël.' Immediately the collector went round the galleries and bought one of his canvases, explaining the reasons that had prompted him to do so. The result was a rise in the price of his pictures – once it was generally known that Rosy had 'gone in' for Staël, which had the same effect, in the narrow world of the art trade, as if the Rothschilds or Lazard Frères had taken some fatherly interest in a little known gold or copper mine.

It would be wrong to believe, however, as is sometimes done, that Staël was excessively attached to success or to money. Having known the bitterness of poverty and neglect, he certainly appreciated the change in his circumstances that occurred when his paintings began to sell well. Moreover, he came from a background that had been accustomed to wealth and comfortable living. It was hardly surprising then that he should have enjoyed the possession of money, as it permitted him, *grand seigneur russe* that he was, to dispense splendid hospitality and to be as lavish as his nature demanded. His generosity was touching. Before calling to see us in London he would rush to Fortnum's so as to arrive armed with several boxes of gorgeous chocolates for my wife. However, he was aware of the problems that arise with success: 'ma peinture commence à devenir une grosse affaire d'argent, quelle horreur, Denys et comment faire,' he wrote to me on one occasion.

Nicolas's character had many endearing sides. His interest in everyday political and literary matters was considerable, and, like many Frenchmen, he had a touching belief in the special power of the British Secret Service. He was aware of the latest gossip in the Parisian world, and his information about literary circles was largely derived from his friends, René Char, the poet, Guy Dumur and Georges Duthuit. It was also in keeping with his cosmopolitan nature – and very Russian perhaps – that he was such a traveller: he knew North Africa, Spain, Italy, as well as Holland and Belgium. He had spent nearly a year living in Naples: and his stories of behaviour in that curious city were fascinating. This varied experience of life, as of art, made him a singularly complete figure.

England held a special place in his affections. Not only did he know and appreciate our painting, from Turner, Constable and Bonington to Sickert and Victor Pasmore, to whom I introduced him, but he quickly won admirers in this country. Clive Bell, for instance, was one of the very first to realise his qualities, while Mary Hutchinson acquired a minute picture by him. English life had many facets that appealed to him: he responded, for example, to the nostalgic appeal of St James' and greatly enjoyed staying in Duke's Hotel, where he found the echoes of aristocratic life that linger in that quarter much to his taste, conscious as he was of the traditions that had been cut short in his own country by the Revolution. He was equally delighted by the Port of London, and, like Derain and Vlaminck before him, he enjoyed its light and the curious life that he found there. I once asked him how he managed on such excursions, as he knew so little English. 'C'est facile,' was his reply. 'I go into a pub, have a beer, and then,' he concluded, 'on s'entend très rapidement avec ces braves gens.'

It was in London, too, that Staël had what was virtually his first important exhibition of paintings. This took place at the Matthiesen Galleries in Bond Street in 1952, and I was very flattered when Nicolas asked me to write the preface for it and to help with the arrangements. The exhibition – as with all such endeavours – was attended by a rush of letters, telephone calls and visits, the inevitable prelude to the great day itself. Naturally he supervised the hanging and came over for the opening. For those who knew him casually, he may well have presented a cool, even a disdainful appearance. In fact, the opposite was true. Both he and Françoise de Staël were under an immense nervous strain. He was satisfied with the result: the press was generous. After we had read the notices and gone over what everyone had said, he leaned back in the armchair with the words 'Voilà nous sommes arrivés'. It was true.

Staël went through the same agonies when he crossed to New York for the exhibition of his work at Knoedler's, as I well remember seeing him just before he left and immediately on his return. 'Figurez vous,' he wrote at the time, 'que Françoise et moi on a fait une promenade jusqu'à Ravenne avant le départ pour bien garder dans les yeux le pur roman du Mausolée du Galla Placidia, manger du poisson et boire un des meilleurs vins du monde.' While in New York he wrote to say how lost he found himself there and how much he longed for Europe. 'Je vous embrasse . . . et vous prie de baiser pour moi chaque pierre de Londres: je ferai la même chose à Paris moi-même.' He could not wait to return to 'notre chère vieille Europe'.

Europe and all it stood for meant much to Nicolas. He was, I think, one of the most broadly cultivated artists that I've met. He had the rare gift of bringing out the pictorial qualities of any work discussed and making one see the artist's side of art, especially where colour was concerned. He was familiar not only with modern painters but with the Old Masters – an achievement rather unusual for a contemporary artist. Typical of his interest in such matters was that he should have specially crossed to London for the exhibition of Dutch painting at the Royal Academy in 1953. It was a privilege to accompany him on that occasion and to hear him talk of Rembrandt, Hercules Seghers (whose paintings he believed could not be surpassed) and Philip de Konincks. His interest in the latter was particularly strong, and this artist's large horizontal landscapes, with their expanse of open sky, may well have exerted a considerable influence on him.

The problem of the artistic sources for any modern artist is complex and of the utmost fascination; Staël himself never felt bound by any doctrinaire approach. One must reckon, therefore, with the possibility that he was fired by contact with artistic forms or movements that might seem quite remote from his personality – at first sight. There can be few painters, for example, who owned, as he did, a complete set of *La Revue Blanche*, which he allowed me to consult when I was preparing a study on this fascinating and important periodical that later appeared in *Signature*, which was, incidentally, the first English magazine to print an article on Staël. It was his habit, so he said, to read the essays in the *Revue* from time to time, and he was particularly fascinated by some of the Scandinavian writings published in it, as well as by its theatrical and art criticism and Antonin Proust's essay on Manet. The 1890s appealed strongly to Staël, and he made a practice of studying its painters and writers: he was keenly interested in Gustave Moreau, for

example, and, if my memory serves, he wrote or considered writing an appreciation of him. He thought in broad terms, and when hearing that I was preparing an essay on Toulouse-Lautrec he sent me a word: 'N'oubliez pas Zola.'

Staël's own painting achieves an immediate impact owing to its extreme concentration of effect and individuality of colour. His large oeuvre of around 500 to 600 pictures, the result of little more than 10 years' work, is a tribute to his belief, expressed on many occasions, that all activities must be conducted with intensity. This forcefulness is revealed in the rapidity with which he moved from one phase to another: yet the successive stages of his evolution were not the outcome of restlessness; they stemmed from a desire to examine and resolve particular problems.

From the outset Staël was intrigued by the paradoxes of movement and by the desire to charge non-figurative painting with a dramatic, expressive content. After working in a figurative style in the 1940s – as in his 'Portrait of Jeannine', the 'Still-life' belonging to Monsieur Wulpert or his drawings (that recall Picasso's sketches of the Blue and Rose period), he adopted an abstract manner. His lozenge-like forms, perhaps indicative of the influence of Magnelli, were as early as 1943 framed by black or dark grey surrounds: that is to say, he was already experimenting with the play of tones that preoccupied him through the years. At the same time, he introduced sudden shots of flame-like colour – usually red or scarlet – to diversify the composition.

The linearism and light tonalities of the early phase surrendered in about 1945–46 to a group of extremely dark paintings. These contained a heavily encrusted and dense impasto, and only occasionally was relief provided by means of pinkish or greyish tones, that may owe something to the example of his fellow Russian, Lanskoy. The passion for black which possessed Staël at this point was shared by other Parisian painters; but unlike Hans Hartung, for instance, he did not use a shiny surface and a graphic form: on the contrary, his grey and oyster colours were compelled to force their way out of the opaque treacle crust that enclosed them. The paint was often dragged over the surface of the canvas and worked up into taut blobs so as to create small areas of dramatic tension reminiscent of the effects achieved by Soutine in certain of his Cagnes landscapes or still-life pictures. The struggle that took place between these conflicting elements gave his painting a dramatic intensity: the compelling clash of diagonals recalls Piranesi, a comparison borne out by Staël's drawings, in which the ink bites the paper with the fierceness of an etcher's needle. (His drawings may owe something to Fernand Léger, under whom he studied.) These are pictures that suggest a painter struggling to break through and to express a series of conflicts (personal and visual at the same time) that could only be vented in non-figurative terms.

This expressionistic period of Staël's painting surrendered to a calmer moment when he began to compose in terms of shapes rather than strips of colour: the harmony of the design was brought about in such pictures through the juxtaposition of single coloured blocks. The general tonality was muted, although occasional passages of a fiery colour, often worked into a spiky texture, gave variety and savour to the composition. Although intent on the representation of pure formal values, Staël's findings were based, to some extent, on observations of what lay around him and these were incorporated in his sketches. His large paintings were frequently inspired by the contemplation of the dilapidated walls of Paris houses. Others, however, were 'views' that exist in the haze of half life which occurs when reality and dream intermingle, or in the mysterious yet alert stillness of the snow world. These were paintings that elevate the spirit to the mountains.

That in such paintings he had balanced, one might say, the scales, achieved the equilibrium required and pushed a means of visual expression as far as it would go, meant either that he had to repeat himself and refine a vocabulary that could not bear to be chiselled indefinitely or else alter his style: he chose

the latter course. He had reached a plateau and consolidated; now he began once more to start hacking away in another direction. The route selected was, I think, one of extreme complexity – although the means he chose were simple enough. Before he girded himself for the climb, he underwent a period of gentle relaxation, which was productive of some of his most perfect paintings. These were grey and pale coloured or richly contrasted canvases that reflected his interest in Bonnard and the exquisite spatial harmonies of the Nabis.

Staël was captivated by the play of tones in any composition, as in any scene that came his way. In talking of his own pictures, for example, he would constantly emphasise such elements as 'rouge, rouge-bleu, bleu, bleu-gris, gris, brun-noire': in other words, he was attempting to divide his vision of the external as the internal world into a series of coloured passages that corresponded to a harmony that arose from this juxtaposition. This idea of relating colour, so as to achieve a sort of mystical state of exact absolutes, obsessed him during his career, and helps, I believe, to explain his fascinated respect for Braque. Writing to me of a visit to a private collection which was especially rich in paintings by Braque of the Cubist period, he declared: 'Mais là ou l'histoire devient passionante mais alors tout à fait passionante c'est au moment précis ou l'on saisit les Braque dans la lumière ou ils ont été peints, cette espèce de lumière diffuse et violente que le tableau reçoit d'autant mieux qu'il a tout fait pour y résister avec toute l'abnégation que cela comporte . . . Ces Braques font grande peinture comme Uccello fait grande peinture et acquièrent un mystère, une simplicité, une force sans précedent avec toute la parenté de Corot à Cézanne et naturellement libre.'

The crucial moment in his career came, I think, in 1951–2. He wrote to me at that date: 'Je pense pouvoir évoluer, Dieu sait comment, vers plus de clarté en peinture et que cela me met dans un état désagréable du trouble permanent.' The effort of facing up to the problems of figurative painting was immense, and he felt the strain, as he told me on several occasions. What he had to do was nothing less than bridge the gulf from abstract to figurative painting, or, in other words, to reverse the course of his development. He felt that the style he had achieved could yield no more: it had brought him to a full stop. His conviction that a new departure was essential was confirmed by the most casual occurrence: his presence at a football match played by Sweden and France at night. It had the same effect on him, one might even say, as the Circus had on Lautrec or Degas: it enabled him to take risks. The intensity of the contact between the players, the 'jeu', as he expressed it, of the 'rouge et bleu', compelled him actually to represent the figures, as can be seen in the series of brilliant sketches, which are perhaps rather more successful than the finished painting.

The novelty of his approach came over in his landscape paintings, which seemed to me then, as they do now, to represent some of his most personal and perfect work. His small studies, for instance, composed with yellows and ochres, or blues and greys, possess a singular freshness of accent as of approach: they show how he had been interested in Whistler, whose paintings he admired: he was very enthusiastic when I showed him photographs of small sea-pieces by this artist. Staël's devotion to nature was passionate; he pursued her moods with a huntsman's persistence. I would often drop in on him in the morning, and would sometimes find him cold and tired on his return from excursions at dawn to Gentilly or the flower market on the Quais. His love for flowers transpires in the magnificent bouquet belonging to Jacques Dubourg, which recalls certain still-life pictures by Delacroix and Courbet. It was at this period, too, that, like Courbet before him (whose works he admired enormously), he began to study the relations between sky and a horizontal plane, as in 'Les Toits de Paris' or in various sketches painted at Gentilly, on the Seine or the Normandy coast. We would often talk about Courbet's impressive contribution and of the fascination of the sky. He was anxious that I should write an essay on his own work in

relation to the landscape tradition ('libre vaste ciel paysage marine Bonington Corot Lorrain . . .' were his words), in which he was to be 'englobé . . . comme un joyau dans une châsse'.

Staël perfected an instrument that could be bent to will, and the paintings from the last three years of his life are distinguished by the sheer brio of their effect. He revelled in a liberated colour, in the violets and reds, the oranges and blacks that he forced to meet and to accord in his canvases. There was no holding him, and once again he was prepared to risk his money on a single throw; and he pulled off what he wanted. An eye that had been trained to capture the nuances of a more Northern landscape now delighted in the stark sharp light of the South: 'le soleil fulgurant à force d'être bleu' (he wrote), 'la mer devient rouge, et suit le cycle que vous savez de tout ce qui est intense dans l'arc en ciel'. His landscapes of the South of France or of Sicily possess a 'synthetist' quality reminiscent of Gauguin or the Fauves. Many stand fast by reason of their exuberant optimism and the radiance of their light: but others could also give off a smoky iridescence that recalls the late Monet.

For all their apparent simplicity, Staël's later works possess a strange complexity. On the one hand, we are constantly reminded of his painter's eye and of his knack of placing objects so that they stand in perfect relationship one to the other, as may be observed in his still-life compositions that suggest a study of Manet and Velázquez, whose work he examined in Spain in 1955. On the other, the extreme polish of his later style is offset by the vitality that informs his nudes, where the conflict of bold primary colours awards the figure a fierceness that recalls Munch or German expressionism. Such compositions as the 'Still-life in the studio' or the 'Seagulls', the latter painted after he had been reading Chekhov with his daughter Anne, possess a quality that is almost hallucinatory: are they not the sad, silent heralds of his solitary fate?

The reasons that induced Nicolas to take the step that he did are not our concern. It must be said, however, that, as with all his actions, it was one that was accompanied by dignity and reserve. He knew that the wilful termination of one's own life can become an act of nobility as the Stoics demonstrated. That nobility and a determination to proceed with skill towards his chosen destiny marked Nicolas's end. He selected the place with deliberation: it was perhaps appropriate. Antibes can exude the pleasurable atmosphere of the Riviera, but it has another and darker note: it has the starkness, the inevitability of the Mediterranean, that sense of invincible tragedy and even cruelty that lies beneath the surface of the South, or so it may seem to a Northerner.

Staël will surely be counted as one of the most influential painters of his generation. He stands out by reason of his adoption of a monumental style, his use of impasto and his solid yet refined blocks of colour: and he had also the courage to embrace a tradition when he deemed it necessary. Staël is significant in yet another way: he is one of those painters (Kandinsky is another) whose work forms a bridge between the aesthetic ideals of the East and West: not only did a constructivist flavour stamp his early pictures, but towards the end of his life he was intrigued by the possibilities of what he termed a Byzantine style.

Staël will remain a paradoxical figure. His last paintings show that he was on the verge of yet another departure: he had achieved a brilliant luminosity, the 'clarté' that he loved and so fervently sought. But the pressures were too great: the impulses too strong. He was meteoric and titanic: his grandly optimistic painting stands strong and bold in the middle of our fluctuating age. It enjoys the same positive character that he had as a man: it has the quality of life enhancement.

Denys Sutton
Whitechapel Gallery, 1956

Postscript 1981

In the years since the death of Nicolas de Staël in 1955 considerable changes have taken place in the nature of painting: realism is once again in favour. In Staël's day, many pundits proclaimed that the only valid style then and in the future was abstraction: that this claim was forcibly advanced may have been partly due to the escapist element in a style of painting that was generally free of content and usually colourful and decorative. Staël's impact on his contemporaries is now seen to have been considerable. He appealed both to believers in abstraction and to those who sought a new approach by means of a figurative style. Both groups appreciated his sense of colour, muted in the early works, more radiant in the later pictures, and his delight in paint for its own sake, in 'une belle tranche de peinture'. Staël's connection with Russian art now seems closer than was generally realised in his lifetime; the grey desolate space that appears in some of his 'landscapes' presents affinities with that found in the paintings of Levitan, a friend of Chekhov.

Staël's achievement as a painter who moved from abstraction to embrace a figurative style needs little stressing. One of his deep convictions was that no break occurs in the continuity of painting; methods and language may change, but the problems of expression in terms of pigment remain as constant and demanding as ever. It is a conviction borne out by the quality of his work.

Denys Sutton

15

Selected Letters

Nicolas de Staël was an avid correspondent and from his early youth wrote long letters, first to his family and then to such close friends as René Char, Pierre Lecuire and Jacques Dubourg, expanding his ideas on art. When Staël first turned to abstraction in 1942 he had been as attracted by its theoretical side as by its potential for plastic expression, and throughout his life he found it necessary to explore his ideas and experiences in words as well as through his painting. His writing style – elliptical, often enigmatic and poetic – is distinctive and full of vitality. This small selection of some of the major letters he wrote between 1952 and 1954 – a period of great change in his art and life – show, better than a commentary could, the anxiety and urgency underlying these new developments. Staël's acute perceptiveness in expressing his doubts, fears and elation is illuminating and provides a vivid accompaniment to an appreciation of his painting.

Letter to Jacques Dubourg, June 1952
(Chastel 1968, pp. 218 + 228)

Dear Dubourg,
Thankyou for your cheque. Here, as far as I can understand, is what is happening within me as regards things on your side. Top priority: painting:
I cannot forsee what I will do tomorrow, but at the moment I am extending the planes to their maximum within the confines of the virgin canvas – what I mean is that the painted surface yields its form as if it were still virgin; formlessness carries a thousand dangers when the form hasn't been seen elsewhere and in the absence of something to which one is used. Obviously composition ranges from a thickly applied sensuous rhythm to the most thinly applied and detached possible. But all this belongs to some language of which I can only discern a part.

On the other hand one must still, and before all else, do good traditional painting – one must tell oneself this every morning – at the same time breaking with tradition to all appearances because tradition is not the same thing for anyone. What can one do, I believe in the circumstances from which a work of art is born; at the moment all this seems confused but one day with any luck it will be recognised that I am evolving logically and that each painting for me is a whole; this will then become accepted fact and my painting won't be asked for what no other painting could or will ever give. My dream is to paint as few paintings as possible but ones that are more and more complete; for the time being everything that comes into my head runs on like society conversation and I blast the canvas without flinching the moment I sense something at the end of my fingers that can convey what I'm feeling inside. But you know this business: two things matter, the force and intensity of the touch and that of the thought behind it; anyway it's totally impossible to talk about either one or the other at the moment. A perrenial topic. Concise painting done out of doors but executed alone, one to one in the studio, will always have more concision than the other kind. And what can one do if by dint of burning up the retina of one's eye on the 'shattering-blue' as Char puts it, one ends up seeing the sea red and the sand violet – one can but run and quickly. I shall bring enough materials to work here seriously one year. – You'll have pyramids of bathers surrounded by sky, sand, water and the wide wind.

Well, I could go on for ever . . .

With friendship and thanks, Nicolas

Letter to Jacques Dubourg, Le Lavandou, June 1952
(Chastel 1968, p.218)

This Greek light clearly teaches us an important lesson; only stone or marble can stand up to its consuming radiation. All said and done neither Cézanne, nor Van Gogh, nor Bonnard made use of it otherwise than as a psychic spur; I mean that on the principal, intimate level they could really have painted what they painted anywhere – not the Greeks, with them it's a totality; their sculpture takes and renders this sunlight in all its multiplicity in a way that it would be impossible to do elsewhere.

Now, I'm not sure one can say it like this, but between absolute form and absolute formlessness, which are often very close, there exists a balance which only mass can express through volume. Colour is literally consumed; one has to retreat to the shade under the sails, hang on to every barely perceptible plane if one doesn't want to end up with a flat Pompei fresco. As for me, I'm working as hard as I can; I'll bring back a good number of studies but no paintings in the sense that I understand the word; paintings to be done, yes, but in my studio in Paris. I need to step back, I need distance of all kinds, that of the studio, that of open curtains à la Matisse, closed every other moment, and that of calm. That being said, I am consuming quantities of colour and it's possible that out of a hundred studies there may be a few that will hit the mark, but I can't tell at all at the moment. If I show with you next year, I shall carve two or three marble sculptures for the exhibition . . .

All the best, Nicolas

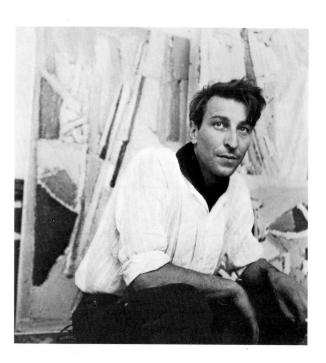

Letter to Pierre Lecuire, Paris, 14 May 1953
(*Lettres de Nicolas de Staël à Pierre Lecuire*, Paris 1966)

Dear Lecuire,
It seems that I will never come to the end of all that I would like to say to you.

But a while ago – I shall probably forget it tomorrow – I was slow in insisting to you that there are only two valid things in art:
1) The lightning flash of authority
2) The lightning flash of hesitation

That's all. The one comes out of the other, but in their highest degree the two can be distinguished quite clearly.

Matisse at the age of 84 manages to hold on to these brilliant flashes even with little bits of paper. And we will never know whether Descartes is of any more use to us than as a slide-rule, for all the evidence one sees.

The rest will remain under the ground because the sky is up there and the rest is dead.

Well, I shan't go on, See you soon Nicolas

Be careful with genius. It's a curious word. One never does anything, as you know full well.

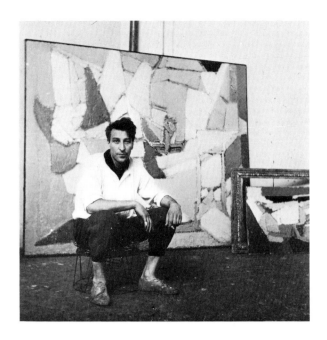

Letter to Jacques Dubourg, Antibes, 6 November 1954
(Chastel 1968, p. 354)

Dear Jacques,
Don't treat me as equal to Courbet. He is an immense fellow; it will take a few centuries for it to be recognised. I say immense because without artistic theory, without conventionalism, without preamble, he turns out a continuous flow of unique paintings, with the same certainty as a river that runs towards the sea, dense, radiating sonorous light, and always restrained. Cézanne is a kid beside him.

At Lyons there was an oak tree that comes from Cincinnati.* Just look at it – what a tree, what sky! Poor Cézanne with his logic. There is a logic in Courbet that supports all the illogicalities – now that's logic. I'm still completely bowled over by it all; and he nearly always paints each painting differently to the next. Always unexpected. Of course the provinces, Lyons, the Place du Terreau, the sublime building, all help to make the exhibition explode like a bombshell.

But the Toilette de la Mariée,** the lesbians,*** with its collage of a still life in front, the undergrowth, really Jacques, it is wonderful to be able to paint to such a degree pictures that are idiotic, inspired, miraculous – the deer in the snow – **** and the infinite happiness of it all that pours forth endlessly. Even Rembrandt has an artistic philosophy, but that's not for him. What a marvel. To paint just as it comes. Well, I could go on for ever. He is a titan, Courbet. For myself, I am what I am, we'll see in ten years time, or later.

You have got, in my view, some of my major canvases at the Boulevard Haussmann; look at them; I'll try to send you in the next delivery some even better ones.

All the best, Nicolas

*Le Grand Chêne d'Ornans 1864, Museum of Fine Arts, Philadelphia
**La Toilette de la Mariée 1870, Smith College Museum of Art, Northampton
***Le Sommeil 1866, Musée des Beaux Arts de la Ville de Paris
****Chevreuils Dans la Neige 1861, private collection

Letter to Jacques Dubourg, Antibes, November 1954
(Chastel 1968, pp. 348 + 354)

Dear Jacques,
Right, I've begun to work; annoying light, like a ping-pong ball, but it should settle down with winter approaching. You will have some paintings in December. I'm going to try figures, nudes, portraits and groups of people. I have to do it, I can't help it, the time has come; I can't paint acres of still lifes and landscapes, it's not enough. But don't hurry me, bring in the pennies, and we'll do good things.

I thought about Goya for a long time on leaving Madrid. If he had had someone to calm him down a little he would have been a great painter. For me you see, all the psychological aspect, critique of manners, critique of character, his irritation in front of certain people, superimposes itself on the painting, really like a hair floating on top of the soup – it's annoying and it adds nothing. When he is so distant in front of some admiral or other, or a general in patent leather slippers, that he doesn't have the time to analyse, then the whole thing is almost perfect enough to enrapture one. The same applies to the witches, the abortionists, the whores and the Duchess. He is not detached enough from what he does, despite his divine touch – because this fact is indisputable, his touch is divine, it's overwhelming how sensitive it is, and how from it flows smoothly an acute delight . . .

As a lesser case in point one thinks of Picasso, overwrought by Paris, but Picasso never had Goya's temperament, never. One would have liked to see Goya paint still lifes. There is the head of a dog that's practically a still life in mid air, yellow, now that's a singular tour de force, really unique. Goya's work as a whole doesn't go all the way – not for me. It's annoying: so much talent, so much temperament that nobody calmed down. How is it that all those whores didn't manage to bring him peace? A mystery. Because you know, Jacques, Daumier for example, Daumier is a great painter, because Daumier doesn't criticise, Daumier doesn't judge, he's got it all in his bones, in his guts; it's impossible to believe that the way Daumier paints a nose or an ear could be a critique, it's all part of a whole with him, it is a complete world, full, rounded, that turns without fail and his hand and eye roam over it without being able, without needing, to analyse – that's how it is, and that's all. Not with Goya. It's precisely the way he paints a nose or an ear in relation to the rest that I don't like, because it is not great, he is not fully there. If he had only vaguely sketched it all it would pass but so insistent, it doesn't – not for me. It's not intelligent enough, and it's not stupid enough.

On the other hand, I saw the first proofs of his etchings of the Tauromachia. The copper and the applied art give him suddenly such grandeur that it is as moving as could be and so simple. Here he is once more unique. It's curious this Goya business, but I prefer the whole of the French School, without argument. Whereas Velazquez remains immense, disciplined, unconstrained, simple – a different breed of man. El Greco is very great, sometimes very, when he refrains from perfuming his work with incense, but this is rare, even in Spain: his

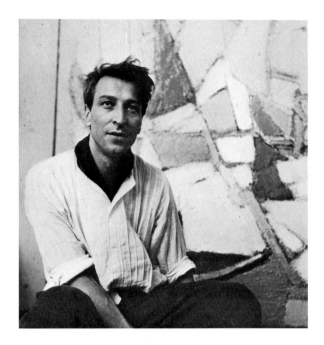

I don't want to be systematically either too close or too far from the subject – neither one nor the other – but I believe in obsession because without obsession I would do nothing; whether fantasy obsession or direct obsession is more valuable I don't know, and all being said, I don't care, provided it all balances out as best it can, preferably without equilibrium. I lose contact with the canvas at each instant, find it again, lose it again . . . This is necessary because I believe in the adventitious, I can only proceed from incident to incident. As soon as I sense too much logic I become irritated and swing naturally over to the illogical. Of course all this is not easy to say, not easy to see – there is no language for it, and, if you like, the metric system of it all remains to be invented when I have stopped painting. There are very few paintings that I see the exact size they are, either from memory or face to face, and the dimensions I use are quite frankly left to chance because I believe in chance and not in exact dimensions. I believe in chance in exactly the same way I see by chance, with a constant obstinacy; it's even this that determines that when I see, I see like no one else. And there you are right, there are paintings in me which can't come out, wherever I may be, because one must wait for chance, or eat a carrot to make it happen. Thankyou again for your friendship Douglas; one doesn't choose one's path in painting, one walks as best one can, with flat or strong feet, with bare feet or in shoes – one could even establish judgements in painting on nothing more than the painter's shoes, boots or espadrilles – who knows? But I do the walking, for you to do the looking.

Sometimes I get anxious in my friendship for you, me, the others, to know in what way you see – but the telephone is there. Between the most and the least there is such a range of nuances, of elephantine proportions; one could already put round every word one says the sign > or < like in arithmetic . . .

So see you soon, yours, Nicolas

replica of the painting in Vienna, one or two portraits and the waltz of the virgins in the little chapel on the road. The Burial of Count Orgaz?* The lower part of the painting, yes, but the sky? You know, in the basement of the Prado one can see the French School. There's a Claude Lorrain that I'd gladly take off the wall to have a good look at, also a Watteau, and a Poussin.**

It's good to feel oneself in France, there is always someone carrying flowers and a bird always rises. The weather here is superb. I'm trying to get to grips with some still lifes; I have painted a guitar like Manet – in a manner of speaking – but one could think about it . . .

Yours Nicolas

*In the Santo Tome church
**Claude Lorrain *Toby and the Angel* or Roman *Saint Pauline embarking at Ostia*; Watteau: *The Marriage Contract*, *The Fête Champêtre*; Poussin: *Landscape with Ruins* or *Parnassus*

Letter to Douglas Cooper, January 1955
(Chastel 1968, p. 382 + 396)

Dear Douglas,
I'm replying a little more seriously to your kind letter of the 11 January. What is important in what you say is that you give one aspect of your opinion whereas painting, true painting, always tends towards all aspects, that is to say, towards the impossible sum of the present moment, the past and the future. The reasons why one may or may not like my painting matter little to me because I'm doing something which can't be examined closely, which can't be taken to pieces, which has a value through its adventitious quality, which one may accept or not. One functions as best one can. In my case, in order to renew myself, to develop, I need to always work differently from one thing to another with no *a priori* artistic philosophy. One uses strong, delicate, or very delicate, direct or indirect values, or even the converse of value – what matters is that it should be right, always. But the more the approach to this 'rightness' differs from one painting to another, the more the path to it seems absurd, the more it interests me to travel down it. Impressionist? I don't know what that means because since we began categorising it painting has had a narrow escape.

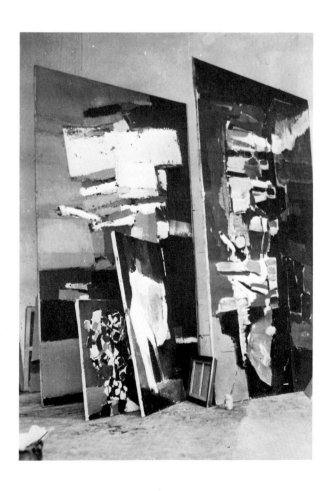

Letter to Pierre Lecuire, Antibes, 13 December 1954
(*Lettres de Nicolas de Staël à Pierre Lecuire*, Paris 1966)

Pierre, it is all obscure, like one's feelings. One mustn't, one can't understand.

Chance – how can one help it – is fire; everything rests on being able to use it, but one's temperament inclines that way or not. That's all.

I believe one must do everything in order to foresee things down to the last shadow, to see them in their obscurity, but the fire is unique, and will remain so.

The more the shadow is precise, strong, inevitable, the more one has the opportunity to strike fast, clearly, powerfully.

But go ahead, and send me news of how it goes.

Your friend, Nicolas

One must never know where it comes from or where it is going to. Tears are material as good as any other.

Letter to Jacques Dubourg, Antibes, December 1954
(Chastel 1968, p. 366)

Dear Jacques,
Thankyou for your letter. What I'm writing to you is a bit difficult, but there you are. What I am trying to achieve is a continuous renewal, truly continuous, and it is not easy. I know what my painting is underneath its appearances, its violence, its continual play of strength, it's a fragile thing, in the sense of sublime, fragile like love. I believe, in as far as I have control over myself, that I always try to make a more or less decisive action from my possibilities as a painter and when I attack a large canvas, when it begins to be good, I always become painfully aware of how too much is owing to chance and I feel dizzy; it is a chance born of strength but it still looks like chance, like a sort of backhanded virtuosity, and this throws me into the most pitiful state of discouragement. I lose my grasp and even the three metre canvases I begin – on which I just put a few well thought out touches each day, always end up in bewilderment. I can't master it – in the real sense of the word, if there is a sense; I would like to manage to strike with full deliberation, fully conscious, even if I strike fast or with force. The important thing is to keep as calm as one can, right to the end. I am at Antibes trying precisely to change fundamentally in this way. If you assist me I won't come back to Paris until June to exhibit the best of them at your gallery. I know that my solitude is inhuman; I can't see any way out of it but I can see the means to progresss seriously. I don't know if it can be called to progress, but it matters little, the business is worth the trouble; if I remain isolated for a few years I will be, believe me, in a different situation, and you Jacques, you will have the most sensational place in the world because you will be selling paintings of essential truth which will be major events in themselves, outside all the known rules. Think about it, it's not easy but we're going to try, really try.

If the vertigo which I hold to as an attribute would gently turn towards more concision, more freedom, away from persecution, things will become clearer. The surprise caused by a painting or by one period or another, is normal in my work; it's as if things completed move into a haze once they are no longer there. But all this, who knows, isn't it perhaps all an idiotic dream? But it doesn't matter. Until my death I shall always keep my tomorrows unknown – as long as things go alright . . .

Looking forward to your letter with pleasure, Nicolas

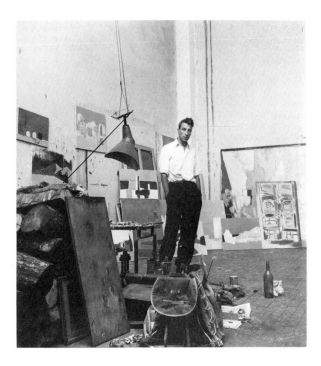

Note on the catalogue

Certain paintings exhibited in Paris have not been brought to London; most of them are indicated in the pages that follow by an asterisk after the title.

Each catalogue entry contains French title and date, technique and support, dimensions in centimetres and details of signature and inscription. HIST lists the previous owners, EXP the places the work has been exhibited, and BIBL the references to the particular painting in books and magazines. Full details about the exhibitions and a bibliography will be found on pp. 173–5.

In certain cases, a related drawing or document is reproduced on the same page as the catalogue entry.

1 Portrait de Jeannine, 1941-1942

Huile sur toile
81 × 60
Collection particulière

Oil on canvas
81 × 60
Private collection

EXP.
Paris 1956, n° 4
Arles 1958, n°1
Turin 1960, n° 1, repr. p. 31
Rotterdam/Zurich 1965, n°1, repr.
Boston/Chicago/New York 1965-1966,
n°1, repr.
Saint Paul 1972, n°1, repr. p. 43

BIBL.
Réalités 1957, repr. p. 62
Cooper 1961, p. 12, repr. coul. pl. 1
Granville 1965, repr. coul. p. 86
Grojnowski 1966, p. 942
Chastel 1968, n° 2 repr. p. 55
Archives Maeght 1972, repr. p. 43, n° 1
Dumur 1975, p. 23, repr. coul. p. 8

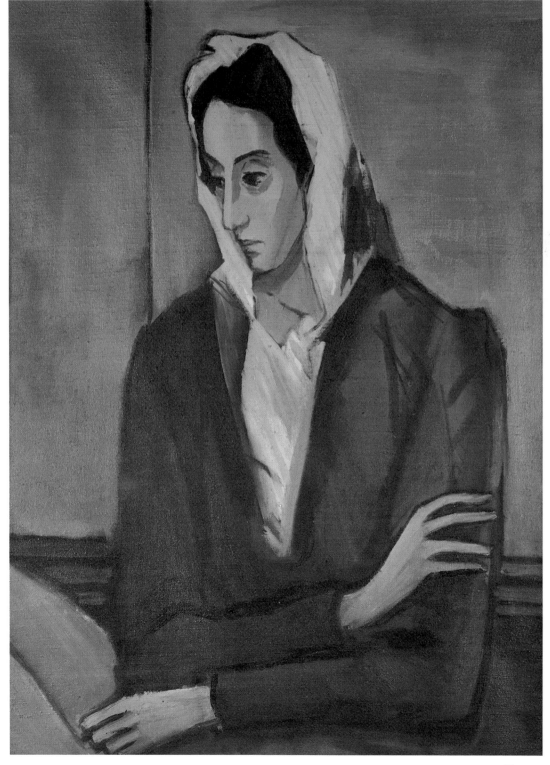

2 Composition, 1942

Huile sur toile
130 × 71
Musée de La Boverie, Liège

Oil on canvas
130 × 71
Musée de La Boverie, Liège

HIST.
Yan Elligers, Nice
Jacques Dubourg, Paris
Bellanger, Paris
Hugo Gouthier
Real Lessard, Paris

BIBL.
Gindertaël 1960, repr. coul. pl. 1
(daté 1944)
Guichard-Meili 1966, repr. pl. 1
Chastel 1968, n° 5, repr. p. 57

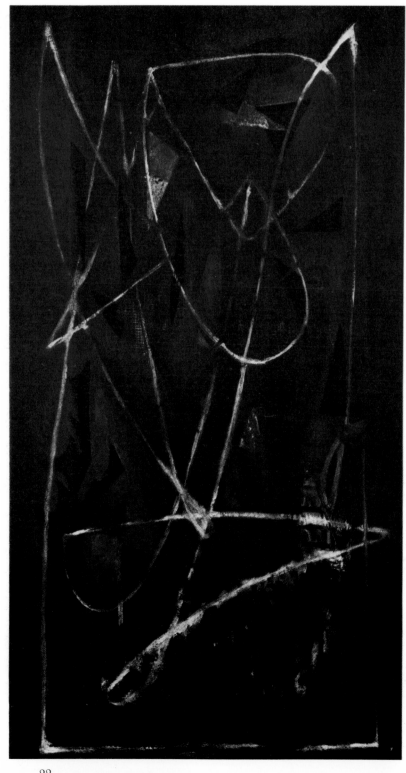

3 Composition, 1943

Huile sur toile
114 × 72
s.d.b.d. : Nicolas de Staël 1943
Cadre peint par l'artiste
Jacques Matarasso, Nice

Oil on canvas
114 × 72
s.d.l.r. : Nicolas de Staël 1943
Frame painted by the artist.
Jacques Matarasso, Nice

EXP.
Paris 1956, n° 10
Londres 1956, n° 4

BIBL.
Wescher 1965, repr. coul. p. 86
Granville 1965, repr. coul. p. 86
Chastel 1968, n° 6, repr. p. 57

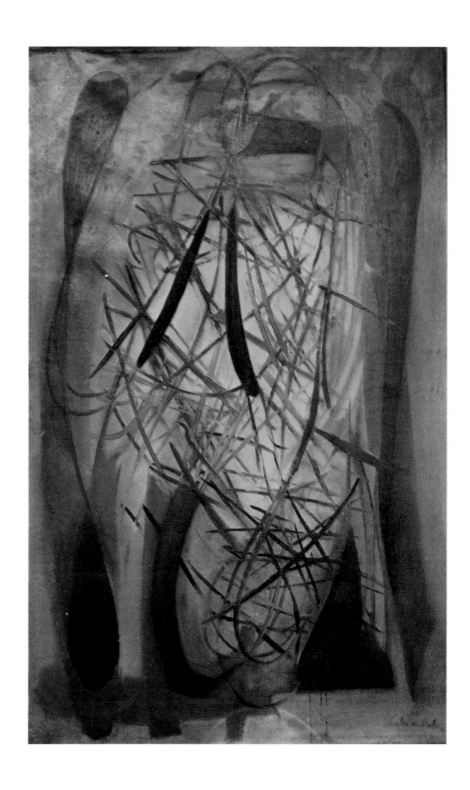

4 Composition, 1943*

Huile sur toile *Oil on canvas*
113 × 78 *113 × 78*
s.b.d. : Staël *s.l.r. : Staël*
Collection particulière *Private collection*

HIST. BIBL.
Jeanne Bucher, Paris *Chastel 1968, n° 13, repr. p. 59*

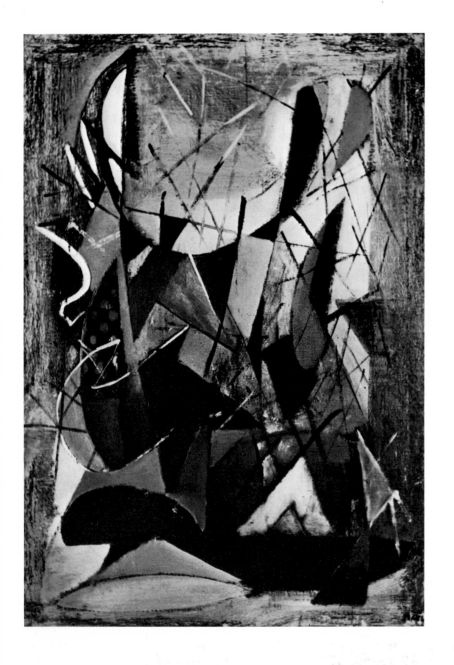

5 Astronomie-composition, 1944

Huile sur bois
240 × 103
Igor Troubetzkoï, Paris

HIST.
René Drouin, Paris

Oil on wood
240 × 103
Igor Troubetzkoï, Paris

EXP.
Paris 1945, n° 109
Berne 1957, n° 3
Rotterdam/Zurich 1965, n° 3, repr.
Boston/Chicago/New York 1965-1966
n° 3, repr.
Saint Paul 1972, n° 4, repr. p. 48

BIBL.
Le Spectateur des Arts 1944, repr. p. 22
Grojnowski 1966, p. 943
Chastel 1968, n° 27, repr. p. 63 et coul. p. 65
Archives Maeght 1972, repr. p. 48, n.° 4
Dumur 1975, repr coul. p. 5

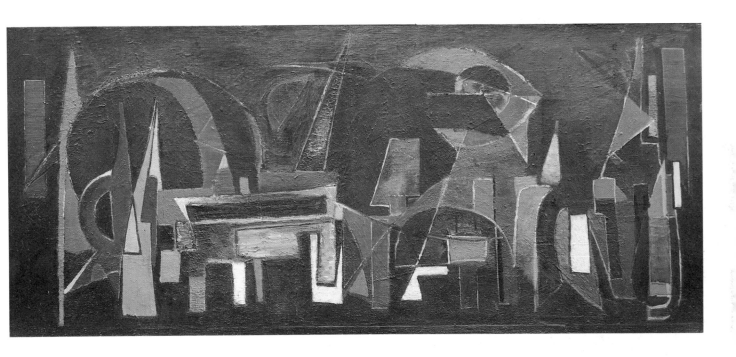

6 Les rayons du jour, 1944

Huile sur toile
105 × 69
s.b.d. : Staël
Collection particulière, Paris

Oil on canvas
105 × 69
s.l.r. : Staël
Private collection, Paris

HIST.
Jeanne Bucher, Paris

EXP.
Paris 1956, n° 11
Berne 1957, n° 6, repr.
Hanovre/Hambourg 1959-1960, n° 1 repr.
Turin 1960, n° 6, repr. p. 6
Bâle 1964, n° 1, repr. coul.
Rotterdam/Zurich 1965, n° 4 repr.
Boston/Chicago/New York 1965-1966,
n° 4, repr.
Saint Paul 1972, n° 3, repr. p. 47

BIBL.
Cooper 1961, repr. coul. pl. 4
Chastel 1968, n° 20, repr. p. 42
Archives Maeght 1972, repr. p. 47, n° 3

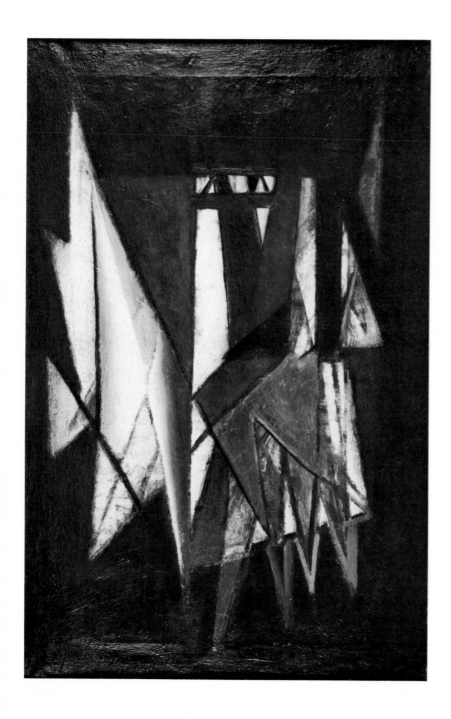

7 La part du vent, 1944

Huile sur toile
114 × 146
s.b.g. : Staël
Louis Clayeux, Paris

Oil on canvas
114 × 146
S.l.l. : Staël
Louis Clayeux, Paris

EXP.
Berne 1957, n° 4
Saint Paul 1972, n° 5, repr. p. 51

BIBL.
Cahiers d'Art 1946, repr. p. 415
Chastel 1968, n° 28, repr. p. 64
Archives Maeght 1972, repr. p. 51, n° 5

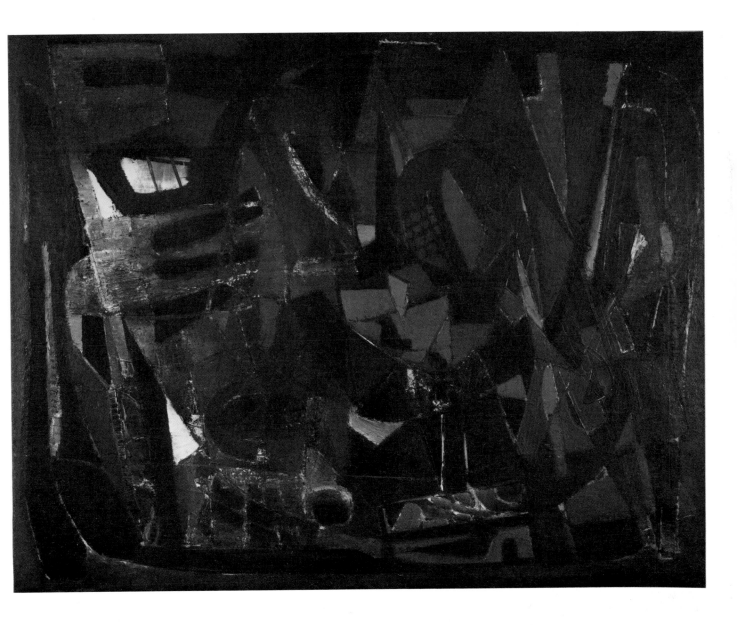

8 La gare de Vaugirard, 1945

Huile sur toile
100 × 73
s.d.b.d. : Staël 45
Galerie Jeanne Bucher, Paris

Oil on canvas
100 × 73
s.d.l.r. : Staël 45
Jeanne Bucher Gallery, Paris

EXP.
Berne 1957, n° 5
Bâle 1964, n° 8

BIBL.
Chastel 1968, n° 32, repr. p. 64

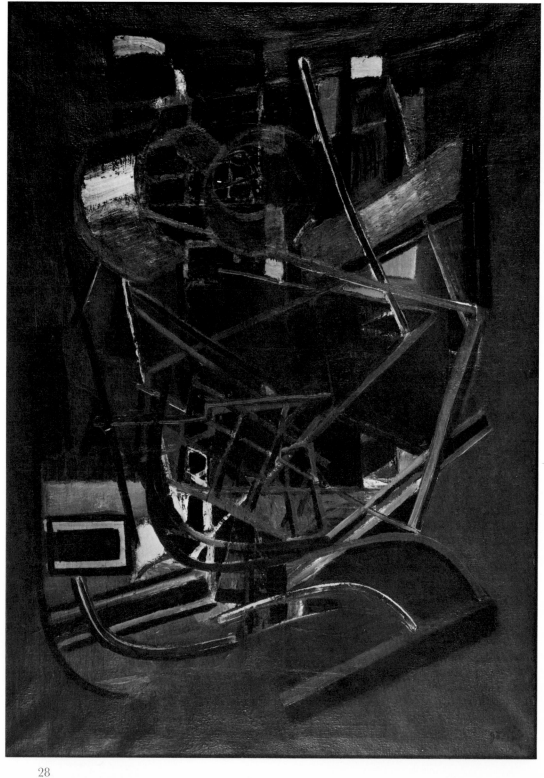

9 Fable, 1945

Huile sur toile
54 × 65
s. au dos : Staël
Collection particulière

Oil on canvas
54 × 65
s. on the back : Staël
Private collection

HIST.
Coll. particulière, Paris
Rex de C. Nan Kivell, Londres

EXP.
Edimbourg 1967, n° 2

BIBL.
Chastel 1968, n° 43, repr. p. 67

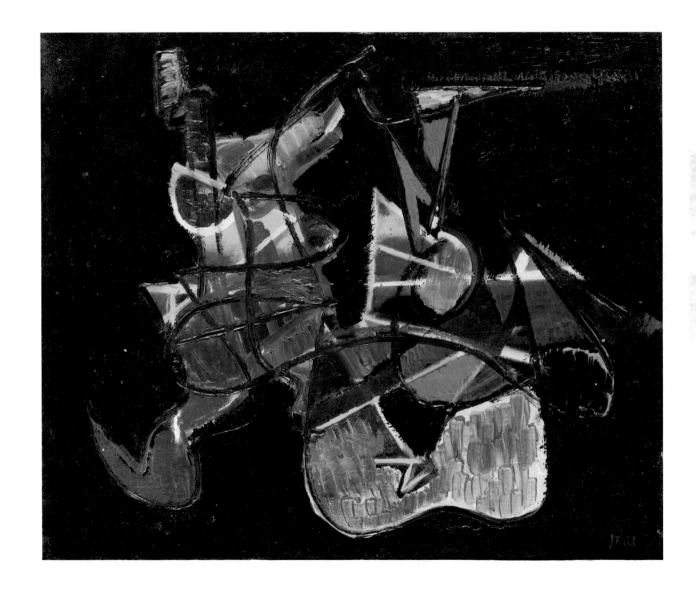

10 Composition en noir, 1946

Huile sur toile
200 × 150,5
s.d. au dos : 1946
Kunsthaus, Zurich, Association
des Amis zurichois de l'art

Oil on canvas
200 × 150,5
s.d. on the back : 1946
Kunsthaus, Zurich, Zurich Friends
of Art Society

HIST.
Jean Bauret, Paris
Jacques Dubourg, Paris
Coll. Dr. Peter Nathan, Zurich

EXP.
Paris 1950, n° 1
Paris 1956, n° 19
Berne 1957, n° 10
Rotterdam/Zurich 1965, n° 7, repr.
Saint Paul 1972, n° 7, repr. p. 53

BIBL.
Duthuit 1950, repr. p. 384
Gindertaël 1950, repr. pl. II
Waldberg 1950, repr. p. 143
Gindertaël 1960, repr. p. 3
Chastel 1968, n° 61, repr. p. 73
Archives Maeght 1972, repr. p. 53, n° 7
Dumur 1975, repr. coul. p. 12

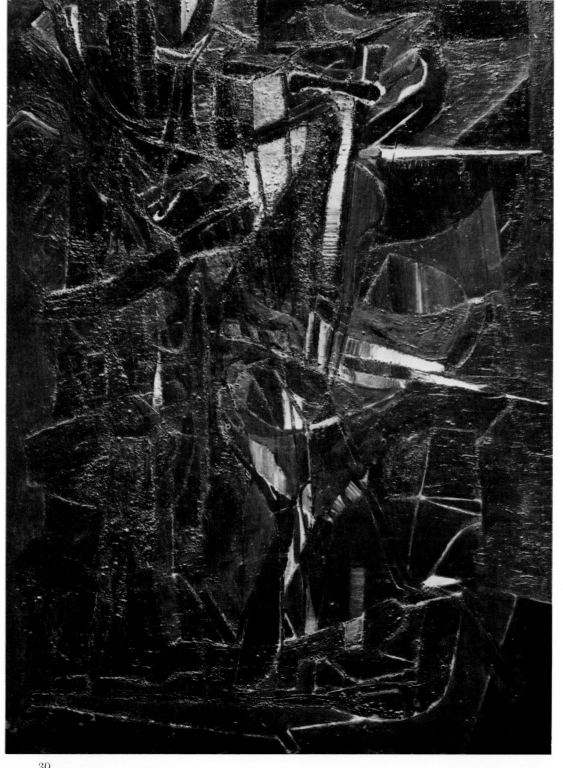

11 Le cube, 1946

Huile sur toile
65 × 54
s.d.h.d. et bg.
Louis Carré et Cie, Paris

Oil on canvas
65 × 54
s.d.u.r. and l.l
Louis Carré and Co, Paris

EXP.
Paris 1964, n° 1
Boston/Chicago/New York 1965-1966,
n° 7, repr.

BIBL.
Chastel 1968, n° 65, repr. p. 74

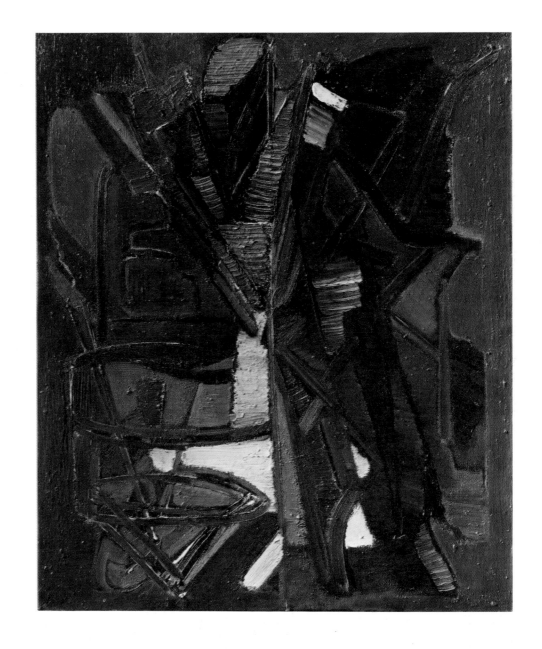

12 La vie dure, 1946

Huile sur toile
142 × 161
s.d. et titre au dos : La vie dure,
Nicolas de Staël, 28-10-46
Paris, Musée National d'Art
Moderne

Oil on canvas
142 × 161
s.d. and title on the back : La vie dure,
Nicolas de Staël, 28-10-46
Paris, Musée National d'Art Moderne

HIST.
Louis Carré, Paris
Achat du MNAM en 1980

EXP.
Berne 1957, n° 16
Arles 1958, n° 11
Paris 1964, n° 6

BIBL.
Gindertaël 1950, repr. pl. III
Cooper 1961, p. 22, repr. coul. pl. 5
Chastel 1968, n° 78, repr. p. 77

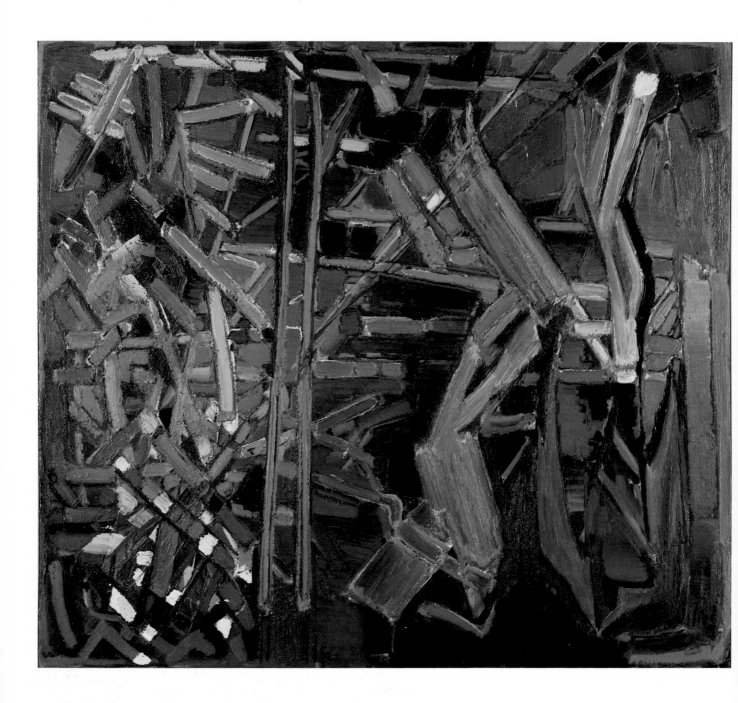

13 Porte sans porte, 1946

Huile sur toile
189 × 94
s.d. au dos : Staël 1946
Collection particulière, France

Oil on canvas
189 × 94
s.d. on the back : Staël 1946
Private collection, France

HIST.
Louis Carré, Paris
G. David Thompson, Pittsburgh
Galerie Beyeler, Bâle

EXP.
Berne 1957, n° 12
Arles 1958, n° 10
Hanovre/Hambourg 1959-1960, n° 6
Turin 1960, n° 14, repr. p. 44
Bâle 1964, n° 9, repr. coul.

BIBL.
Cooper 1961, p. 22
Chastel 1968, n° 73, repr. p. 75

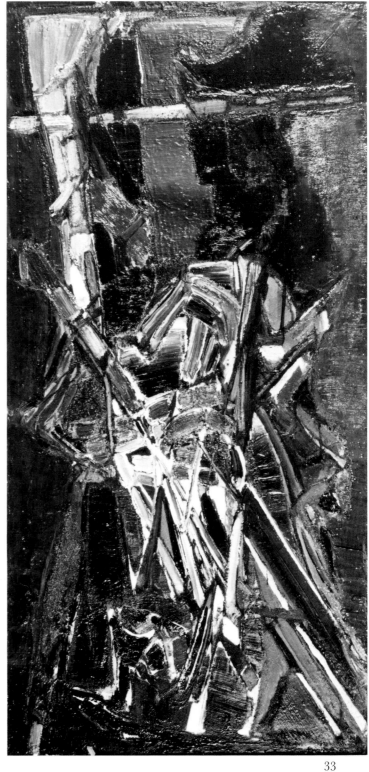

14 Bâtons rompus, 1947 *

Huile sur toile
81 × 65
s.h.d.
Collection particulière

Oil on canvas
81 × 65
s.u.r.
Private collection

HIST.
Louis Carré, Paris

EXP.
Paris 1964, n° 10

BIBL.
Chastel 1968, n° 96, non repr.

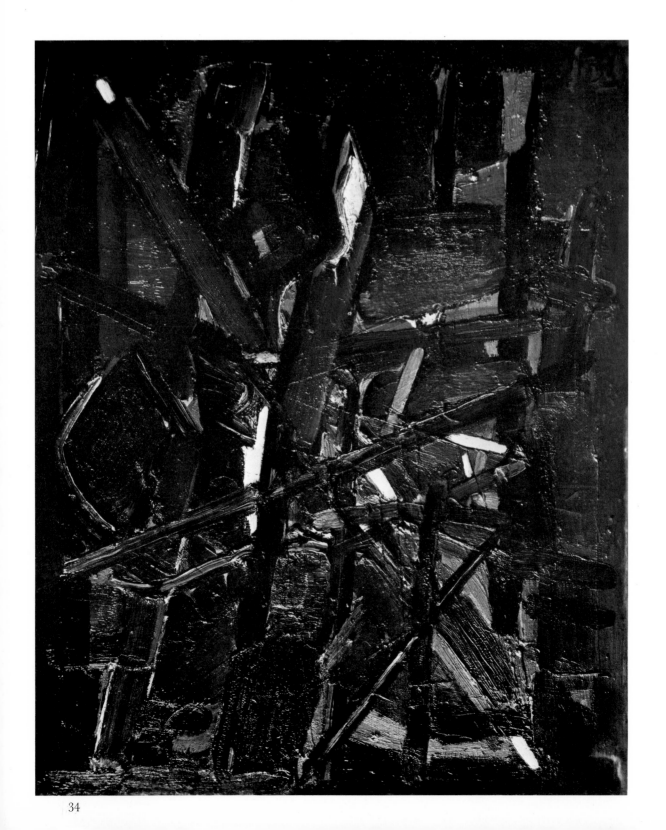

15 Barrière, 1947

Huile sur toile
61 × 50
s.b.g. : Staël
Louis Carré et Cie, Paris

Oil on canvas
61 × 50
s.l.l. : Staël
Louis Carré and Co, Paris

EXP.
Paris 1964, n° 11

BIBLIO.
Gindertaël 1960, repr. coul. pl. 1 bis
Cooper 1961, p. 22
Guichard-Meili 1966, repr. coul. pl. 2
Chastel 1968, n° 101, repr. p. 86

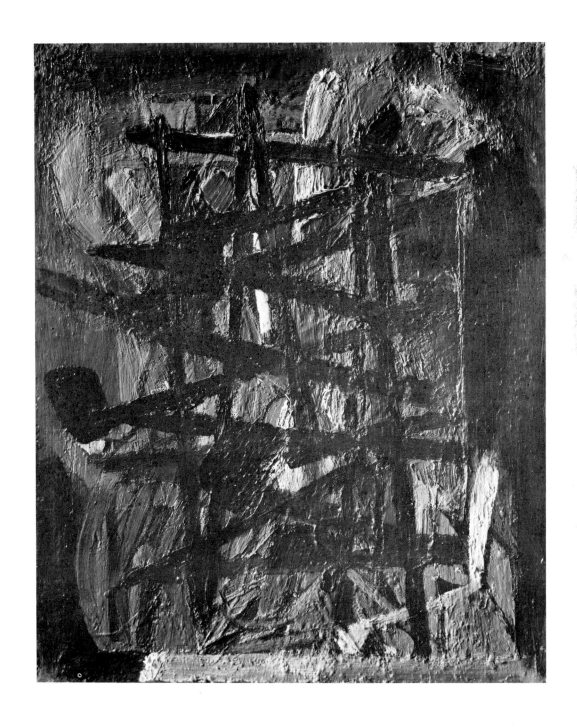

16 Composition en rouge, 1947

Huile sur toile
22 × 27
Vieira da Silva, Arpad Szenes,
Paris

Oil on canvas
22 × 27
Vieira da Silva, Arpad Szenes, Paris

HIST.
Coll. R.P. Laval, Paris

BIBL.
Chastel 1968, n° 102, rep. p. 86

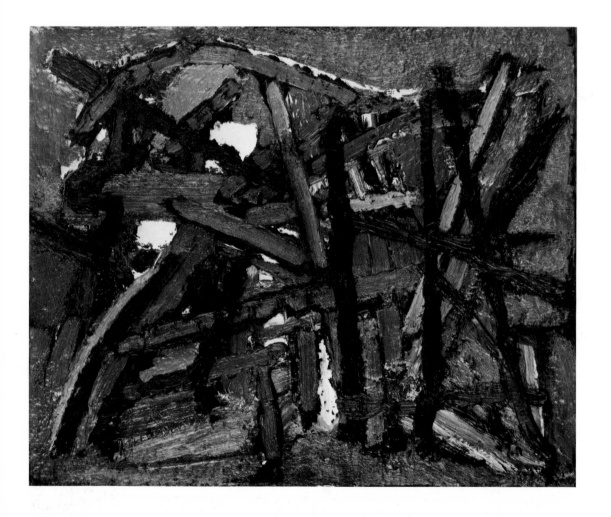

17 Ressentiment, 1947*

Huile sur toile
100 × 81
s.b.d. : Staël
Collection particulière, Paris

Oil on canvas
100 × 81
s.l.r. : Staël
Private collection, Paris

HIST.
Louis Carré, Paris

EXP.
Berne 1957, n° 18
Paris 1964, n° 15
Rotterdam/Zurich 1965, n° 17, repr.
Boston/Chicago/New York 1966, n° 11,
repr.

BIBL.
Brion 1959, repr.
Cooper 1961, repr. pl. 12
Granville 1965, repr. coul. p. 87
Chastel 1968, n° 104, repr. p. 86

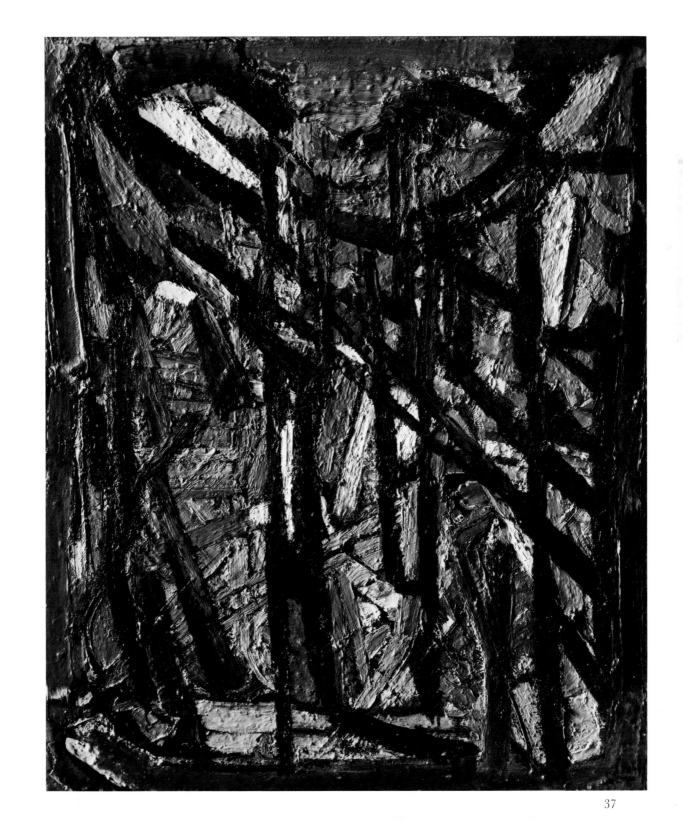

18 Lance-pierre, 1947

Huile sur toile
35 × 27

s.h.d. : Staël, s.d. au dos
Collection particulière

HIST.
Louis Carré, Paris

Oil on canvas
35 × 27

s.u.r. : Staël, s.d. on the back
Private collection

EXP.
Paris 1956, n° 30
Arles 1958, n° 14
Paris 1964, n° 17

BIBL.
Cooper 1961, p. 23
Chastel 1968, n° 115, p. 90

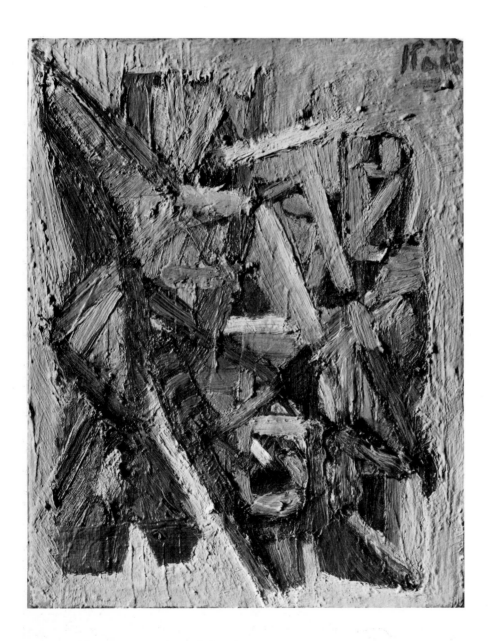

19 Brise-lames, 1947

Huile sur toile
150 × 160

s.d.b.d. : Staël 47, s. au dos
Collection particulière, France

HIST.
Louis Carré, Paris

Oil on canvas
150 × 160

s.d.l.r. : Staël 47, s. on the back
Private collection, France

EXP.
Etiolles 1948
Paris 1956, n° 27
Berne 1957, n° 19
Arles 1958, n° 13, repr. pl. II
Paris 1964, n° 14
Rotterdam/Zurich 1965, n° 12, repr.
Boston/Chicago/New York 1965-1966,
n° 8, repr.
Saint Paul 1972, n° 13, repr. coul. p. 50

BIBL.
Cooper 1961, p. 23
Cooper 1956, p. 141
Chastel 1968, n° 116, repr. p. 90 et coul. p. 84
Archives Maeght 1972, repr. coul. p. 50, n° 13

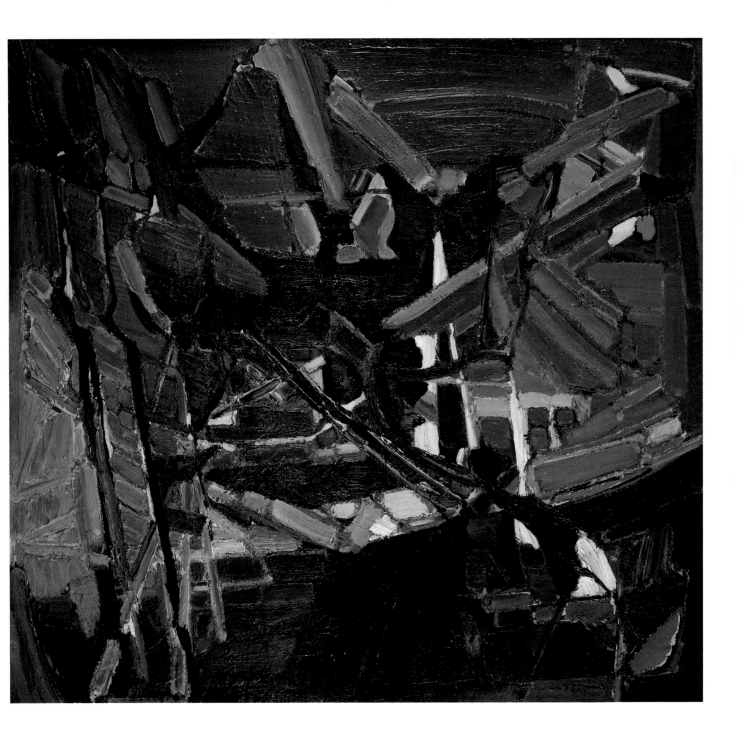

20 Composition, 1947*

Huile sur toile
46 × 55
s.d.b.g. : Staël 47
s.d. au dos : Staël 47
Musée des Beaux Arts, Dijon
Donation Granville,

Oil on canvas
46 × 55
s.d.l.l. : Staël 47
s.d. on the back : Staël 47
Musée des Beaux Arts, Dijon,
Donation Granville

EXP.
Paris 1956, n° 32
Rotterdam/Zurich 1965, n° 19 repr.
Boston/Chicago/New York 1965-1966,
n° 12, repr.

BIBL.
Chastel 1968, n° 109, repr. p. 89
Lemoine 1976, repr.

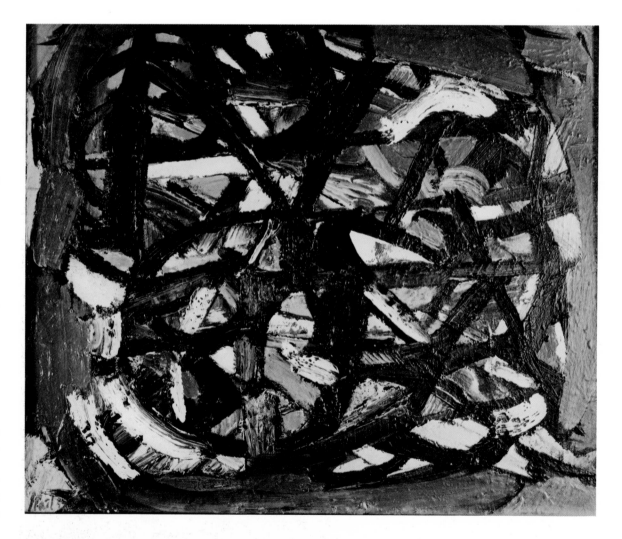

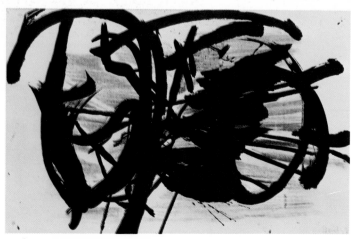

21 Composition, 1947

Huile sur toile
90 × 116
Michel Laval

Oil on canvas
90 × 116
Michel Laval

BIBL.
Chastel 1968, n° 110, repr. p. 89

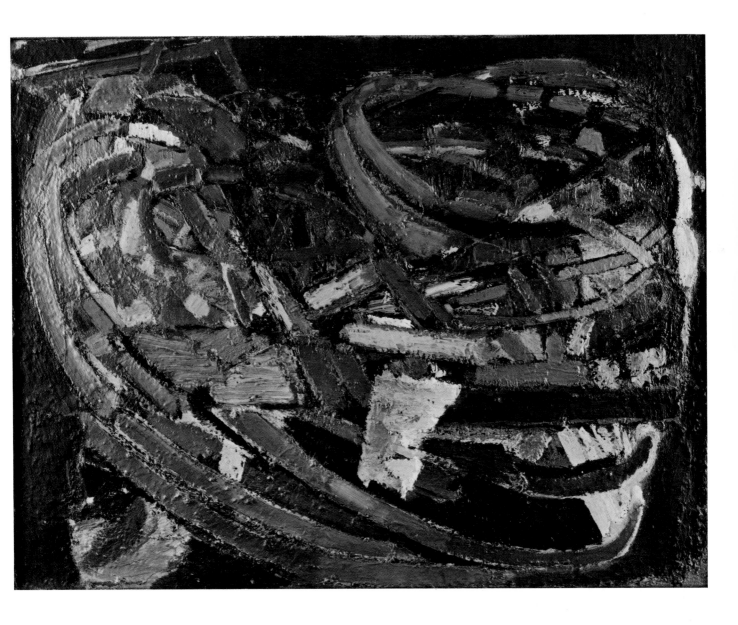

22 Composition, 1947

Huile sur toile
194 × 129
Collection particulière

Oil on canvas
194 × 129
Private collection

BIBL.
Chastel 1968, n° 118, repr. p. 90

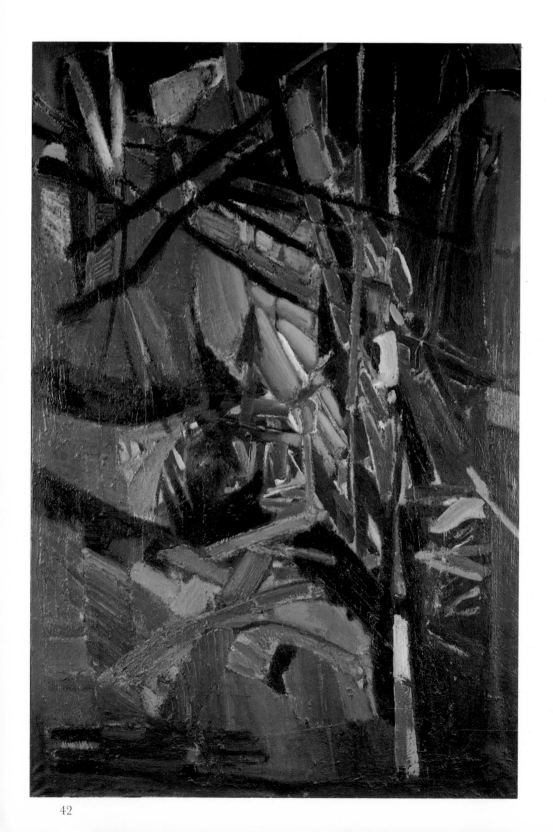

23 A Piranèse, 1948

Huile sur toile
100 × 73

s.d.b.g. : Staël 48, s. au dos :
Nicolas de Staël, mai 1948
Sonja Henie-Niels Onstad
Foundations, Norvège

Oil on canvas
100 ×. 73

s.d.l.l. : Staël 48, s. on the back :
Nicolas de Staël, mai 1948
Sonja Henie-Niels Onstad Foundations,
Norway

HIST.
T. Schempp, New York
John L. Senior Jr. New York
Joseph Cantor, Indianapolis
Stephen Hahn, New York
Berggruen, Paris
Mathias Fels, Paris

EXP.
Saint Paul 1972, n°14 repr. p. 58

BIBL.
Gindertaël 1950, repr. pl. X
Courthion 1952, repr. pl. LIV
Chastel 1968, n° 120 repr. p. 95
Archives Maeght 1972, repr. p. 58, n° 14

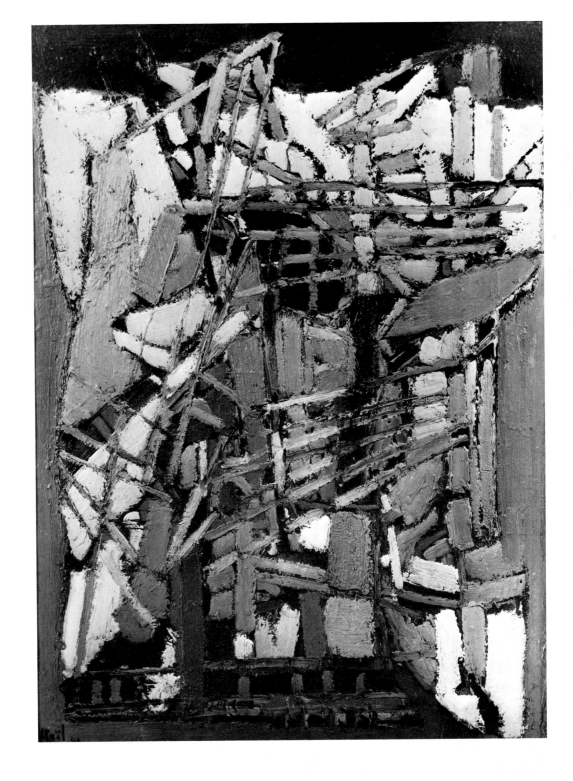

24 Composition grise, 1948

Huile sur toile
150 × 75
s.b.g. : Staël, d. au dos : juin 1948
Collection Thyssen-Bornemisza,
Lugano

Oil on canvas
150 × 75
s.l.l. : Staël, d. on the back : june 1948
Thyssen-Bornemisza Collection, Lugano

HIST.
Dr. Soulard, Paris
Jeanne Bucher, Paris
Coll Embiricos, New York

EXP.
New York 1953, n° 7
Paris 1956, n° 35
Berne 1957, n° 22
Hanovre/Hambourg 1959-1960,
n° 9, repr. p. 9

BIBL.
Gindertaël 1950, repr. pl. XIII
Tudal 1958, repr. coul. p. 9
Cabanne 1962, repr. p. 24
Chastel 1968, n° 128, repr. p. 98

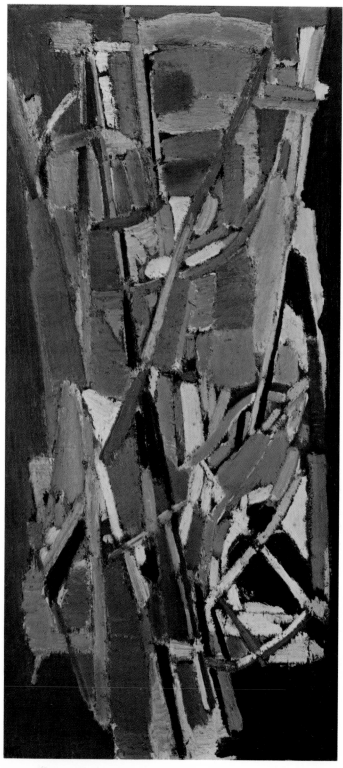

25 Harmonie grise, beige, taches rouges, 1948

Huile sur toile
116 × 81
s.d.b. Staël, s.d. au dos : Staël 1948
Jacques Dubourg, Paris

Oil on canvas
116 × 81
s.l.r. : Staël, s.d. on the back : Staël 1948
Jacques Dubourg, Paris

EXP.
Montevideo 1948, n° 3
Paris 1950, n° 4
Londres 1952, n°4
Paris 1956, n° 34
Londres 1956, n° 11, repr.
Paris 1957, n° 6
Genève 1967, n° 1, repr. coul. p. 9
Paris 1969, n° 3
Saint Paul 1972 n° 16, repr. p. 60

BIBL.
Chastel 1968, n° 130, repr. p. 99 et coul. p. 93
Archives Maeght 1972, repr. p. 60,
n° 16

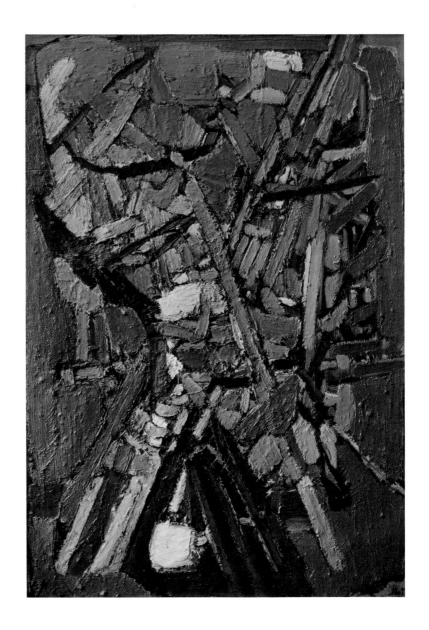

26 Composition abstraite, 1948*

Huile sur toile
60 × 81
s.b.g : Staël
Musées Nationaux, Donation
Pierre Lévy

Oil on canvas
60 × 81
s.l.l. : Staël
Musées Nationaux, Donation Pierre Lévy

HIST.
Vente Crédit municipal de Paris,
17 mai 1962, n° 30, repr.

BIBL.
Chastel 1968, n° 136, repr. p. 9

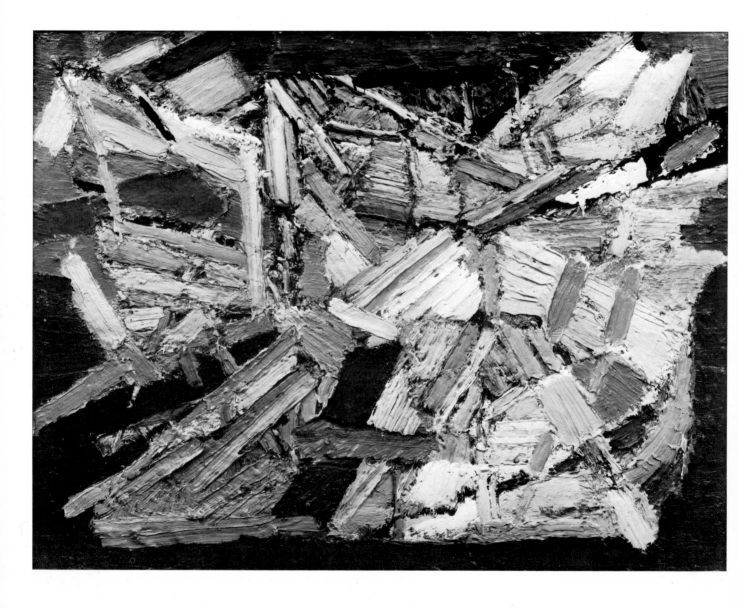

27 Espace à Crans, 1948

Huile sur toile
46 × 81
s.b.d. : Staël
Collection particulière, Londres

Oil on canvas
46 × 81
s.l.r. Staël
Private collection, London

HIST.
Farra, Paris
M. et Mme Joseph R. Shapiro,
Oak Park

BIBL.
Chastel 1968, n° 142, repr. p. 102

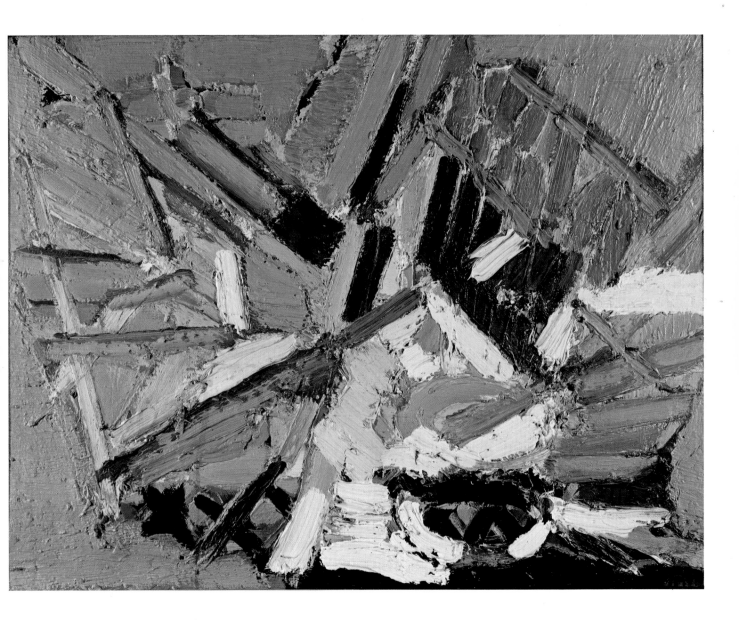

28 Composition céladon, 1948*

Huile sur toile
73 × 60
s.b.d. : Staël
Musée des Beaux Arts, Dijon,
Donation Granville

Oil on canvas
73 × 60
s.l.r. : Staël
Musée des Beaux Arts, Dijon, Donation
Granville

HIST.
Atelier de l'artiste, acquis en 1952

EXP.
Turin 1960, n° 22, repr. p. 52
Rotterdam/Zurich 1965, n° 21, repr.
Boston/Chicago/New York 1965-66,
n° 14, repr.
Saint Paul 1972, n° 17, repr. p. 61

BIBL.
Bigongiari 1960, repr. coul. p. 13
Gindertaël 1960, repr. coul. pl. 1 ter.
Cooper 1961, p. 23
Guichard-Meili 1966, repr. coul. pl. 4
Chastel 1968, n° 148, repr. p. 106
Archives Maeght 1972, repr. p. 61,
n° 17
Lemoine 1976, p. 255, repr.

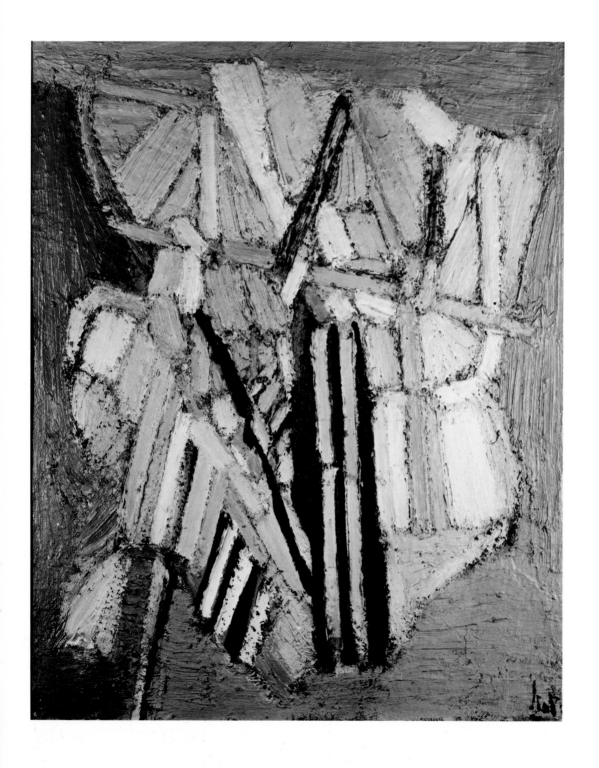

29 Chemin difficile, 1948*

Huile sur toile
100 × 81

s.d.b. : Staël, s.d. au dos :
Nicolas de Staël, juin 1948
Mr and Mrs F.R. Hensel

Oil on canvas
100 × 81

s.l.r. : Staël, s.d. on the back : Nicolas
de Staël, june 1948
Mr and Mrs F.R. Hensel

HIST.
T. Schempp, New York
Mrs Julien Bobbe, Indianapolis

BIBL.
Chastel 1968, n° 143, repr. p. 102

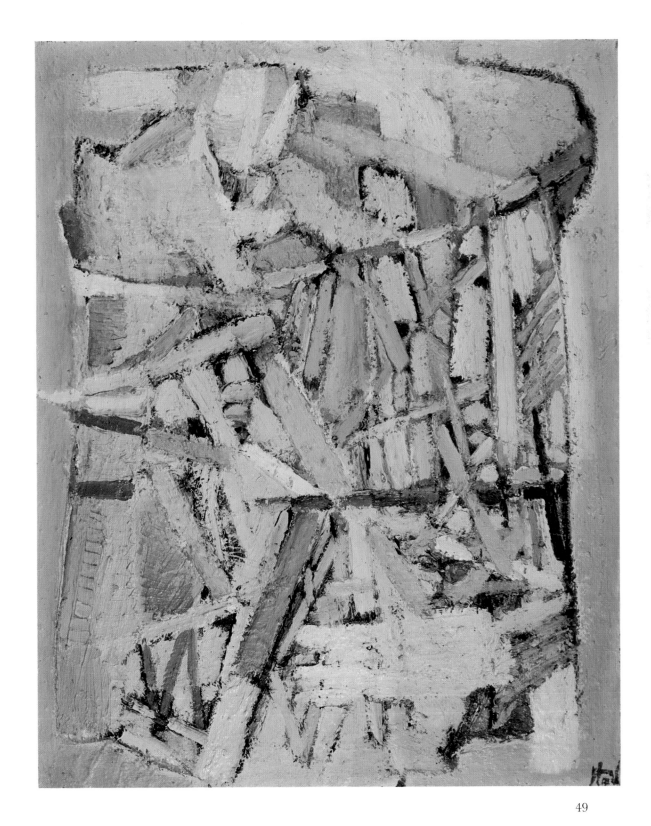

30 Nord, 1949

Huile sur toile
24,1 × 41,2
s.b.d. : Staël
The Phillips Collection,
Washington

Oil on canvas
24,1 × 41,2
s.l.r. : Staël
The Phillips Collection, Washington

HIST.
T. Schempp, New York

BIBL.
Chastel 1968, n° 166, repr. p. 111 et
coul. p. 113
Deschamps 1971, repr. coul. pp. 10-11

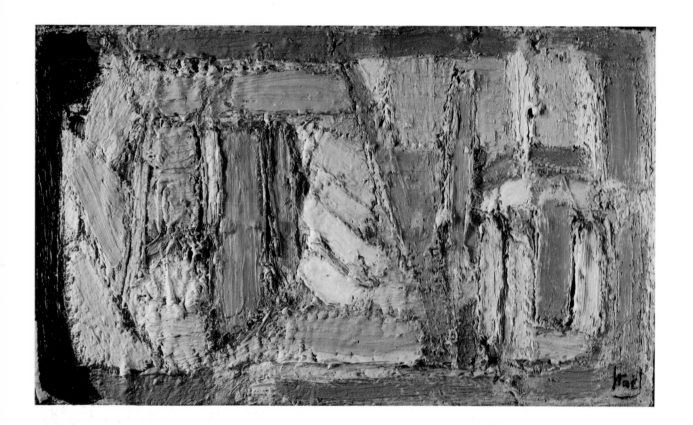

31 Composition, 1949

Huile sur toile
116 × 81
Hubert Fandre

Oil on canvas
116 × 81
Hubert Fandre

BIBL.
Chastel 1968, n° 170, repr. p. 115

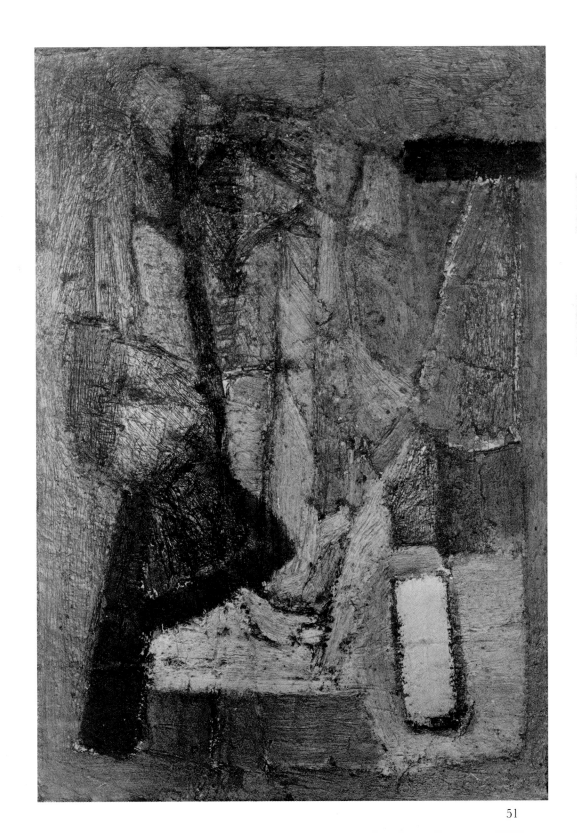

BIBL.
Chastel 1968, n° 170, repr. p. 115

32 Composition, 1949*

Huile sur toile
200 × 100
s. au dos : Staël
Collection particulière, Paris

Oil on canvas
200 × 100
s. on the back : Staël
Private collection, Paris

EXP.
Paris 1956, n° 37

BIBL.
Gindertaël 1950, repr. pl. XVI
Landini 1956, p. 73
Chastel 1968, n° 171, rep. p. 115

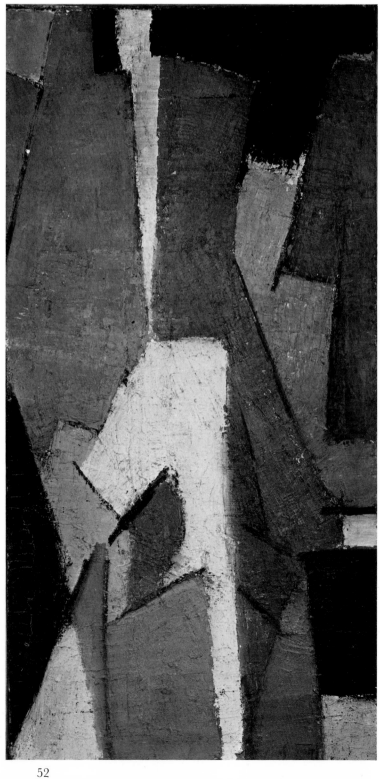

33 Composition, 1949*

Huile sur toile
162 × 114
s.b.g. : Staël 1949
s.d. au dos : Staël 1949
Musée national d'Art Moderne, Paris

Oil on canvas
162 × 114
s.d.l.l. Staël 1949
s.d. on the back : Staël 1949
Musée National d'Art Moderne, Paris

HIST.
Achat de l'Etat en 1950

EXP.
Paris 1949
Rotterdam/Zurich 1965, n° 26, repr.
Boston/Chicago/New York 1965-1966,
n° 21, repr.
Saint-Paul 1972, n° 21, repr. coul. p. 67

BIBL.
Gindertaël 1950, repr. pl. XV
Courthion 1952, repr. pl. LVII (sous
le titre « Taille »)
Art-Documents 1953, repr. (sous le
titre « Taille »)
Granville 1965, repr. coul. p. 86
Chastel 1968, n° 172, repr. p. 115
Archives Maeght 1972, repr. coul. p. 67, n° 21

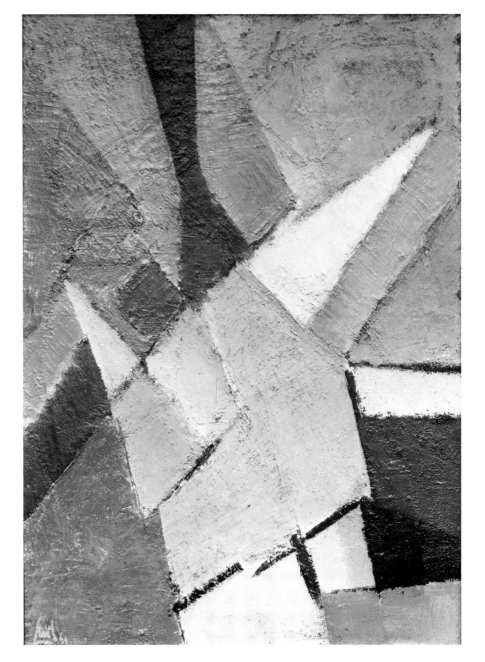

34 Composition, calme, 1949

Huile sur toile
97 × 163
s.b.d. : Staël
Sidney Janis Gallery, New York

Oil on canvas
97 × 163
s.l.r. : Staël
Sidney Janis Gallery, New York

HIST.
T. Schempp, New York
Lee A. Ault, New York

EXP.
Rotterdam/Zurich 1965, n° 23

BIBL.
Gindertaël 1950, rep. pl. XVII
Chastel 1968, n° 182, rep. p. 117
Archives Maeght 1972, rep. p. 65, n°22

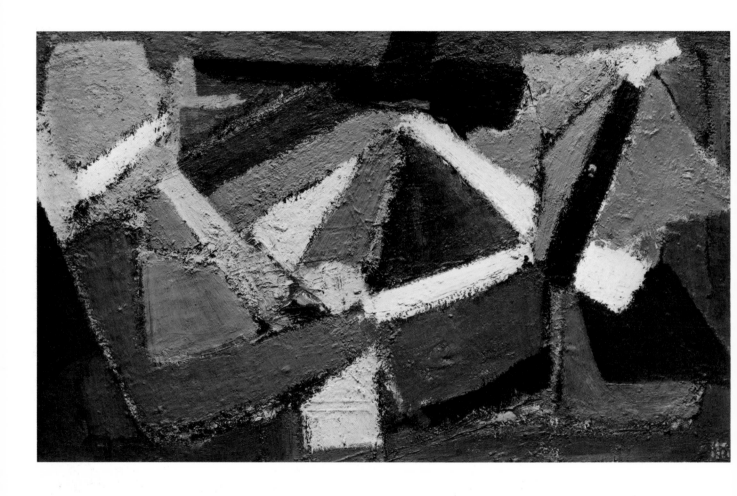

35 Composition, 1949

Huile sur isorel
97 × 130
Collection particulière,

Oil on board
97 × 130
Private collection, Paris

HIST.
P. David, Paris

BIBL.
Chastel 1968, n° 191, rep. p. 120

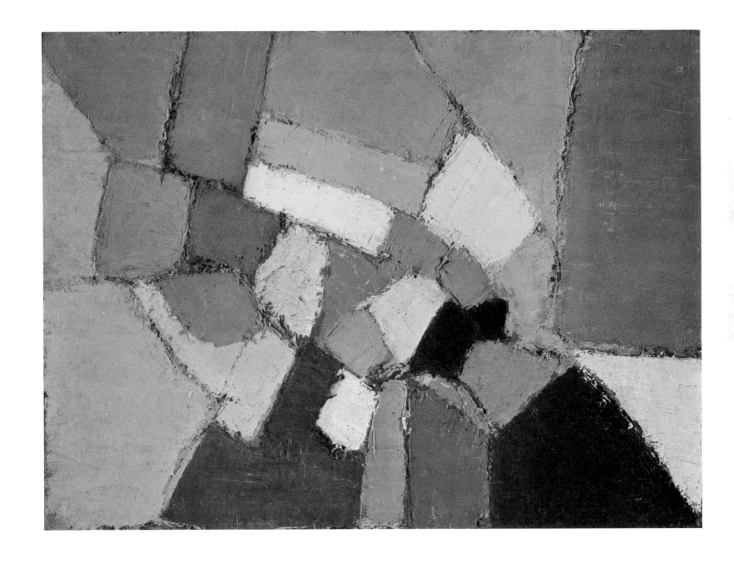

36 Composition, 1949*

Huile sur toile
100 × 65
s.b.d. : Staël
Collection particulière, Paris

Oil on canvas
100 × 65
s.l.r. : Staël
Private collection, Paris

EXP.
Arles 1958, n° 19

BIBL.
Chastel 1968, n° 200, rep. p. 125

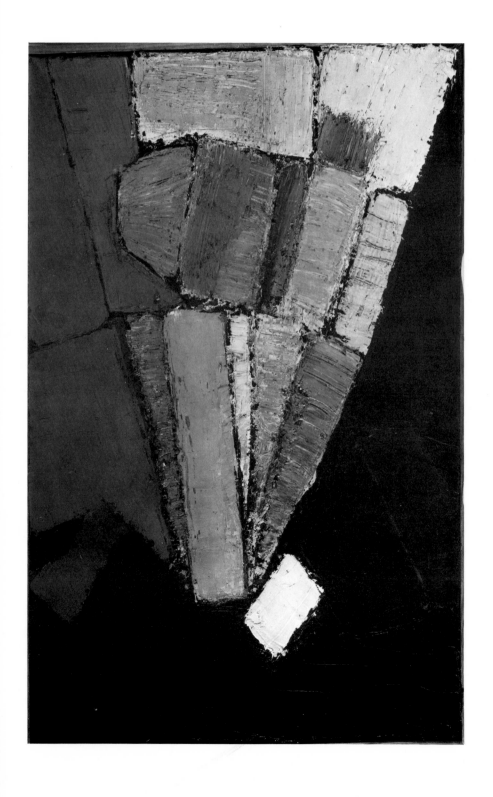

37 Nocturne, 1950

Huile sur toile
99,6 × 147,3
s.b.g. : Staël
The Phillips Collection, Washington

Oil on canvas
99,6 × 147,3
s.l.l. : Staël
The Phillips Collection, Washington

HIST.
T. Schempp, New York

EXP.
New York 1950
New York 1953, n° 9
New York 1955, n° 9, exp. itinérante

BIBL.
Gindertaël 1950, repr. pl. XXVII
Chastel 1968, n° 201, repr. p. 127
Dumur 1975, repr. coul. p. 24

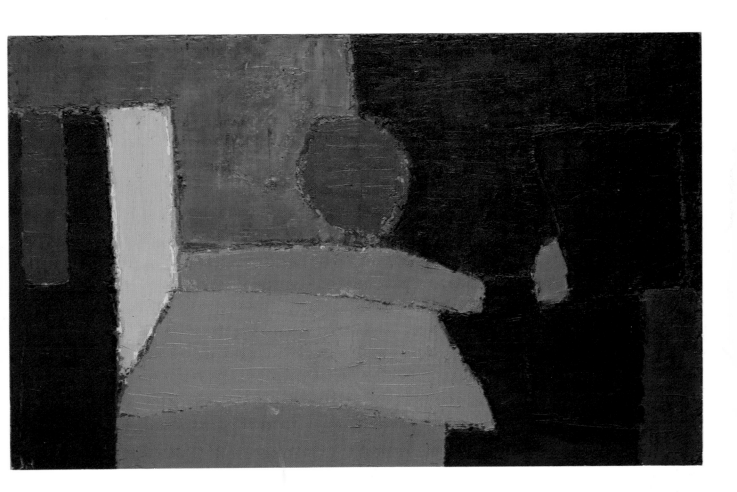

38 Composition, 1950

Huile sur toile
99 × 72
s.b.d. : Staël
Collection particulière, Paris

Oil on canvas
99 × 72
s.l.r. : Staël
Private collection, Paris

HIST.
Jacques Dubourg, Paris

EXP.
Paris 1956, n° 89

BIBL.
Waldberg 1950, repr. face p. 80
Chastel 1968, n° 207, repr. p. 129

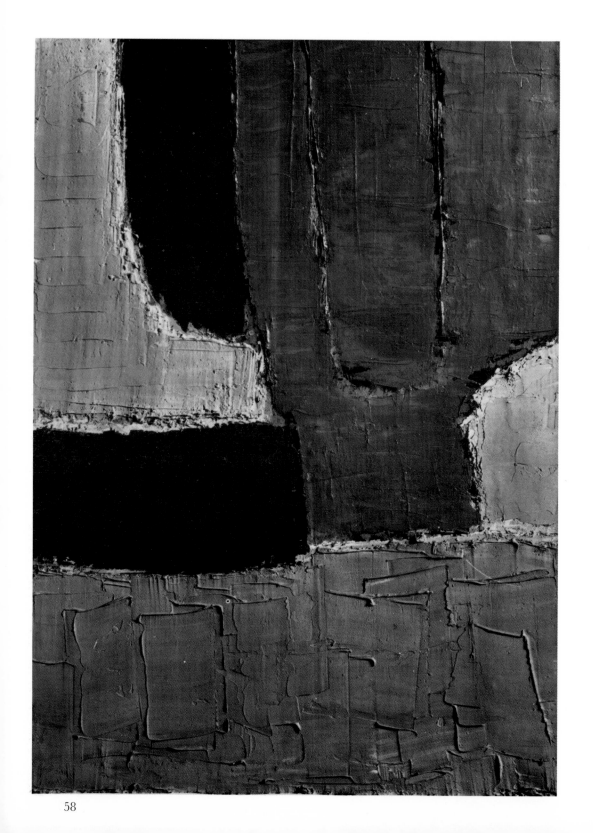

39 Composition, 1950 *

Huile sur toile
100 × 73
Collection particulière, Genève

Oil on canvas
100 × 73
Private collection, Geneva

HIST.
Jacques Dubourg, Paris
S. Tézenas, Paris

EXP.
Charlottenborg 1950, n° 187
Paris 1956, n° 42, repr. pl. V
Londres 1956, n° 15, repr.
Berne 1957, n° 25, repr.
Arles 1958, n° 21
Hanovre/Hambourg 1959-1960, n° 17
Turin 1960, n° 31, repr. p. 61

BIBL.
Gindertaël 1950, repr. pl. XX
Cooper 1961, repr. pl. 18
Chastel 1968, n° 208, repr. p. 129

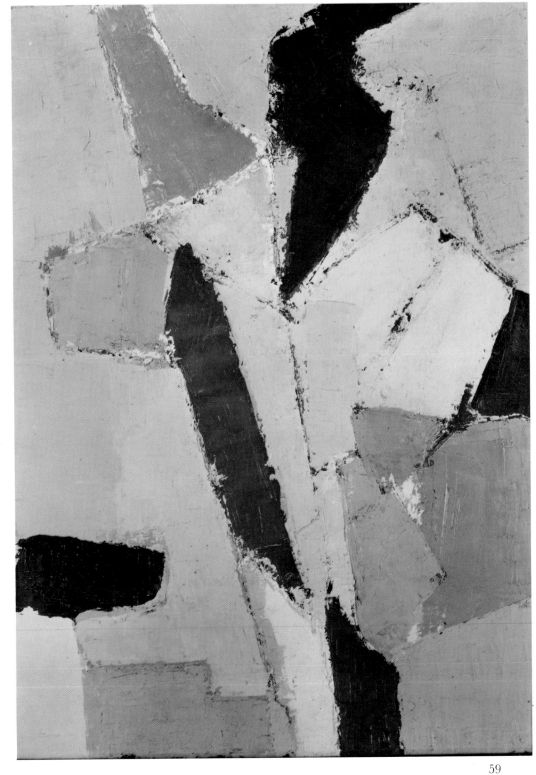

40 Composition, 1950

Huile sur toile
46 × 55
s.b.d. : Staël
Collection particulière

Oil on canvas
46 × 55
s.l.r. : Staël
Private collection

HIST.
Jacques Dubourg, Paris

EXP.
Paris 1950
Charlottenborg 1950, n° 186
Londres 1952, n° 7
Paris 1957, n° 7
Arles 1958, n° 22
Hanovre/Hambourg 1959-1960, n° 15
Turin 1960, n° 30, repr.
Rotterdam/Zurich 1965, n° 33, repr.
Boston/Chicago/New York 1965-1966,
n° 29, repr.

BIBL.
Gindertaël 1950, repr. pl. XIX
Chastel 1968, n°205, repr. p. 129 et coul. p. 123

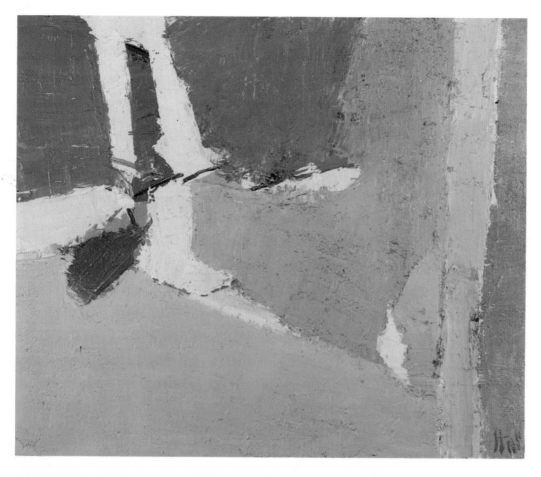

41 Composition en gris, 1950

Huile sur toile
115 × 195
s.b.d : Staël, s.d. au dos :
mars 1950
Collection particulière, Paris

Oil on canvas
115 × 195
s.l.r. : Staël, s.d. on the back : march
1950
Private collection, Paris

HIST.
Jacques Dubourg, Paris

EXP.
Paris 1950, n°12
Charlottenborg 1950, n° 129
Paris 1956, n° 40
Berne 1957, n° 32
Hanovre/Hambourg 1959-1960, n° 16
Turin 1960, n° 29, repr. p. 59
Rotterdam/Zurich 1965, n°31, repr.
coul.
Boston/Chicago/New York 1965-1966,
n° 26, repr. coul.
Saint-Paul 1972, n° 27, repr. coul.

BIBL.
Bigongiari 1960, repr. p. 23
Cooper 1961, repr. pl. 15
Chastel 1968, n° 211, repr. p. 130
et coul. p. 134
Archives Maeght 1972, repr. coul. p. 68,
n°27
Dumur 1975, repr. coul. p. 21

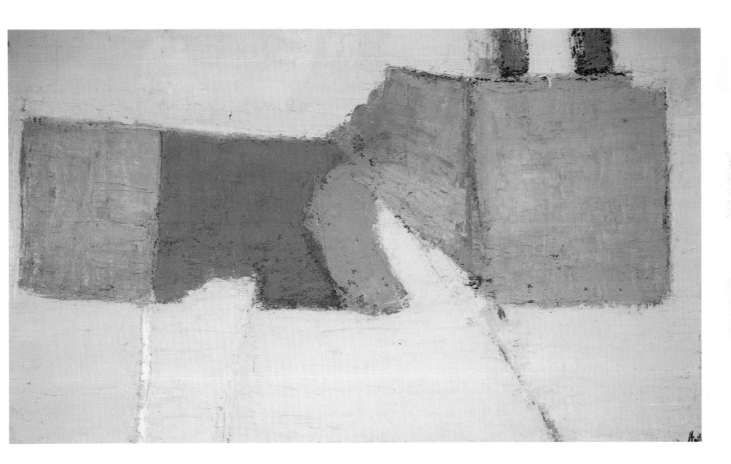

42 La procession, 1950*

Huile sur toile
33 × 55

s.d. au dos : Staël 1950
Musée des Beaux Arts, Dijon, Donation
Granville

Oil on canvas
33 × 35

s.d. on the back : Staël 1950
Musée des Beaux Arts, Dijon, Donation
Granville

HIST.
Atelier de l'artiste, acquis en 1950

EXP.
Paris 1956, n° 41
Arles 1958, n° 20, repr. pl. III
Hanovre/Hambourg 1959-1960, n° 19,
repr. p. 12
Turin 1960, n° 33, repr. p. 63
Rotterdam/Zurich 1965, n° 29, repr.
Boston/Chicago/New York 1965-1966,
n° 23, repr.

BIBL.
Alvard et Gindertaël 1952, repr. p. 269
Granville 1965, repr. coul. p. 86
Chastel 1968, n° 223, repr. p. 131
Lemoine 1976, p. 257, repr.

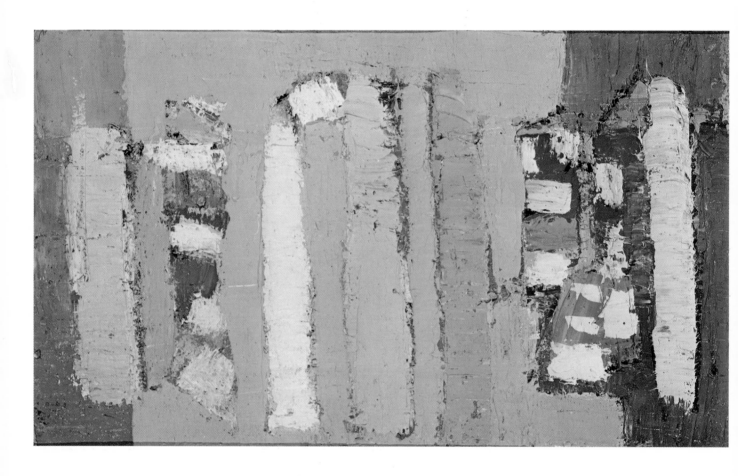

43 Composition, 1950

Huile sur toile
24 × 33
s.h.d. : Staël
Collection particulière

Oil on canvas
24 × 33
s.u.r. : Staël
Private collection

BIBL.
Chastel 1968, n° 240, repr. p. 139

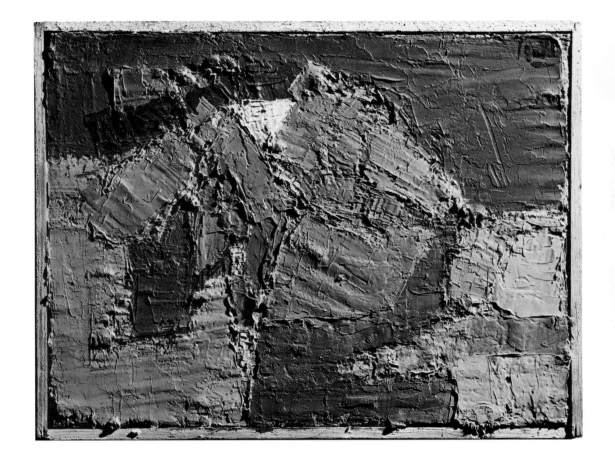

44 Composition, 1950*

Huile sur toile
81 × 130
s.b.d. : Staël
Collection particulière, Paris

Oil on canvas
81 × 130
s.l.r. : Staël
Private collection, Paris

HIST.
Jacques Dubourg, Paris,
Jacques Benador, Genève
Mathias Fels, Paris
Krugier, Genève

EXP.
Zurich 1952, n° 14
Edimbourg 1956
Genève 1958, n° 9
Turin 1960, n° 34, repr. p. 64

BIBL.
Chastel 1968, n° 253, repr. p. 143

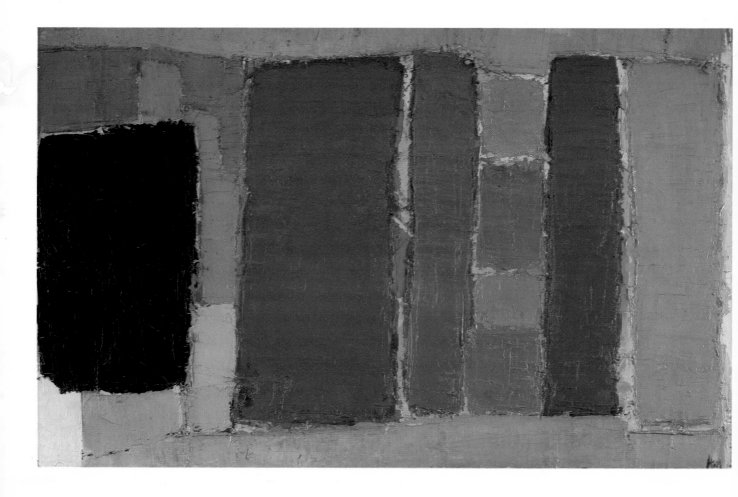

45 Composition, 1950

Huile sur toile
125 × 80
s.b.g. : Staël
The Trustees of the Tate Gallery,
Londres

Oil on canvas
125 × 80
s.l.l. : Staël
The Trustees of the Tate Gallery, London

HIST.
Jacques Dubourg, Paris
Mayor Gallery, Londres
Power, Londres

EXP.
Londres 1956, n° 16, repr.

BIBL.
Chastel 1968, n° 259, repr. p. 145

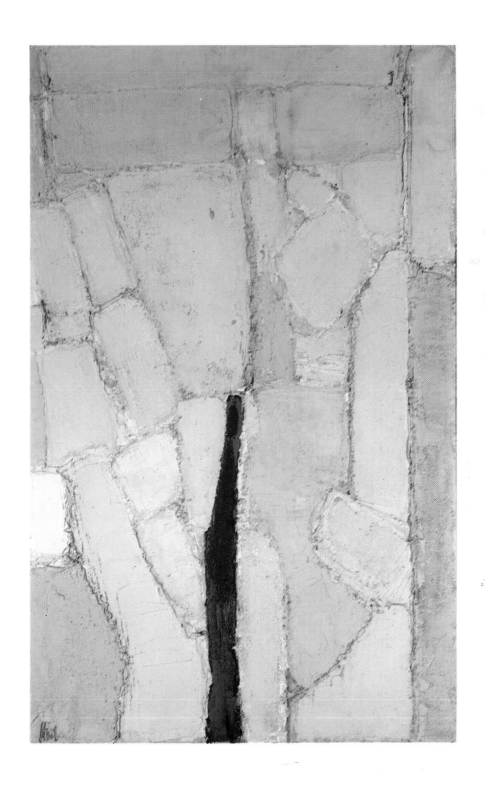

46 Grande composition bleue, 1950-1951

Huile sur isorel
200 × 150
Collection particulière

Oil on board
200 × 150
Private collection

EXP.
Rotterdam/Zurich 1965, n° 30, repr.

BIBL.
Chastel 1968, n° 494, repr. p. 219

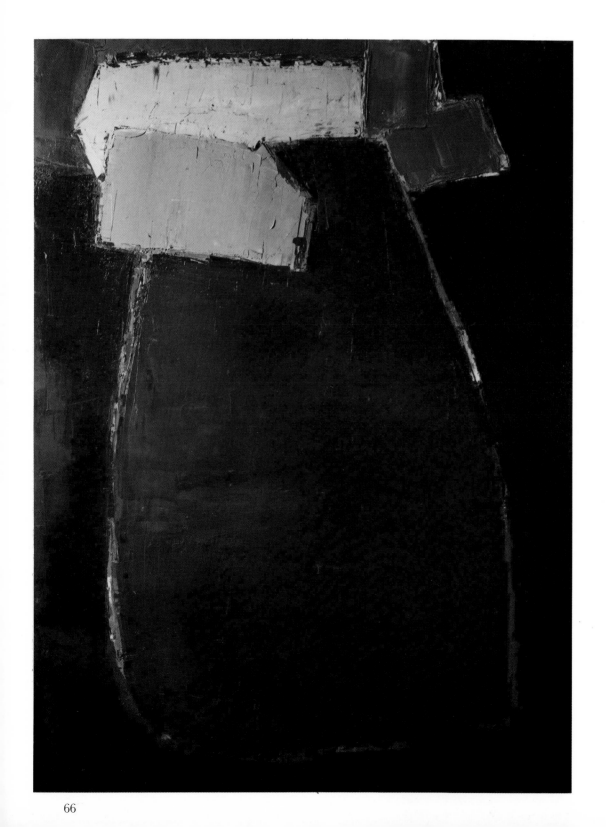

47 La ville blanche, 1951*

Huile sur toile
65 × 92
s.h.d : Staël
Musée des Beaux-Arts, Dijon, Donation
Granville

Oil on canvas
65 × 92
s.u.r. : Staël
Musée des Beaux-Arts, Dijon, Donation
Granville

HIST.
Atelier de l'artiste, acquis en 1951

EXP.
Rotterdam/Zurich 1965, N° 36, repr.
Boston/Chicago/New York 1965-1966,
n° 30, repr.
Saint-Paul 1972, n° 31, repr. p. 73

BIBL.
Granville 1965, repr. coul. p. 90
Chastel 1968, n° 271, repr. p. 155
Archives Maeght, 1972, repr. p. 73
n° 31
Lemoine 1976, p. 262, repr.

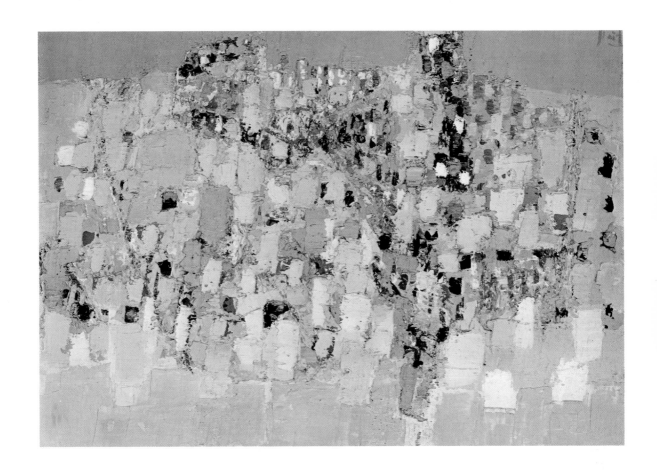

48 Composition, 1951

Huile sur panneau
194 × 96,5
s.h.d. : Staël
Collection particulière

Oil on board
194 × 96,5
s.u.r. : Staël
Private collection

HIST.
Th. Schempp, New York
Knoedler, New York

BIBL.
Chastel 1968, n° 282, repr. p. 159

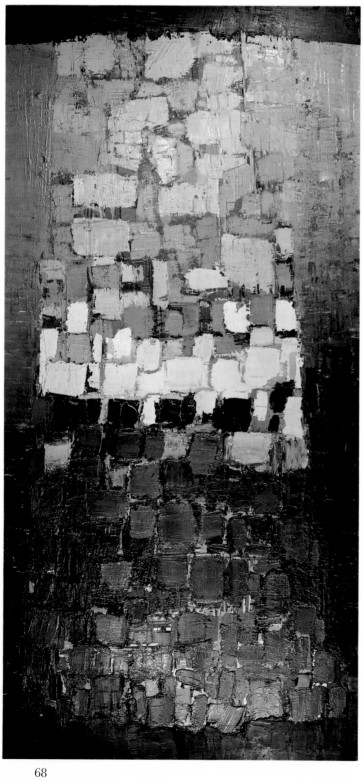

49 Composition fond rouge, 1951

Huile sur toile
54 × 81
s.b.d. : Staël
Dr. Peter Nathan, Zurich

Oil on canvas
54 × 81
s.l.l. : Staël
Dr. Peter Nathan, Zurich

HIST.
Jacques Dubourg, Paris

EXP.
Edimbourg 1957, n° 334
Paris 1957, n° 9
Hanovre/Hambourg 1959-1960, n° 25
Turin 1960, n° 44, repr. p. 74
Rotterdam/Zurich 1965, n° 40, repr.
Paris 1969, n° 6
Saint-Paul 1972, n° 33, repr. coul. p. 77
Zurich 1976, n° 11, repr.

BIBL.
Chastel 1968, n° 286, repr. p. 163
Archives Maeght 1972, repr. coul. p. 77,
n° 33
Dumur 1975, repr. coul. p. 28

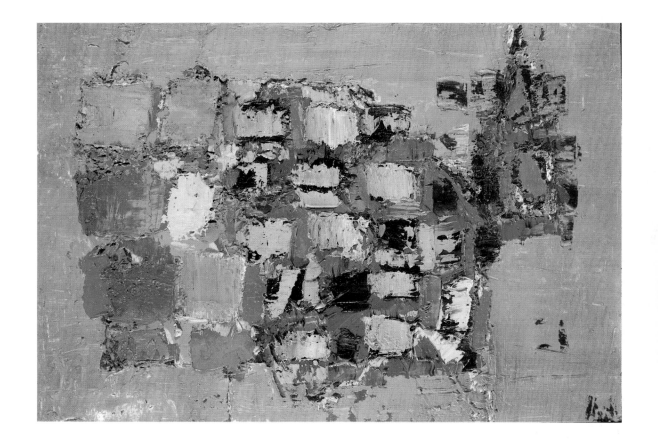

50 Composition fond rouge, 1951

Huile sur isorel
100 × 150
s.d.b.g. : Staël 51
Fonds National d'Art Contemporain,
Paris

Oil on board
100 × 150
s.d.l.l. : Staël 51
Fonds National d'Art Contemporain, Paris

HIST.
Jacques Dubourg, Paris

EXP.
Londres 1952, n° 19
Paris 1956, n° 45
Saint Paul 1972, n° 35, repr. p. 76

BIBL.
Chastel 1968, n° 291, repr. p. 165
Archives Maeght 1972, repr. p. 76,
n° 35

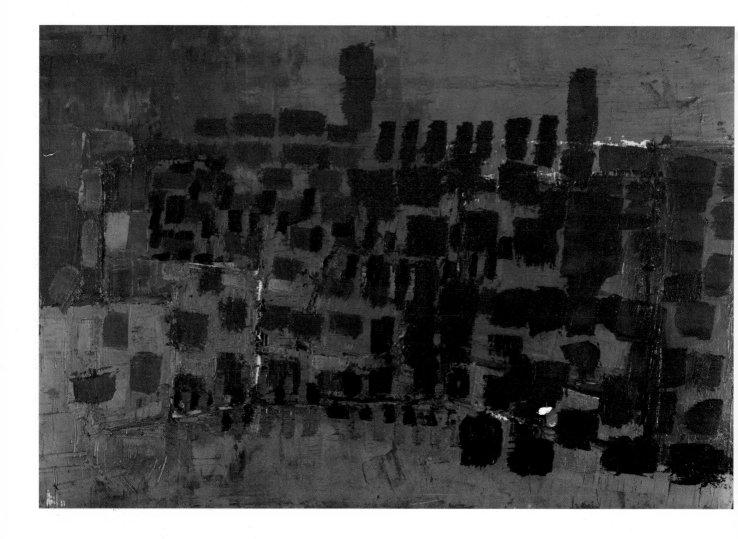

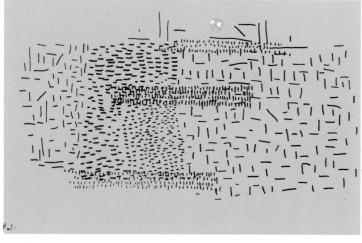

51 Composition, 1951

Huile sur toile
81 × 100
s.b.d. : Staël
Gimpel-Hanover Galerie, Zurich

Oil on canvas
81 × 100
s.l.r. : Staël
Gimpel-Hanover Gallery, Zurich

HIST.
Jacques Dubourg, Paris

EXP.
Londres 1952, h. c.
Londres 1956, n° 18, repr.
Hanovre/Hambourg 1959-1960, n° 27,
repr. p. 15
Turin 1960, n° 42, repr. p. 72
Rotterdam/Zurich 1965, n° 37, repr.
Boston/Chicago/New York 1965, n° 32,
repr.
Saint Paul 1972, n° 36, repr. p. 88

BIBL.
Chastel 1968, n° 294, repr. p. 167
Archives Maeght 1972, repr. p. 88,
n° 36

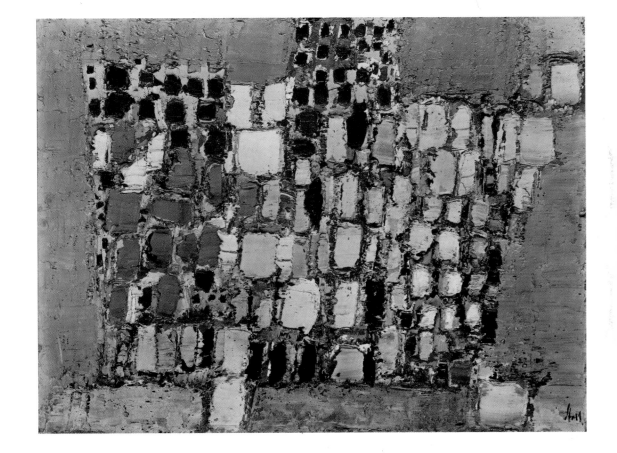

52 Le port, 1951

Huile sur toile
38 × 46,5
s.b.g. : Staël
Collection particulière

Oil on canvas
38 × 46,5
s.l.l. : Staël
Private collection

HIST.
Jacques Dubourg, Paris
Gimpel, Londres

EXP.
Londres 1956, n° 34
Hanovre/Hambourg 1959-1960, n° 21
Turin 1960, n° 45, repr. p. 75
Zurich 1963, n° 8, repr.

BIBL.
Chastel 1968, n° 298, repr. p. 167

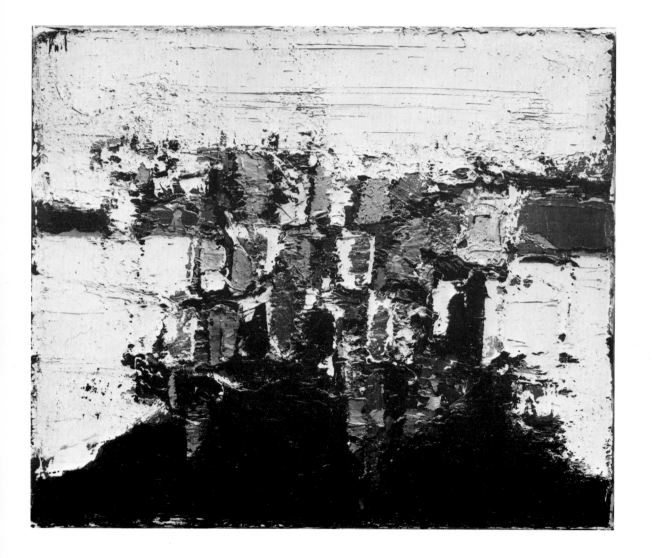

53 Cinq pommes, 1952

Huile sur toile
38 × 61
s.b.g. : Staël
Gimpel Fils, Londres

Oil on canvas
38 × 61
s.l.l. : Staël
Gimpel Fils, London

HIST.
Jacques Dubourg, Paris

EXP.
Edimbourg 1956, n° 325
Rotterdam/Zurich 1965, n° 34, repr.
Boston/Chicago/New York 1965-1966,
n° 25, repr.

BIBL.
Dumur 1952, repr. p. 212
Chastel 1968, n° 320, repr. p. 177

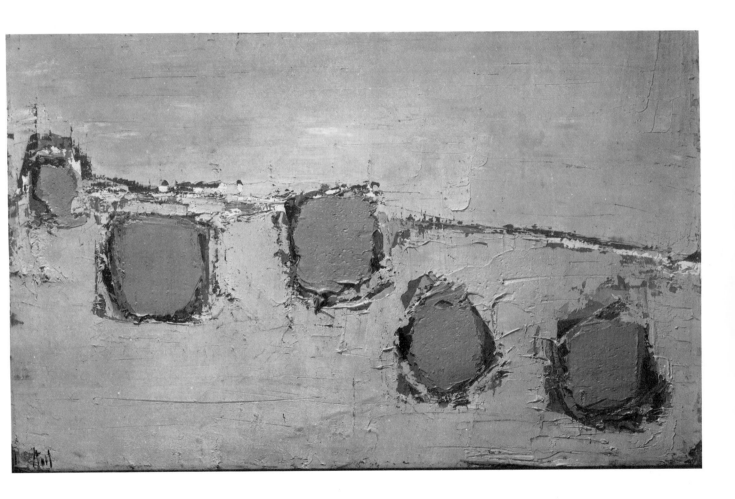

54 Ciel à Honfleur, 1952

Huile sur toile
89 × 130
s.b.g. : Staël
Gimpel-Hanover Galerie , Zurich

Oil on canvas
89 × 130
s.l.l. : Staël
Gimpel-Hanover Gallery, Zurich

HIST.
Knoedler, New York

EXP.
Hanovre/Hambourg 1959-1960, n° 53,
repr. p. 35
Turin 1960, n° 69, repr. p. 99
Zurich/Londres 1963, n° 22, repr. coul.
Saint Paul 1972, n° 40, repr. p. 87

BIBL.
Chastel 1968, n° 365, repr. p. 184
Archives Maeght 1972, repr. p. 87,
n° 40

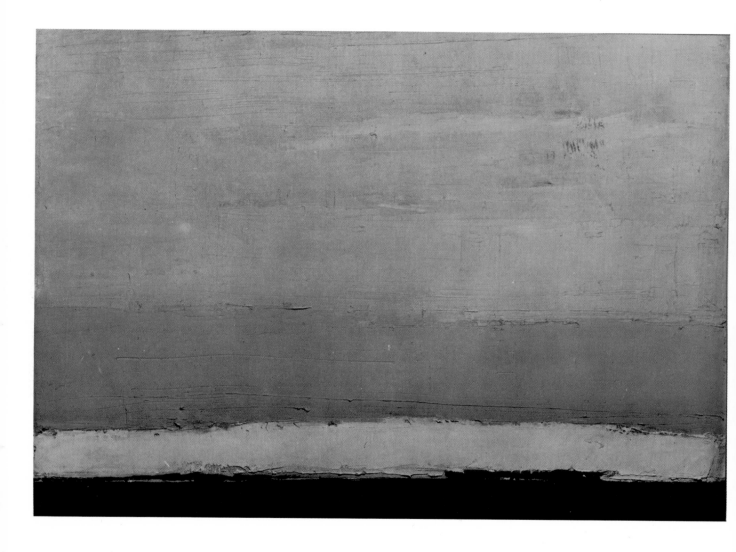

55 Face au Havre, 1952*

Huile sur toile
24 × 32

s.b.g. : Staël
s. au dos et déd: Face au Havre,
à Jeannine Schulmann, Staël 1952-53
Collection particulière

Oil on canvas
24 × 32

s.l.l. : Staël
s. on the back and ded : Face au Havre,
to Jeannine Schulmann, Staël 1952-53
Private collection

EXP.
Hanovre/Hambourg 1959-1960, n° 50
Turin 1960, n° 58, repr. p. 88

BIBL.
Granville 1965, repr. coul. p. 90
Chastel 1968, n° 373, repr. p. 185

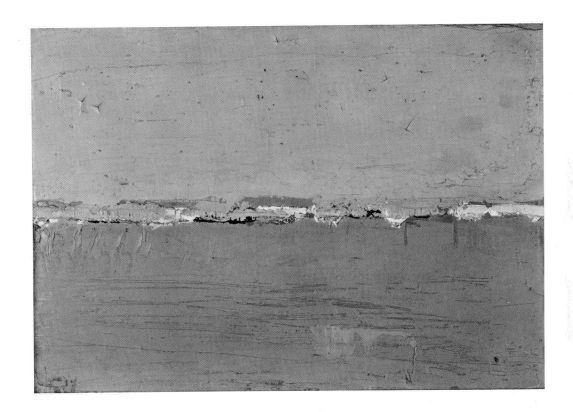

56 Parc des Princes (Les grands footballeurs), 1952

Huile sur toile
200 × 350
s.b.g. : Staël, au dos : Parc des
Princes, Staël 1952
Collection particulière

Oil on canvas
200 × 350
s.l.l. : Staël, on the back :
Parc des Princes, Staël 1952
Private collection

EXP.
Paris 1952, I
New York 1953, n° 43
Paris 1956, n° 55
Berne 1957, n° 50
Saint Paul 1972, n° 42, repr. coul. pp.
78-79

BIBL.
Dumur 1952, repr. p. 21, (premier état)
Cooper 1956, p. 142
Cooper 1961, p. 51
Granville 1965, pp. 94-95
Chastel 1968, n° 386, repr. p. 196 et
coul. p. 189
Archives Maeght 1972, repr. coul. pp.
78-79, n° 42
Dumur 1975, p. 70

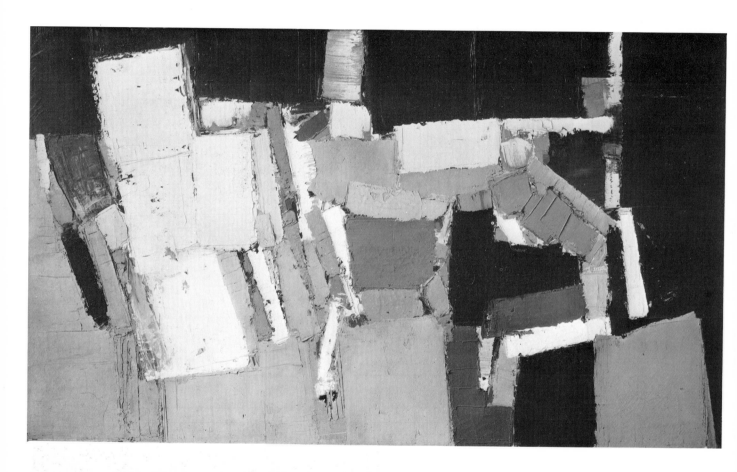

Premier état
First state

57 Parc des Princes, 1952

Huile sur toile
195 × 97
s.b.g. : Staël
Collection particulière, Paris

Oil on canvas
195 × 97
s.l.l. : Staël
Private collection, Paris

EXP.
Paris 1952
Paris 1956, n° 56, repr. pl. VI
Berne 1957, n° 51
Hanovre/Hambourg 1959-1960, n° 31,
repr. p. 25
Turin 1960, n° 66, repr. p. 96
Rotterdam/Zurich 1965, n° 46, repr.
coul.
Boston/Chicago/New York 1965-1966,
n° 37, repr. coul.

BIBL.
Cahiers d'Art 1953, repr. p. 93
Gindertaël 1960, repr. coul. pl. 4 (à
l'envers)
Cooper 1961, p. 51
Guichard-Meili 1966, repr. coul. pl. 7
Chastel 1968, n° 387, repr. p. 196 et
coul. p. 192
Archives Maeght 1972, repr. p. 85,
n° 43
Dumur 1975, repr. coul. p. 33
Chastel 1978, repr. p. 465

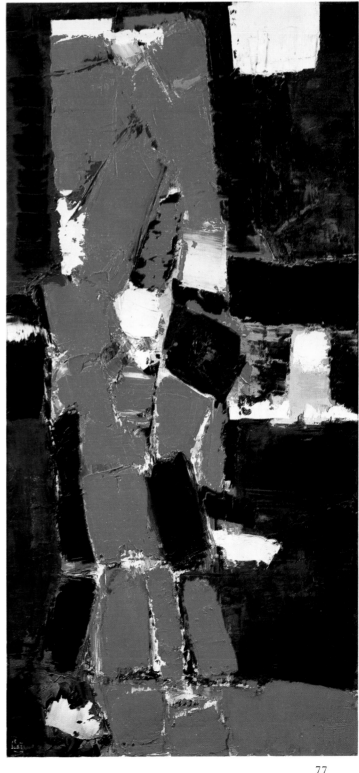

58 Footballeurs, 1952

Huile sur toile
65 × 81
s.h.d. : Staël
Collection particulière

Oil on canvas
65 × 81
s.u.r. : Staël
Private collection

EXP.
Berne 1957, n° 43
Hanovre/Hambourg 1959-1960, n° 32
Genève 1967, n° 19
Saint Paul 1972, n° 45, repr. p. 92

BIBL.
Cooper 1961, p. 50
Chastel 1968, n° 396, repr. p. 197
Archives Maeght 1972, repr. p. 92,
n° 45

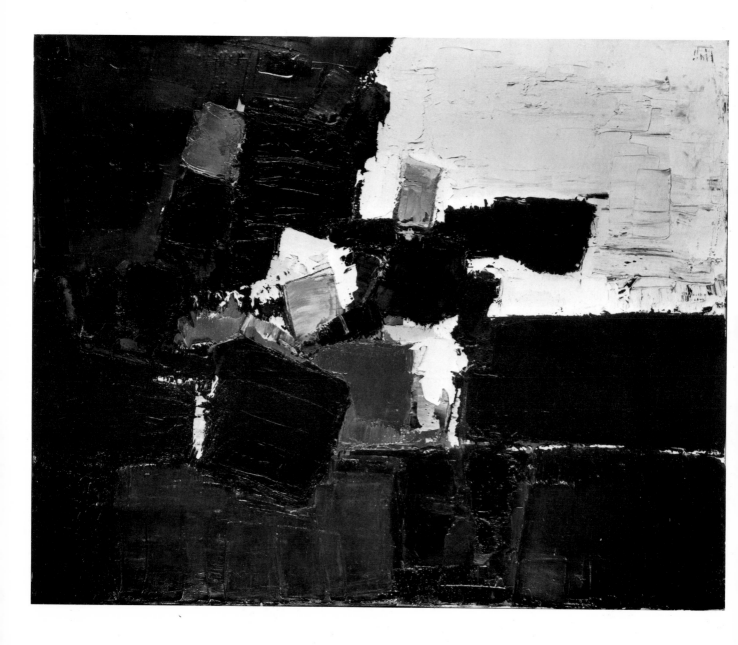

59 Footballeurs, 1952*

Huile sur toile
19 × 27
s. au dos : Staël
Musée des Beaux-Arts, Dijon,
Donation Granville

Oil on canvas
19 × 27
s. on the back
Musée des Beaux-Arts, Dijon, Donation
Granville

HIST.
Atelier de l'artiste, acquis en 1952

EXP.
Paris 1956, n° 52
Londres 1956, n° 25, repr.
Berne 1957, n° 45
Arles 1958, n° 28
Hanovre/Hambourg 1959-1960, n° 34
Turin 1960, n° 63, repr. p. 93
Rotterdam/Zurich 1965, n° 49, repr.
Boston/Chicago/New York 1965-1966,
n° 40, repr.
Saint Paul 1972, n° 46, repr. coul. p. 80

BIBL.
Cooper 1961, p. 50
Chastel 1968, n° 400, repr. p. 197
Archives Maeght 1972, repr. coul. p. 80,
n° 46
Lemoine 1976, p. 268, repr.

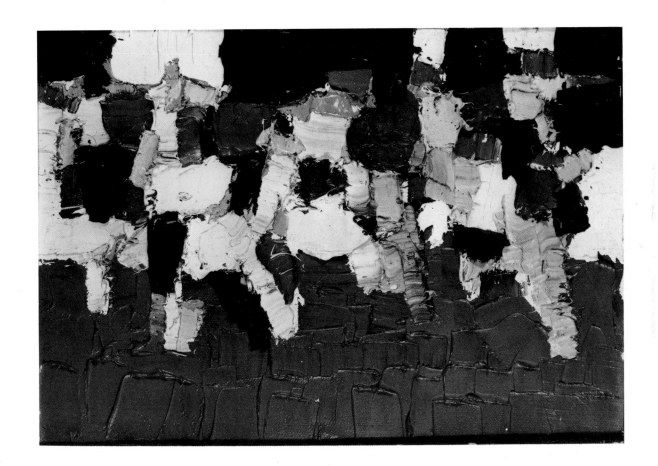

60 Footballeurs 1952*

Huile sur toile
16 × 22
s. au dos : Staël
Musée des Beaux-Arts, Dijon,
Donation Granville

Oil on canvas
16 × 22
s. on the back
Musée des Beaux-Arts, Dijon, Donation
Granville

EXP.
Paris 1956. n° 51
Berne 1957, n° 46
Arles 1958, n° 27, repr. pl. V
Hanovre/Hambourg 1959-1960, n° 36
Turin 1960, n° 65, repr. p. 95
Rotterdam/Zurich 1965, n° 47, repr.
Boston/Chicago/New York 1965-1966,
n° 38, repr.
Saint Paul 1972, n° 47, repr. p. 83

BIBL.
Cooper 1961, p. 50
Granville 1965, repr. coul. p. 86
Sutton 1966, repr. coul. pl. IX
Chastel 1968, n° 406, repr. p. 198
Archives Maeght 1972, repr. p. 83, n° 47
Lemoine 1976, n° 265, repr.

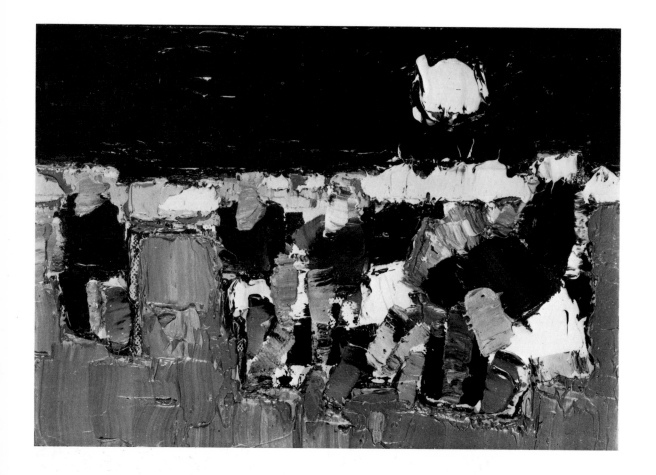

61 Fleurs, 1952

Huile sur toile
140 × 97
s.b.g. : Staël
Collection particulière

Oil on canvas
140 × 97
s.l.l. : Staël
Private collection

HIST.
Th. Schempp, New York
Ira Haupt, New York

EXP.
New York 1953, n° 19
Paris 1956, n° 49
Rotterdam/Zurich 1965, n° 39, repr.
coul.
Boston/Chicago/New York 1965-1966,
n° 34, repr. coul.
Saint Paul 1972, n° 50, repr. coul. p. 90

BIBL.
Dumur 1952, repr. p. 216
Cooper 1956, p. 142, repr. p. 143
Chastel 1968, n° 415, repr. p. 199
Archives Maeght 1972, repr. coul.
p. 90, n°50

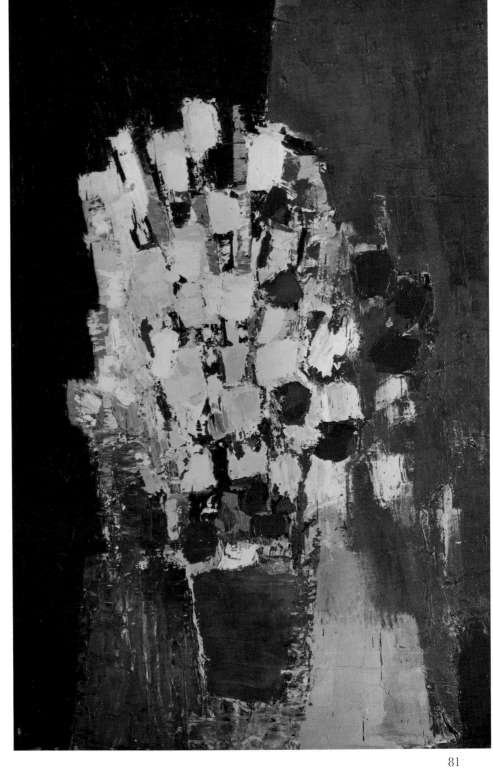

62 Fleurs sur fond noir, 1952

Huile sur toile
129 × 87
s.d.b.g. : Staël 52
Collection particulière

Oil on canvas
129 × 87
s.d.l.l. : Staël 52
Private collection

HIST.
Th. Schempp, New York
Knoedler, New York
Lee Ault, New York
Hans Popper, San Francisco

EXP.
New York 1953, n° 13
U.S.A. 1955-56, n° 19
New York 1966, n° 35
Saint Paul 1972, n° 51, repr. p. 93

BIBL.
Chastel 1968, n° 416, repr. p. 199 et
coul. p. 211
Archives Maeght 1972, repr. p. 93,
n° 51
Dumur 1975, repr. coul. p. 52

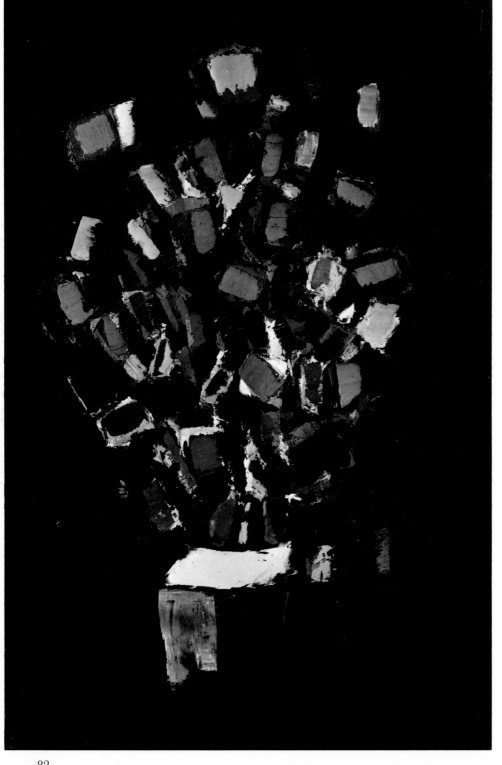

63 Fleurs, 1952

Huile sur toile
81 × 65
s.b.g. : Staël
Collection particulière, Paris

Oil on canvas
81 × 65
s.l.l. : Staël
Private collection, Paris

EXP.
Paris 1956, n° 58, repr. pl. VIII
Londres 1956, n° 29, repr.
Edimbourg 1956, n° 332
Berne 1957, n° 59
Hanovre/Hambourg 1959-1960, n° 40
Turin 1960, n° 51, repr. p. 81
Rotterdam/Zurich 1965, n° 42, repr.
Boston/Chicago/New York 1965-1966
n° 35, repr.
Genève 1967, n° 17, repr.

BIBL.
Cooper 1956, p. 142
Cooper 1961, repr. coul. pl. 34
Sutton 1966, repr. coul. couverture
Chastel 1968, n° 418, repr. p. 199

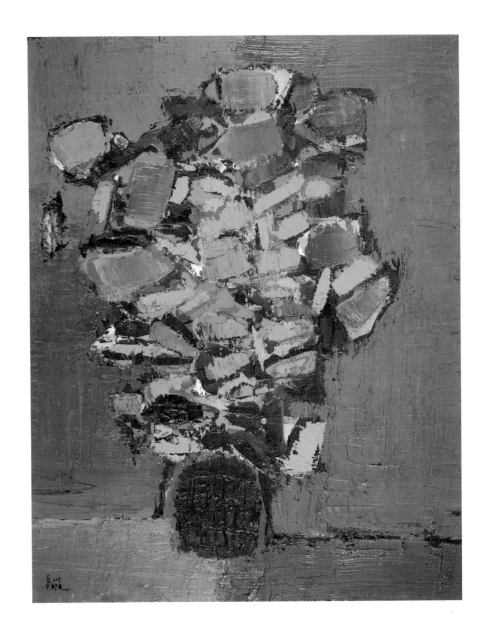

64 Paysage, 1952*

Huile sur toile
33 × 46
Jacques Dubourg, Paris

Oil on canvas
33 × 46
Jacques Dubourg, Paris

EXP.
Berne 1957
Arles 1958, n° 34
Hanovre/Hambourg 1959-1960, n° 48,
repr. p. 31
Turin 1960, n° 60, reproduit p. 90
Rotterdam/Zurich 1965, n° 61, repr.
Boston/Chicago/New York 1965-1966,
n° 47, repr.

BIBL.
Jacobs 1958, repr. p. 43
Cooper 1961, repr. coul. pl. 38
Chastel 1968, n° 437, repr. p. 202

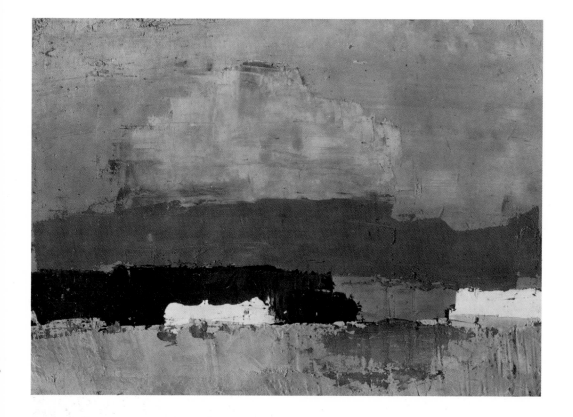

65 Honfleur, 1952*

Huile sur toile
60 × 81
s.b.d. : Staël
Collection particulière

Oil on canvas
60 × 81
s.l.r. : Staël
Private collection

HIST.
Marquise de Potesdad, Paris
Gimpel, Londres
Beyeler, Bâle

EXP.
Arles 1958, n° 36
Bâle 1964, n° 26, repr. coul.

BIBL.
Chastel 1968, n° 457, reproduit p. 208

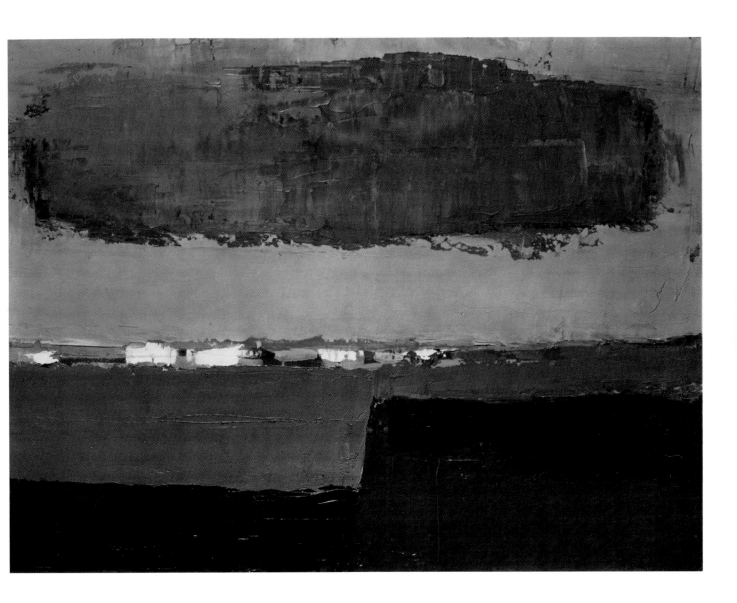

66 Le Parc de Sceaux, 1952

Huile sur toile
161,9 × 114

s.b.g. : Staël, s.d. au dos : Staël 1952
The Phillips Collection, Washington

Oil on canvas
161,9 × 114

s.l.l. : Staël, s.d. on the back : Staël 1952
The Phillips Collection, Washington

HIST.
Th. Schempp, New York
Knoedler, New York

EXP.
New York, 1953, n° 21
U.S.A. 1955-56, n° 15
Saint Paul 1972, n° 56, repr. p. 97

BIBL.
Cooper 1961, p. 61, repr. pl. 30
Cabanne 1962, repr. p. 28
*Chastel 1968, n° 475, repr. p. 214 et
coul. p. 221*
Deschamps 1971, repr. coul. p. 12
*Archives Maeght 1972, repr. p. 97,
n° 56*
Dumur 1975, repr. coul. p. 49

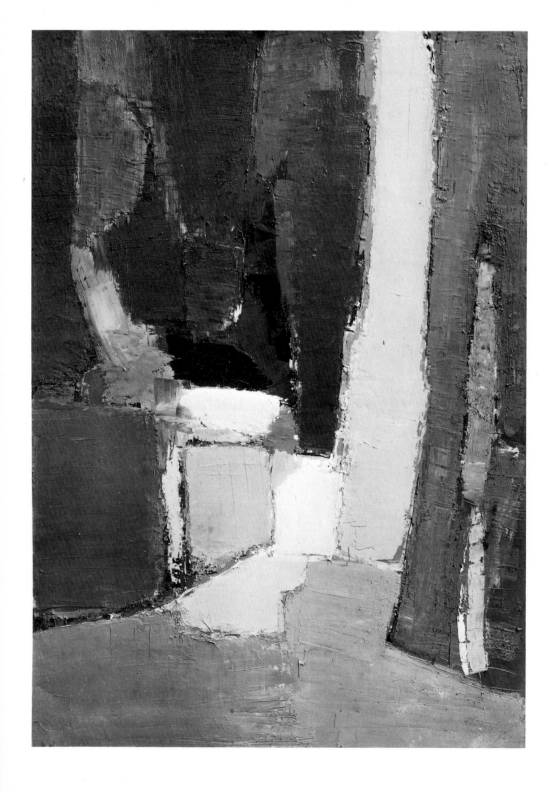

67 Le ciel rouge, 1952

Huile sur toile
130 × 162
s.d.b. : Staël
The Walker Art Center, Minneapolis
Don de la T.B. Walker Foundation

Oil on canvas
130 × 162
s.l.r. : Staël
The Walker Art Center, Minneapolis
Gift of the T.B. Walker Foundation

HIST.
Knoedler, New York
Th. Schempp, New York

EXP.
New York 1953, n° 27
U.S.A. 1955-56, n° 11
Saint Paul 1972, n° 57, repr. coul.
p. 103

BIBL.
Chastel 1968, n° 483, repr. p. 215 et coul. p. 212
Archives Maeght 1972, repr. coul. p. 103, n° 57
Dumur 1975, repr. coul. p. 51

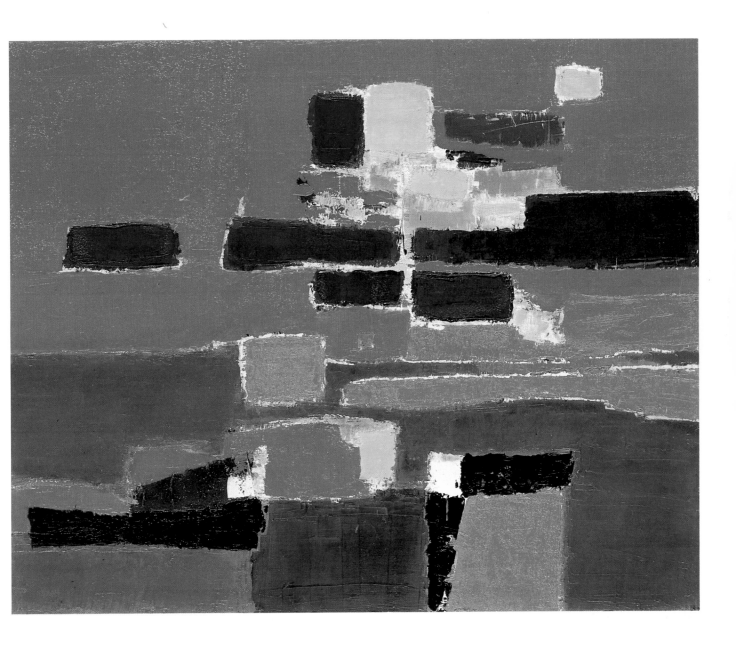

68 Figure au bord de la mer, 1952

Huile sur toile
161,5 × 129,5
s.b.d. : Staël
Kunstsammlung Nordrhein-Westfalen,
Düsseldorf

Oil on canvas
161,5 × 129,5
s.l.r. : Staël
Kunstsammlung Nordrhein-Westfalen,
Düsseldorf

HIST.
Th. Schampp, New York
Lee A. Ault, New York
G. David Thompson, Pittsburg
Galerie Beyeler, Bâle
Achat 1964

EXP.
New York 1953, n° 29
U.S.A. 1955-56, n° 16
Berne 1957, n° 53
Hanovre/Hambourg 1959-1960, n° 52
Bâle 1964, n° 25, repr. coul.
Saint Paul 1972, n° 58, repr. coul.
p. 105

BIBL.
Tudal 1958, repr. coul. p. 21
Brion 1959, repr. coul. p. 41
Cabanne 1962, repr. coul. p. 25
Granville 1965, repr. coul. p. 92
Chastel 1968, n° 520, repr. p. 225
Archives Maeght 1972, repr. coul.
p. 105, n° 58
Dumur 1975, repr. coul. p. 36

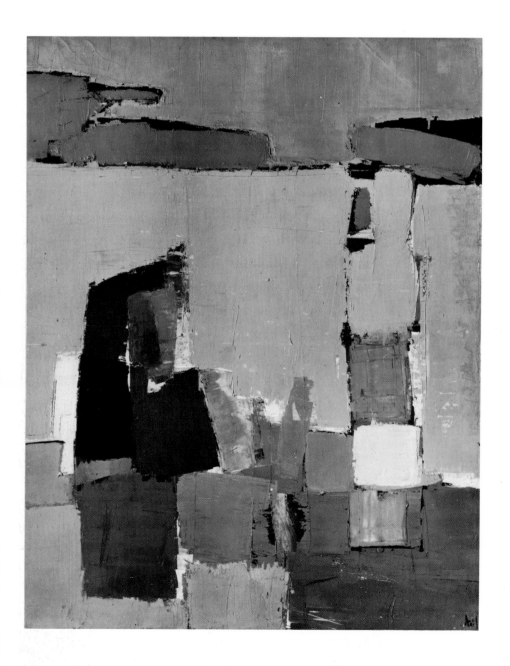

69 Le Lavandou, 1952

Huile sur toile
195 × 97
s.b.g. : Staël
Musée National d'Art Moderne, Paris

HIST.
Jacques Dubourg, Paris
Don de M. et Mme Jacques Dubourg
au MNAM en 1959

Oil on canvas
195 × 97
s.l.l. : Staël
Musée National d'Art Moderne, Paris

EXP.
New York 1953, n° 24
Paris 1956, n° 64, repr. pl. VII
Londres 1956, n° 30, repr.
Hanovre/Hambourg 1959-1960, n° 47,
repr. p. 21
Rotterdam/Zurich 1965, n° 45, repr.
Boston/Chicago/New York, 1965-1966,
n° 36, repr.

BIBL.
Landini 1956, repr. fig. 35 b
Dorival 1959, repr. p. 228
Cooper 1961, p. 61
Sutton 1966, repr. coul. pl. X-XI
Chastel 1968, n° 521, repr. p. 226
Dumur 1975, repr. coul. p. 25

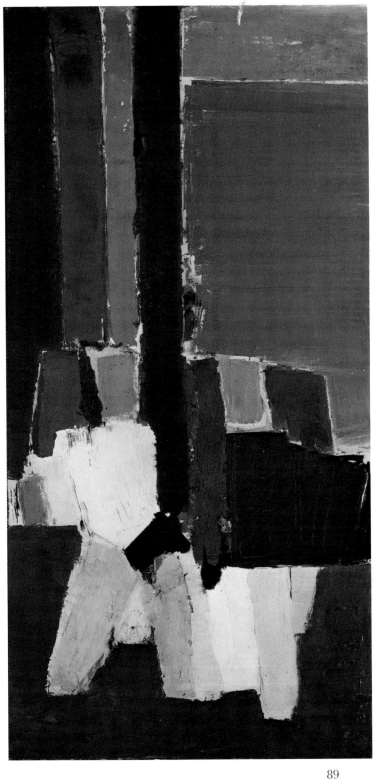

70 Nature morte à la bouteille, 1952 *

Huile sur toile
38 × 55
s.b.g. : Staël
Collection particulière, Paris

Oil on canvas
38 × 55
s.l.l. : Staël
Private collection, Paris

HIST.
Jacques Dubourg, Paris

EXP.
Edimbourg 1956, n° 331
Berne 1957, n° 42
Hanovre/Hambourg 1959-1960, n° 38
Turin 1960, n° 53, repr. p. 83
Rotterdam/Zurich 1965, n° 55, repr.
coul.
Boston/Chicago/New York 1965-1966,
n° 45, repr. coul.
Genève 1967, n° 16
Saint Paul 1972, n° 59, repr. p. 98 et
coul. couv.

BIBL.
Cabanne 1962, repr. p. 29
Sutton 1966, repr. coul. pl. VI
Chastel 1968, n° 524, repr. p. 227
Archives Maeght 1972, repr. p. 98,
n° 59

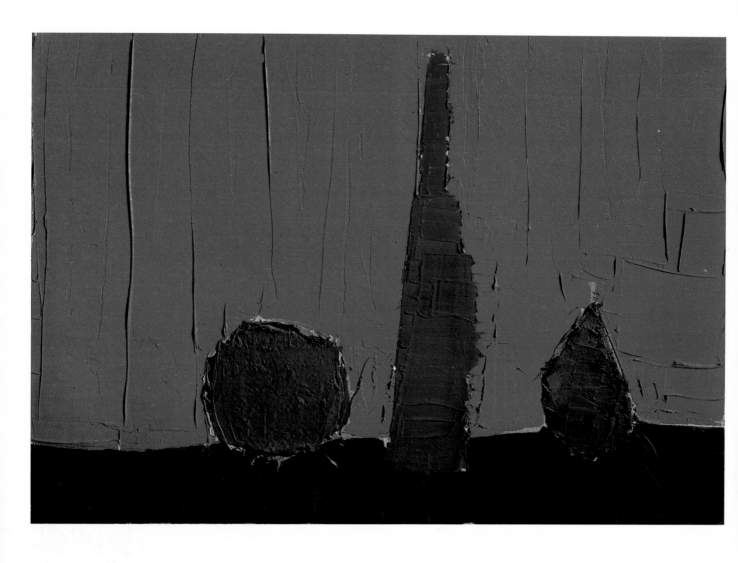

71 Ciel à Honfleur, 1952*

Huile sur toile
92 × 73
s.d.b. : Staël
Collection particulière

Oil on canvas
92 × 73
s.l.r. : Staël
Private collection

HIST.
Jacques Dubourg, Paris

EXP.
New York 1953, n° 20
Londres 1956, n° 33, repr.
Hanovre/Hambourg 1959-60, n° 46
Turin 1960, n° 57, repr. p. 87
Rotterdam/Zurich 1965, n° 54 repr.
Boston/Chicago/New York 1965-1966,
n° 44 repr.
Saint Paul 1972, n° 60, repr. coul.
p. 106

BIBL.
Dumur 1952, repr. p. 218
Fitz Simmons 1953, p. 88
Cooper 1956, p. 142
Gindertaël 1960, repr. coul. pl. 7
Granville 1965, repr. coul. p. 92
Guichard-Meili 1966, repr. coul. pl. 11
Chastel 1968, n° 538, repr. p. 238
Archives Maeght 1972, repr. coul.
p. 106, n° 60

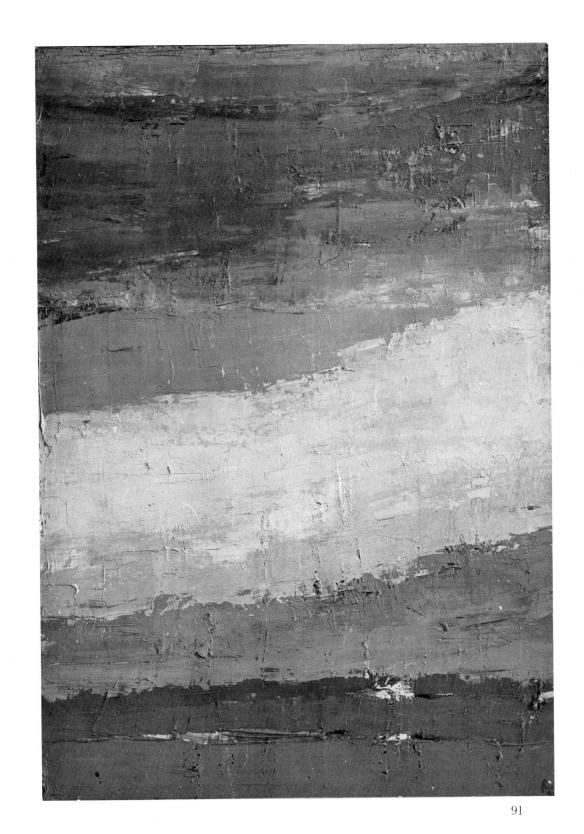

72 La lune, 1953*

Huile sur toile
162 × 97
Françoise de Staël

Oil on canvas
162 × 97
Françoise de Staël

EXP.
Sao Paulo 1953, n° 61
Paris 1956, h.c.
Turin 1960, n° 48, repr. p. 78
Bâle 1964, n° 27, repr. coul.
Rotterdam/Zurich 1965, n° 58, repr.
coul.
Boston/Chicago/New York 1965-1966,
n° 49, repr. coul.
Saint Paul 1972, n° 61, repr. p. 99

BIBL.
Cooper 1961, p. 62, repr. coul. pl. 37
Grojnowski 1966, p. 948
Chastel 1968, n° 543, repr. p. 245
Archives Maeght 1972, repr. p. 99,
n° 61

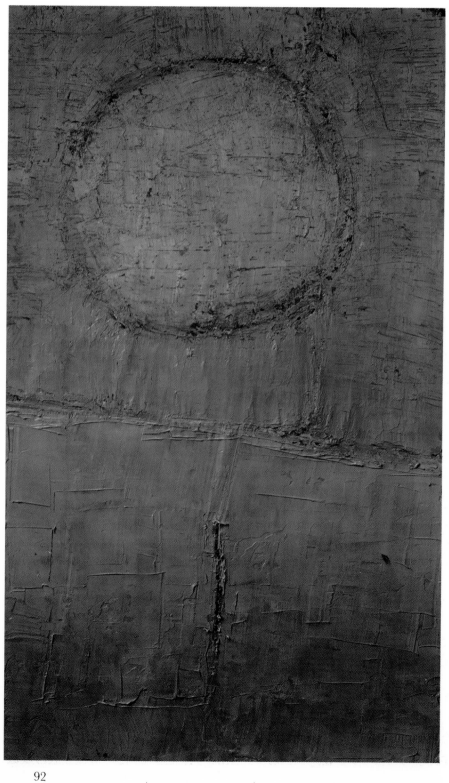

73 Les Indes Galantes, 1953

Huile sur toile
162 × 114
s. au dos
Gimpel-Hanover Galerie, Zurich

Oil on canvas
162 × 114
s. on the back
Gimpel-Hanover Gallery, Zurich

HIST.
Th. Schempp, New York
Knoedler, New York

EXP.
New York 1953, n° 30
Hanovre/Hambourg 1959-1960, n° 55
Turin 1960, n° 70, repr. p. 100
Zurich 1963, n° 21, repr. coul.
Rotterdam/Zurich 1965, n° 66, repr.
coul.
Saint-Paul 1972, n° 63, repr. p. 101

BIBL.
Chastel 1968, n° 550, repr. p. 247
Archives Maeght 1972, repr. p. 101,
n° 63
Dumur 1975, repr. coul. p. 55

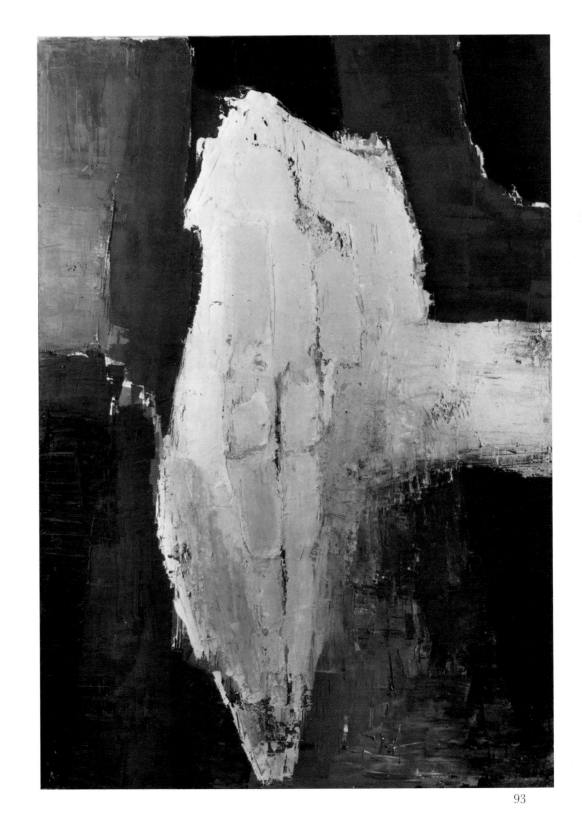

74 Les Indes Galantes, 1953

Huile sur toile
155 × 118
s.b.g. : Staël
Collection particulière

Oil on canvas
155 × 118
s.l.l. : Staël
Private collection

HIST.
Jacques Dubourg, Paris
Philippe Reichenbach, Houston

EXP.
New York 1953, n° 34
Boston/Chicago/New York 1965-1966,
n° 54, repr.
Saint Paul 1972, n° 62, repr. p. 100

BIBL.
Chastel 1968, n° 545, repr. p. 246
Archives Maeght 1972, repr. p. 100,
n° 62
Dumur 1975, p. 73

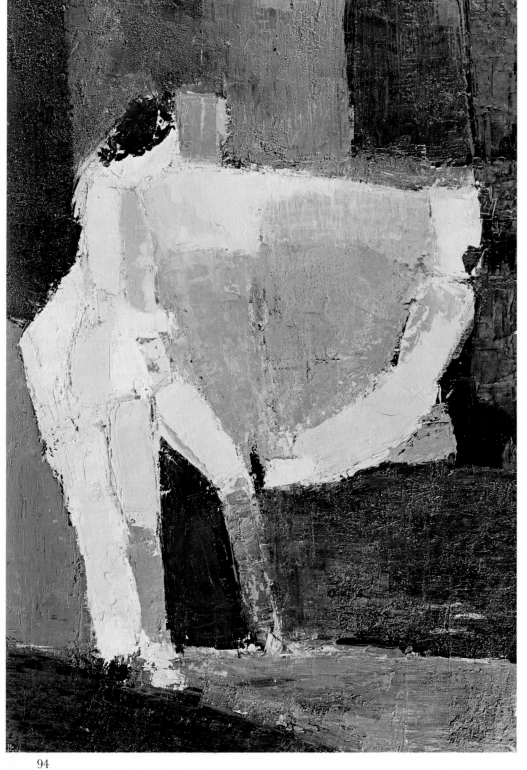

75 Grignan, 1953

Huile sur toile
65 × 81
s.b.g. : Staël
Collection particulière, Londres

Oil on canvas
61 × 81
s.l.l. : Staël
Private collection, London

HIST.
Paul Rosenberg, New York
Mrs Walter Ross, New York

EXP.
New York 1954, n° 12 ; 1958, n° 10 ;
1963, n° 13, repr.
Rotterdam/Zurich 1965, n° 69 repr.
coul.

BIBL.
Chastel 1968, n° 559, repr. p. 249

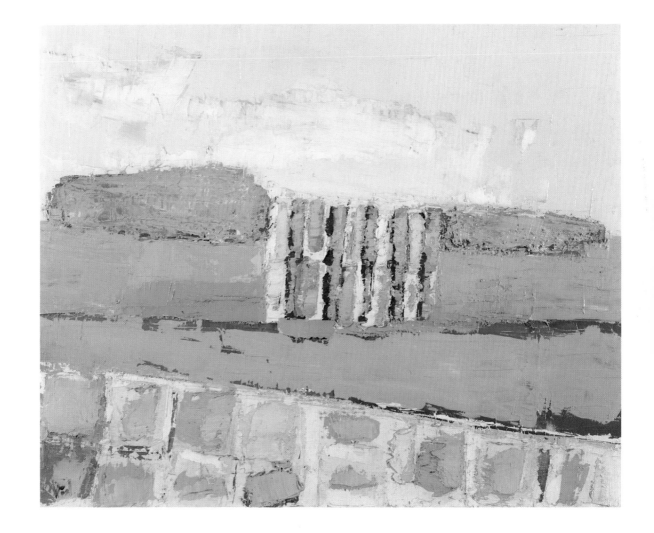

76 Bouteilles dans l'atelier, 1953

Huile sur toile
200 × 350
s.b.g. : Staël
Collection particulière, France

Oil on canvas
200 × 350
s.l.l. : Staël
Private collection, France

HIST.
Jacques Dubourg, Paris

EXP.
Paris 1953
Sao Paulo 1953, n° 62
Paris 1956, n° 68
Berne 1957, n° 39
Paris 1969, n° 11, repr. coul.

BIBL.
Landini 1956, repr. fig. 36
Chastel 1968, n° 570, repr. p. 252 et
coul. p. 257

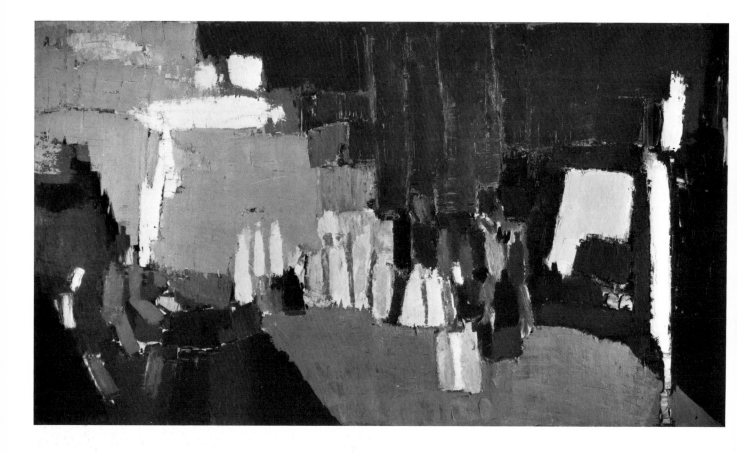

77 Les musiciens, souvenir de Sidney Bechet, 1953

Huile sur toile
162 × 114
s.b.d. : Staël
Jacques Dubourg, Paris

Oil on canvas
162 × 114
s.l.r. : Staël
Jacques Dubourg, Paris

EXP.
Sao Paulo 1953, n° 63
Paris 1956, n° 57, repr. pl. IX
Londres 1956, n° 28, repr.
Berne 1957, n° 60, repr.
Arles 1958, n° 38
Hanovre/Hambourg 1959-1960, n° 51,
repr. p. 29
Turin 1960, n° 68 repr. p. 98
Paris 1969, n° 12

BIBL.
Grenier 1955, repr. coul. p. 46
Cooper 1956, p. 142
Landini 1956, p. 77, repr. fig. 35a
Tudal 1958, repr. coul. p. 45
Jacobs 1958, repr. p. 42
Cooper 1961, p. 61
Sutton 1966, repr. coul. pl. VIII
Guichard-Meili 1966, repr. coul. pl. 10
Chastel 1968, n° 572, repr. p. 253 et
coul. p. 258
Dumur 1975, p. 73, repr. p. 56

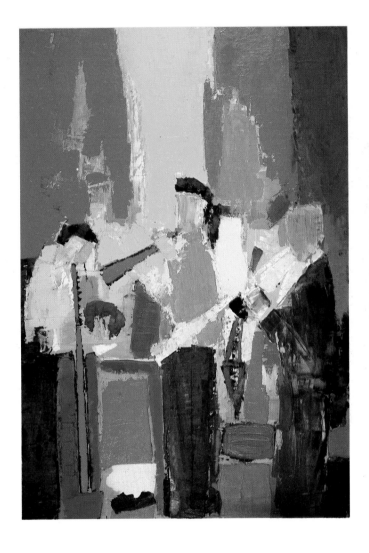

78 Musiciens, 1953

Huile sur toile
162 × 114
s.b.d. : Staël
The Phillips Collection, Washington

Oil on canvas
162 × 114
s.l.r. : Staël
The Phillips Collection, Washington

HIST.
Paul Rosenberg, New York
Th. Schempp, New York

EXP.
New York 1955, n° 1
Rotterdam/Zurich 1965, n° 70, repr.
Boston/Chicago/New York 1965-1966,
n° 58, repr.
Saint Paul 1972, n° 67, repr. coul.
p. 119

BIBL.
Cooper 1956, p. 142
Cooper 1961, p. 61, repr. coul. pl. 41
Granville 1965, repr. coul. p. 94
Chastel 1968, n° 571, repr. p. 253
Archives Maeght 1972, repr. coul.
p. 119, n° 67

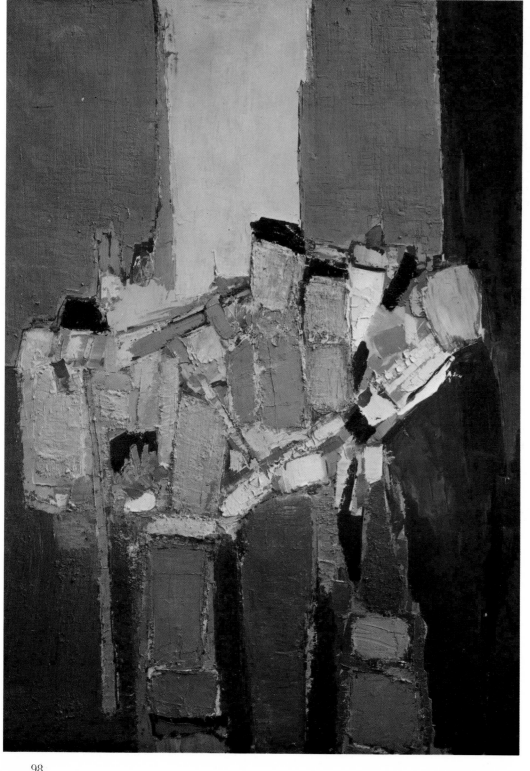

79 Agrigente, 1953

Huile sur toile
73 × 100
s.b.g. : Staël
Kunsthaus, Zurich, Association des
Amis zurichois de l'Art

Oil on canvas
73 × 100
s.l.l. : Staël
Kunsthaus, Zurich, Zurich Friends of
Art Society

HIST.
Jacques Dubourg, Paris

EXP.
Berne 1957, n° 74
Hanovre/Hambourg 1959-1960, n° 63
Turin 1960, n° 87, repr. p. 117, coul.
pl. VIII
Rotterdam/Zurich 1965, n° 81, repr.
Boston/Chicago/New York 1965-1966,
n° 65, repr.
Saint Paul 1972, n° 73, repr. p. 111

BIBL.
Jacobs 1958, repr. p. 42
Sutton 1966, repr. coul. pl. XV
Chastel 1968, n° 680, repr. p. 293
Archives Maeght 1972, repr. p. 111,
n° 73

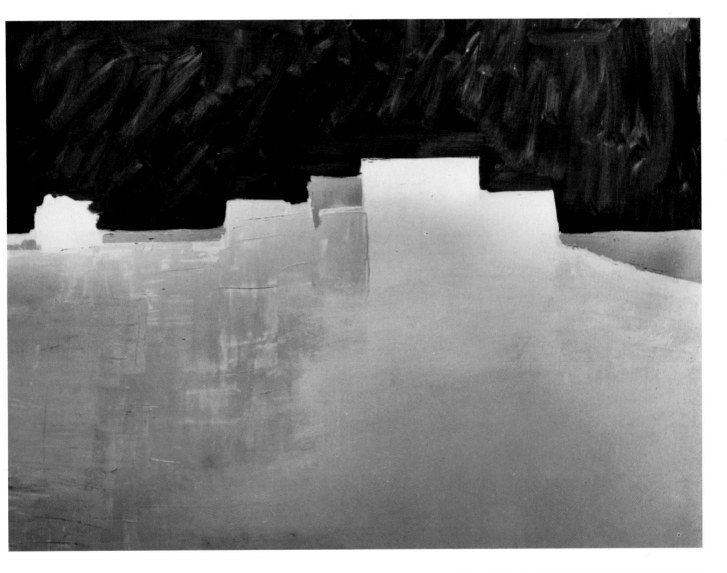

80 Nu debout, 1953

Huile sur toile
146 × 89
Dr. Peter Nathan, Zurich

Oil on canvas
146 × 89
Dr. Peter Nathan, Zurich

HIST.
Jacques Dubourg, Paris
Collection Jasson, Paris

EXP.
Paris 1956, n° 69, repr. pl. XI
Londres 1956, n°32, repr.
Berne 1957, n° 63
Arles 1958, n° 34
Hanovre/Hambourg 1959-1960, n° 56,
repr. p. 30
Turin 1960, n° 71, repr. p. 101 et coul.
pl. VI
Rotterdam/Zurich 1965, n° 64, repr.
Boston/Chicago/New York 1965-1966,
n° 51, repr.
Zurich 1976, n° 13, repr. coul.

BIBL.
Gindertaël 1960, repr. coul. pl. 8
Cooper 1961, p. 62, repr. coul. pl. 45
Guichard-Meili 1966, repr. coul. pl. 12
Chastel 1968, n° 681, repr. p. 294
Deschamps 1971, repr. coul. p. 13
Dumur 1975, repr. coul. p. 54

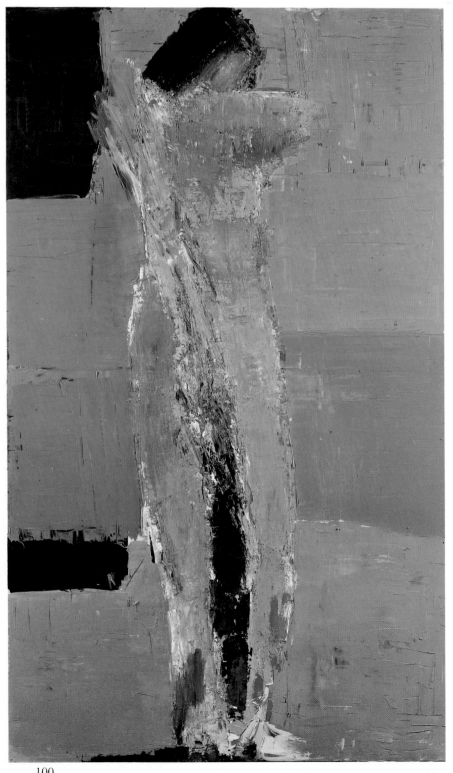

81 Portrait d'Anne, 1953

Huile sur toile
130 × 90
Musée d'Unterlinden, Colmar

Oil on canvas
130 × 90
Musée d'Unterlinden, Colmar

EXP.
Arles 1958, n° 41
Turin 1960, n° 72, repr. p. 102
Rotterdam/Zurich 1965, n° 74, repr.
Boston/Chicago/New York 1965-1966,
n° 62, repr.
Saint Paul 1972, n° 71, repr. coul.
p. 121

BIBL.
Raillard 1958, p. 55
Cooper 1961, repr. coul. pl. 46
Tassi 1965, p. 63
Chastel 1968, n° 688, repr. p. 297
Archives Maeght 1972, repr. coul.
p. 121, n° 76
Dumur 1975, repr. coul. p. 57

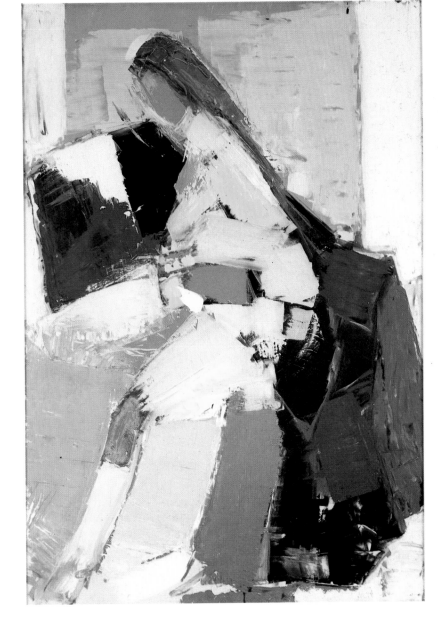

82 Agrigente, 1954*

Huile sur toile
65 × 81
s. au dos : Staël
Collection particulière, France

Oil on canvas
65 × 81
s. on the back : Staël
Private collection, France

HIST.
Jacques Dubourg, Paris

EXP.
Paris 1957, n° 17
Berne 1957, n° 61
Hanovre/Hambourg 1959-1960, n° 64
Turin 1960, n° 88, p. 118

BIBL.
Grenier 1955, repr. p. 53
Gindertaël 1960, repr. pl. 9
Chastel 1968, n° 711, repr. p. 301

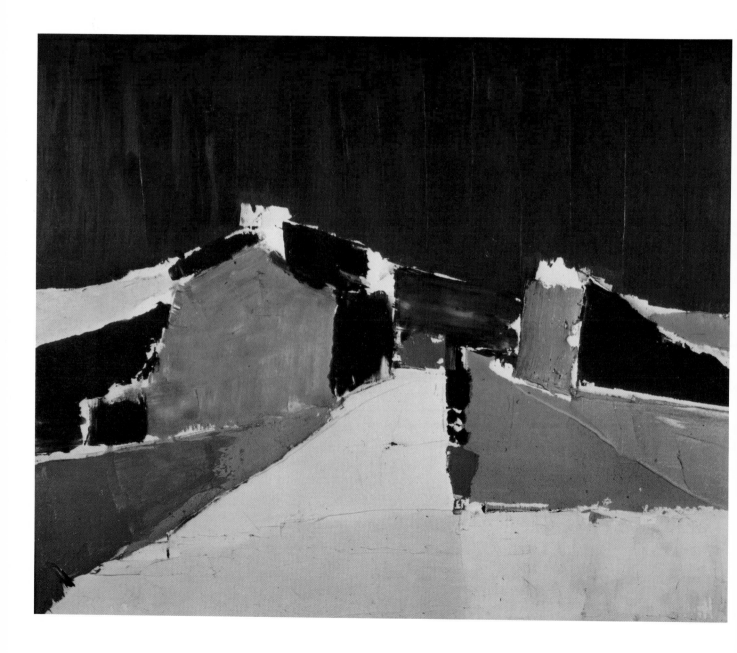

83 Agrigente, 1954

Huile sur toile
60 × 81
s.b.d. : Staël
Collection particulière

Oil on canvas
60 × 81
s.l.r. : Staël
Private collection

BIBL.
Granville 1965, repr. coul. p. 95
Chastel 1968, n° 720, repr. p. 304

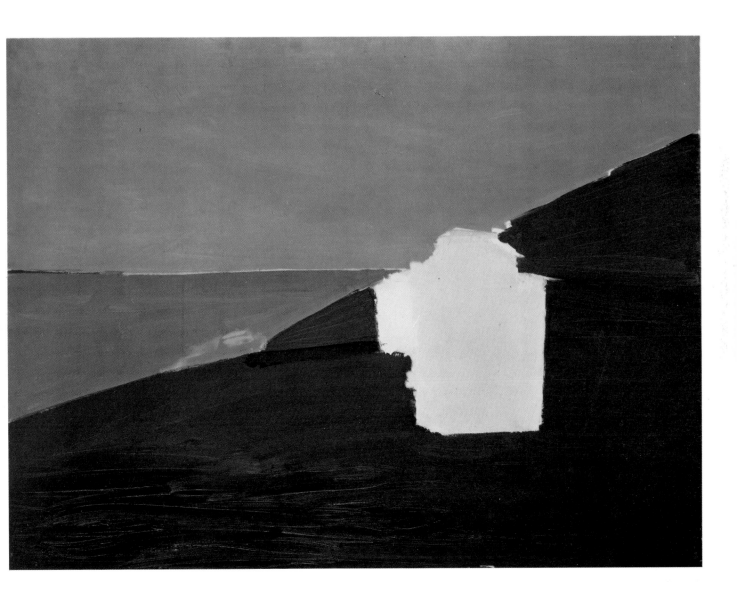

84 Les Martigues, 1954

Huile sur toile
73 × 100
s.b.d. : Staël
Collection particulière

Oil on canvas
73 × 100
s.l.r. : Staël
Private collection

HIST.
Jacques Dubourg, Paris
Jacques Benador, Genève

EXP.
Paris 1954
Edimbourg 1956, n° 338
Turin 1960, n° 80, repr. p. 110

BIBL.
Tassi 1965, p. 64
Chastel 1968, n° 767, repr. p. 319

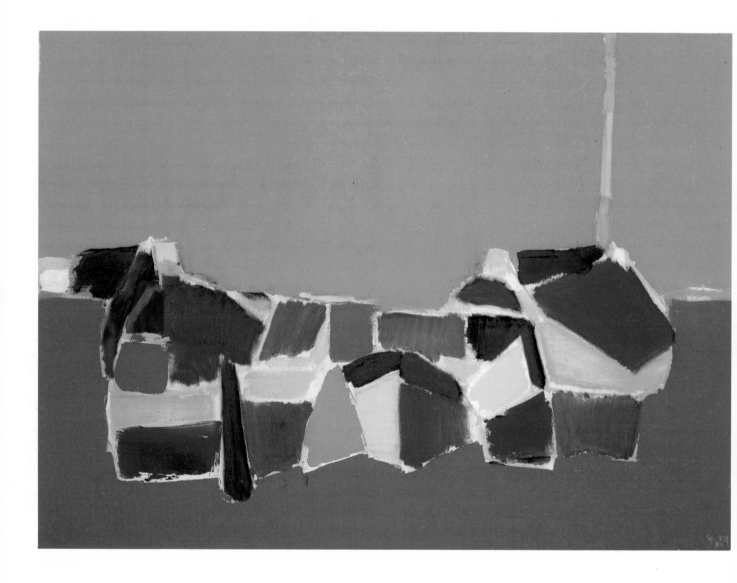

85 La route d'Uzès, 1954*

Huile sur toile
60 × 81
s.b.g. : Staël
Collection particulière, Paris

Oil on canvas
60 × 81
s.l.l. : Staël
Private collection, Paris

HIST.
Jacques Dubourg, Paris
Tooth, Londres
Galerie Beyeler, Bâle
Pinto, Paris
Michèle Dousse, Paris

EXP.
Paris 1954
Londres 1956, n° 7, repr.
Bâle 1964, n° 31, repr. coul.
Rotterdam/Zurich 1965, n° 73, repr.
coul.
Boston/Chicago/New York 1965-1966,
n° 53, repr. coul.
Saint Paul 1972, n° 79, repr. p. 117

BIBL.
Cooper 1956, p. 145
Cooper 1961, pp. 62-74, repr. coul.
pl. 55
Tassi 1965, repr. pl. 53
Grojnowski 1966, p. 948
Chastel 1968, n° 773, repr. p. 321
Archives Maeght 1972, repr. p. 117,
n° 79

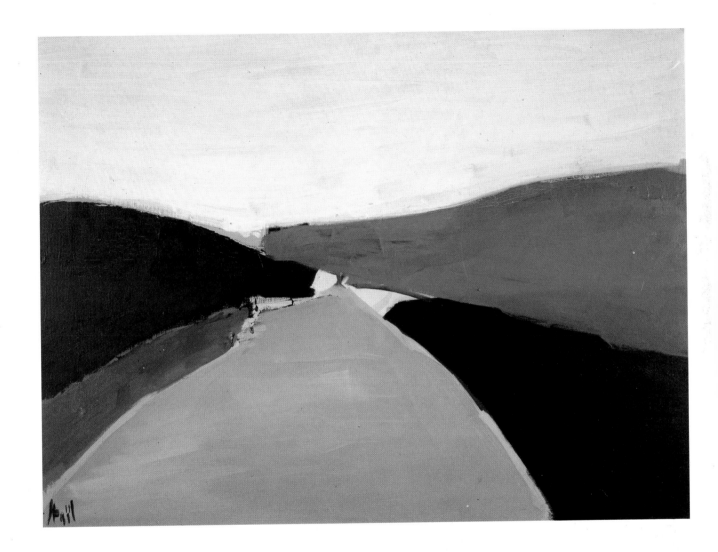

86 La route, 1954

Huile sur toile
60 × 81
Collection particulière

Oil on canvas
60 × 81
Private collection

EXP.
Arles 1958, n° 54

BIBL.
Chastel 1961, repr. coul. p. 224
Chastel 1968, n° 775, repr. p. 321

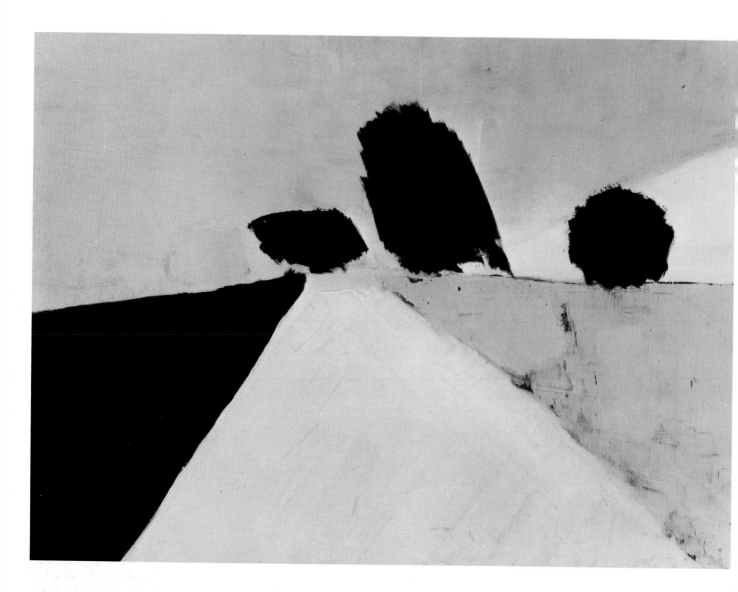

87 Marseille, 1954*

Huile sur toile
81 × 60
Collection particulière, Munich

Oil on canvas
81 × 60
Private collection, München

HIST.
Collection Jacques Dubourg,
Paris

EXP.
Paris 1954
Paris 1956, n° 74
Londres 1956, n° 36 repr.
Berne 1957, n° 66
Hanovre/Hambourg 1959-1960, n° 58
Turin 1960, n° 83, repr. p. 113
Rotterdam/Zurich 1965, n° 72, repr.
Boston/Chicago/New York 1965-1966,
n° 60, repr.

BIBL.
L'Illustration 1954
Cooper 1961, repr. p. 81, pl. 52
Granville 1965, repr. coul. couv.
Time 1965, repr. p. 88

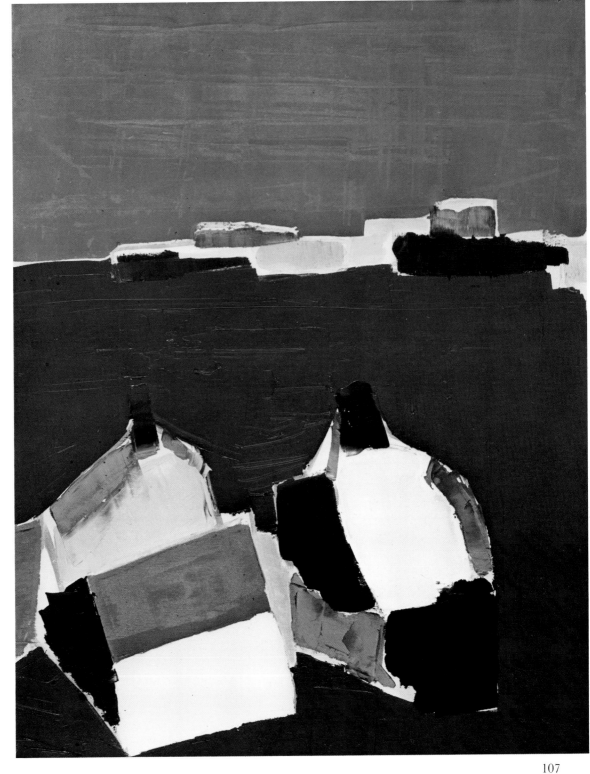

88 Nu couché, 1954*

Huile sur toile
97 × 146
s.b.d. : Staël
Collection particulière

Oil on canvas
97 × 146
s.l.r. : Staël
Private collection

HIST.
Jacques Dubourg, Paris

EXP.
Londres 1956, n° 35, repr.
Paris 1957, n° 14
Berne 1957, n° 62
Rotterdam/Zurich 1965, n° 65, repr.
Boston/Chicago/New York 1965-1966,
n° 70, repr.
Saint Paul 1972, n° 81, repr. coul.
p. 122

BIBL.
Tudal 1958, repr. coul. p. 49
Granville 1965, repr. coul. p. 94
Chastel 1968, n° 789, repr. p. 326
Archives Maeght 1972, repr. coul.
p. 122, n° 81

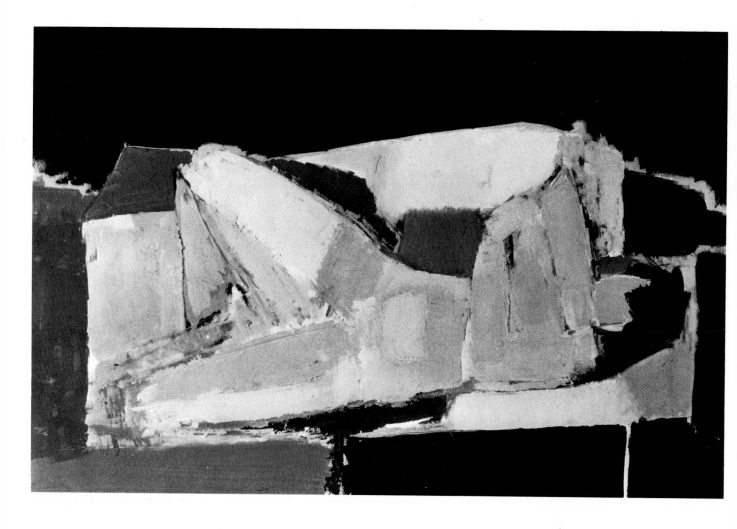

89 Nu couché, 1954*

Huile sur toile
98 × 146
s.b.d.d. et titre au dos
Collection particulière

Oil on canvas
98 × 146
s.l.r.d. and title on the Back
Private collection

HIST.
Paul Rosenberg, New York
Mr and Mrs Stanley Marcus,
New York

EXP.
New York 1954, n° 2
New York 1963, n° 17, repr. p. 8
Boston/Chicago/New York 1965-1966,
n° 62, repr.

BIBL.
Chastel 1968, n° 687, repr. p. 297

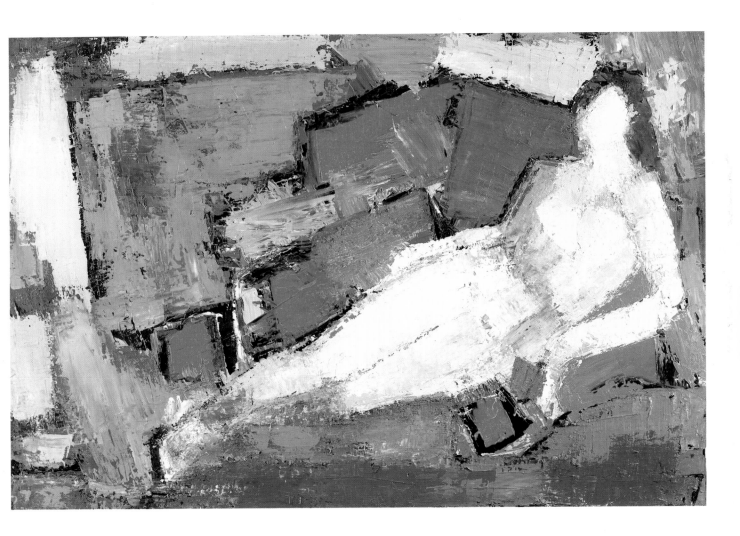

90 Nature morte, 1954

Huile sur toile
65 × 92
s.b.g. : Staël
Collection particulière, Hollande

Oil on canvas
65 × 92
s.l.l. : Staël
Private collection, Holland

BIBL.
Chastel 1968, n° 828, repr. p. 335

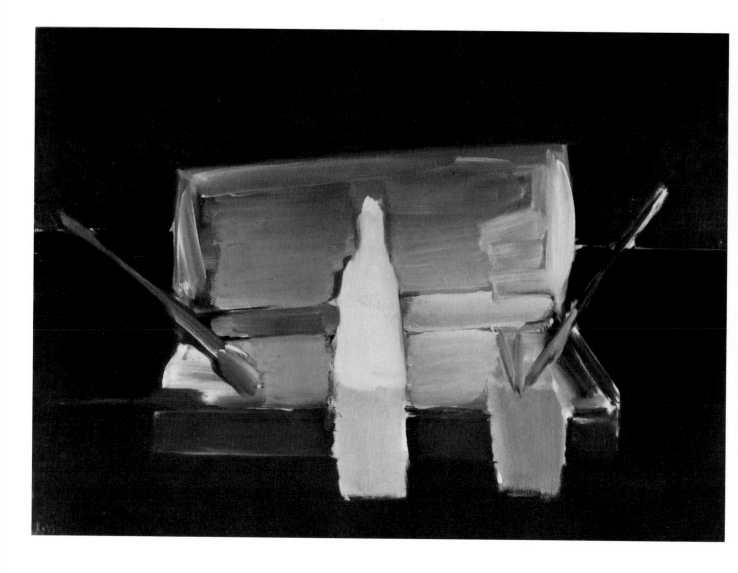

91 Grisaille, 1954*

Huile sur toile
60 × 81
s.b.g. : Staël
The Art Gallery of Ontario, Toronto
Hulin Trust Company

HIST.
Jacques Dubourg, Paris
Tooth, Londres
Sir Edward and Lady Hulton, Londres

Oil on canvas
60 × 81
s.l.l. : Staël
The Art Gallery of Ontario, Toronto
Hulin Trust Company

BIBL.
Cooper 1961, repr. pl. 59
Chastel 1968, N° 835, repr. p. 337

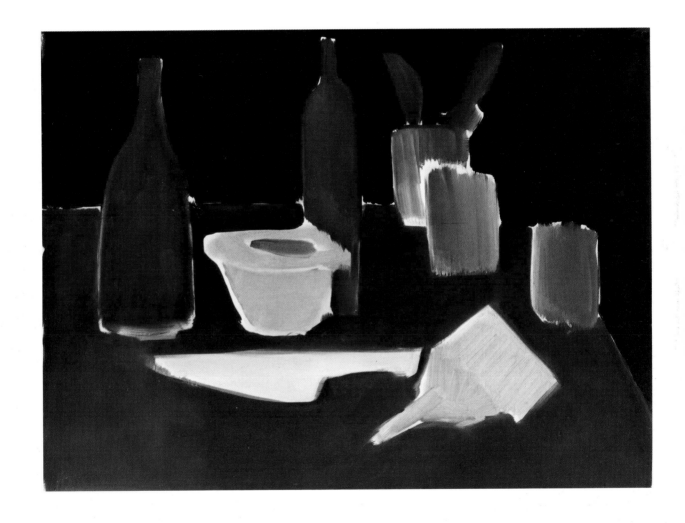

92 La palette, 1954

Huile sur toile
87,5 × 114
s.b.d. : Staël
Collection particulière

Oil on canvas
87,5 × 114
s.l.r. : Staël
Private collection

HIST.
Jacques Dubourg, Paris

EXP.
Paris 1954-1955
Londres 1956, n° 3
Londres 1956, n° 41
Saint Paul 1972, n° 82, repr. p. 124

BIBL.
Zervos 1955, repr. p. 266
Chastel 1968, n° 859, repr. p. 340 et
coul. p. 342
Archives Maeght 1972, repr. p. 124,
n° 82

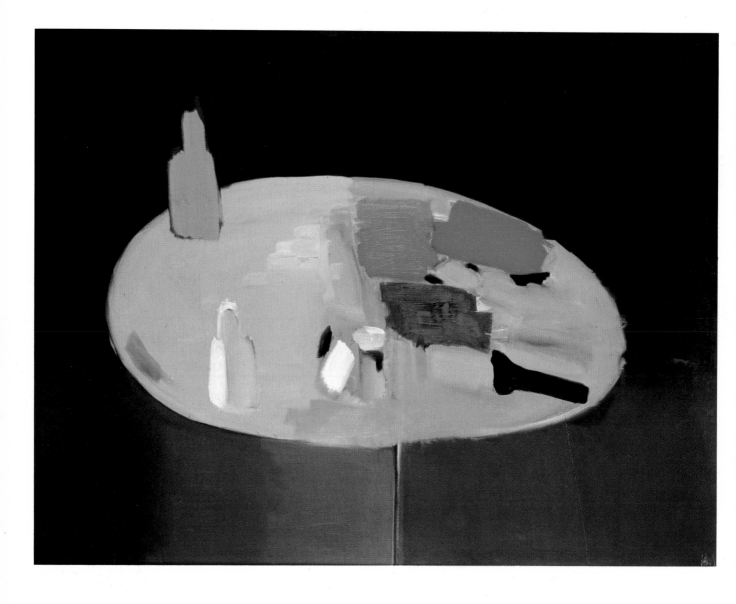

93 Le pont des Arts, la nuit, 1954

Huile sur toile
94 × 116
s. au dos avec la mention :
« Le Pont des Arts »
Collection particulière

Oil on canvas
94 × 116
s. on the back with the title : « Le Pont des Arts »
Private collection

EXP.
Rotterdam/Zurich 1965, n° 84 repr.

BIBL.
Granville 1965, repr. coul. p. 89
Chastel 1968, n° 865, repr. p. 343

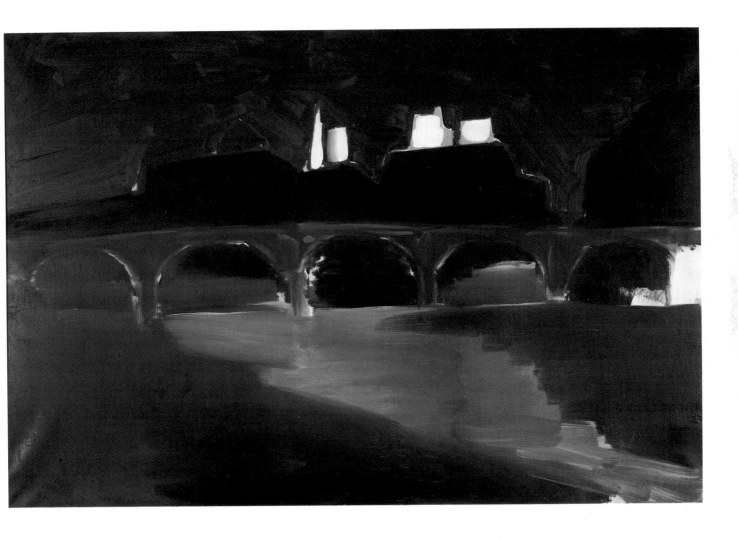

94 La Seine à Paris, 1954*

Huile sur toile
89 × 130
s.b.g. : Staël
Collection particulière

Oil on canvas
89 × 130
s.l.l. : Staël
Private collection

BIBL.
Chastel 1968, n° 870, repr. p. 343

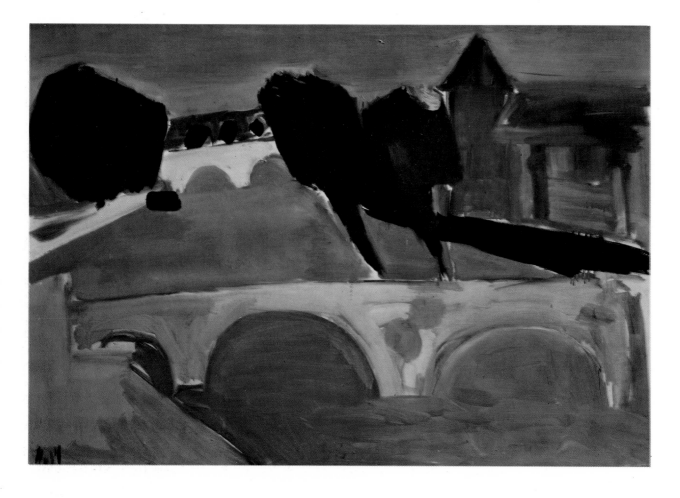

95 Paysage, plage, 1954*

Huile sur toile
46 × 55
Cachet au dos b.g.
Collection particulière, Paris

Oil on canvas
46 × 55
Stamp on the back. l.l.
Private collection, Paris

HIST.
Jacques Dubourg, Paris

EXP.
Hanovre/Hambourg 1959-1960, n° 61
Turin 1960, n° 85, repr. p. 115
Rotterdam/Zurich 1965, n° 83, repr.
coul.
Boston/Chicago/New York 1965-1966,
n° 69, repr. coul.
Paris 1969, N° 17
Saint Paul 1972, n° 86, repr. p. 127

BIBL.
Cooper 1961, repr. coul. pl. 57
Sutton 1965, repr. coul. p. 358
Sutton 1966, repr. p. 1
Chastel 1968 n° 900, repr. p. 349 et
coul. p. 360
Archives Maeght 1972, repr. p. 127,
n° 86

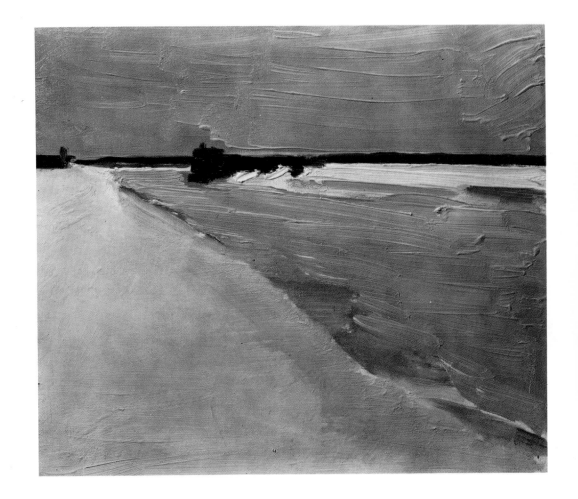

96 Chenal à Gravelines, 1954

Huile sur toile
73 × 100
s.b.g. : Staël
Collection particulière

Oil on canvas
73 × 100
s.l.l. : Staël
Private collection

HIST.
Jacques Dubourg, Paris
Tooth, Londres
Marlborough Gallery, Londres

EXP.
Paris 1953, n° 76

BIBL.
Granville 1965, repr. coul. p. 95
Chastel 1968, n° 901, repr. p. 349

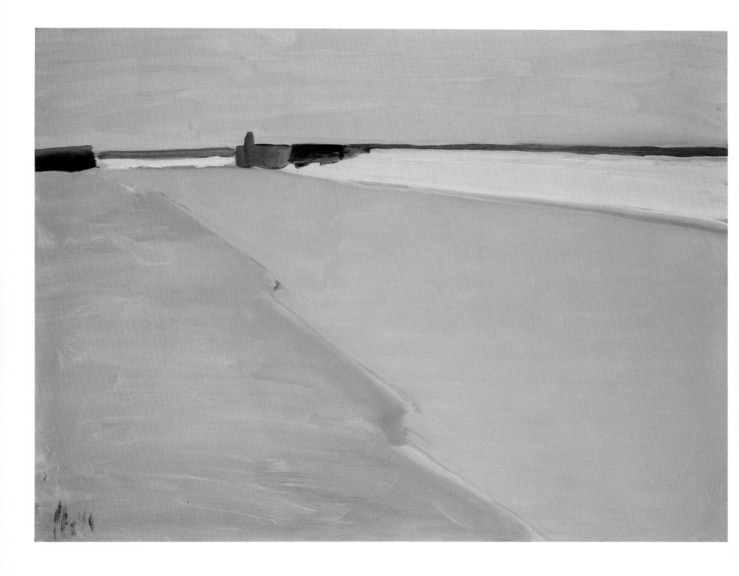

97 Le saladier, 1954*

Huile sur toile
54 × 65
s.b.d. : Staël
Mr. and Mrs. Paul Mellon, Upperville,
Virginie

Oil on canvas
54 × 65
s.l.r. : Staël
Mr. and Mrs. Paul Mellon, Upperville,
Virginia

HIST.
Jacques Dubourg, Paris

EXP.
U.S.A. 1955-1956, n° 22
Paris 1956, n° 84, repr. pl. XVII
Berne 1957, n° 78
Rotterdam/Zurich 1965, n° 78, repr.
Boston/Chicago/New York 1965-1966,
n° 64, repr.
Saint Paul 1972, n° 87, repr. p. 128

BIBL.
Cooper 1956, p. 142
Landini 1956, p. 77
Wescher 1956, p. 19
Chastel 1968, n° 914, repr. p. 352
Archives Maeght 1972, repr. p. 128,
n° 87

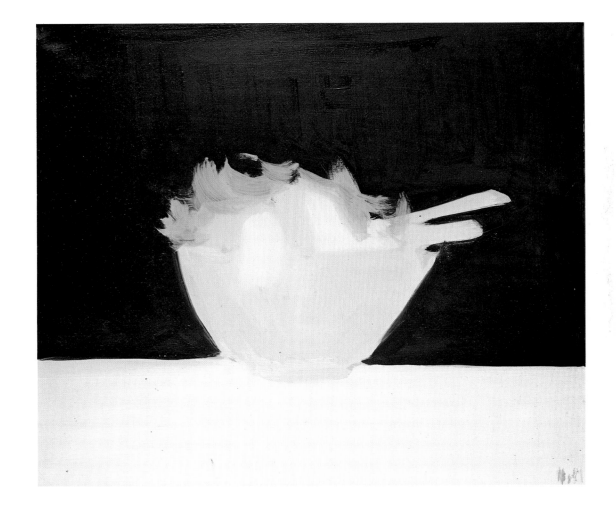

98 Kakis et verre, 1954

Huile sur toile
65 × 81
s.b.g. : : Staël
Collection particulière

Oil on canvas
65 × 81
s.l.l. : Staël
Private collection

HIST.
Jacques Dubourg, Paris
Tooth, Londres

EXP.
Londres 1956, n° 17
Londres 1956, n° 46, repr.
Edimbourg 1956, n° 329

BIBL.
Chastel 1968, n° 924, repr. p. 355

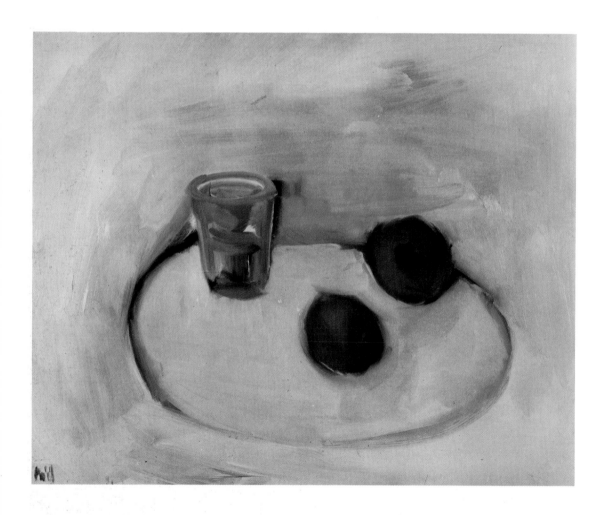

99 Coin d'atelier à Antibes, 1954

Huile sur toile
130 × 89
s.b.g. : Staël
Kunstmuseum, Berne

Oil on canvas
130 × 89
s.l.l. : Staël
Kunstmuseum, Bern

HIST.
Jacques Dubourg, Paris
Dr Nathan, Zurich

EXP.
Saint Paul 1972, n° 88, repr. coul.
p. 135

BIBL.
Chastel 1968, n° 951, repr. p. 358 et
coul. p. 359
Archives Maeght 1972, repr. coul.
p. 135, n° 88

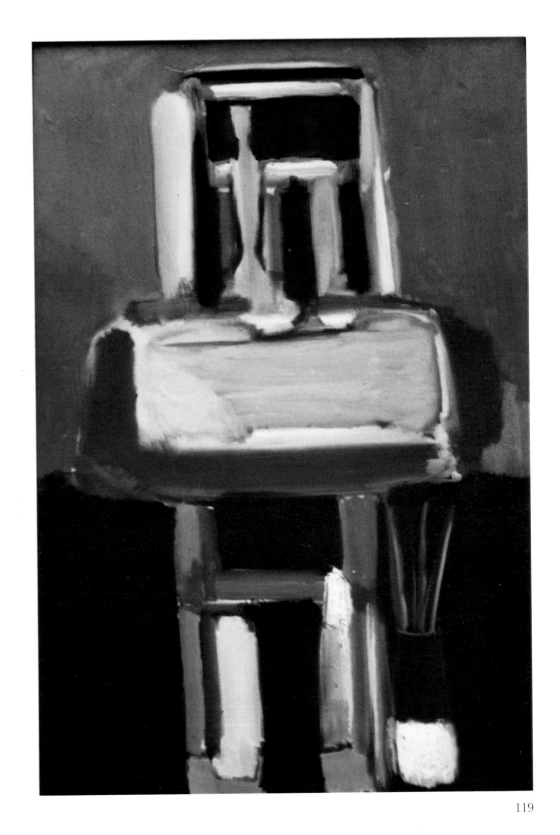

100 Nu gris de dos, 1954*

Huile sur toile
162 × 97
Collection particulière

Oil on canvas
162 × 97
Private collection

EXP.
Antibes 1955, n° 5
Paris 1956, n° 91, repr. pl. XIX
Saint Paul 1972, n° 89, repr. p. 129

BIBL.
Granville 1965, repr. coul. p. 96
Chastel 1968, n° 961, repr. p. 365
Archives Maeght 1972, repr. p. 129,
n° 89

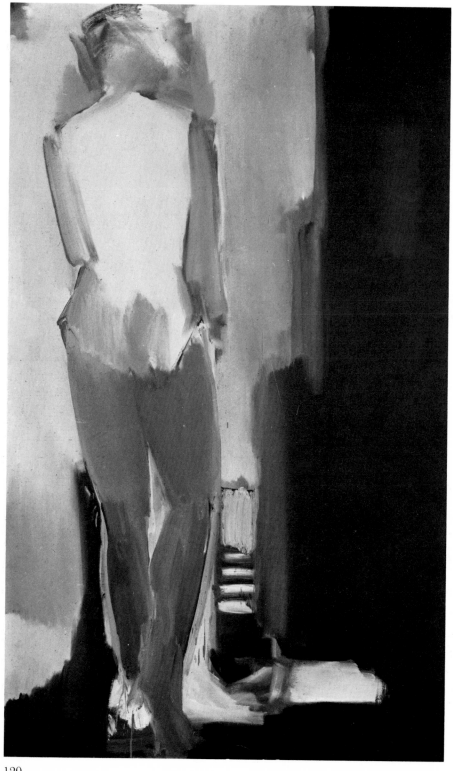

101 Ciel, 1954*

Huile sur toile
130 × 89
Collection particulière

Oil on canvas
130 × 89
Private collection

BIBL.
Chastel 1968, n° 962, repr. p. 365

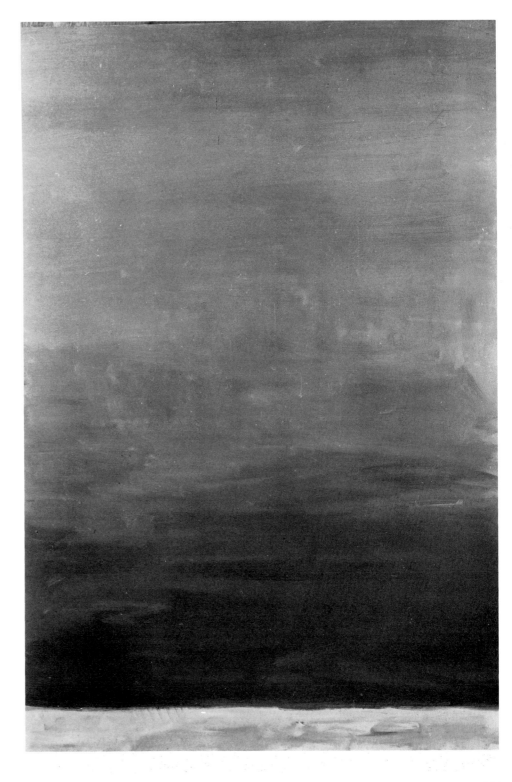

102 Marine claire, 1955*

Huile sur toile
33 × 22
Collection particulière

Oil on canvas
33 × 22
Private collection

EXP.
Saint Paul 1972, n° 90, repr. p. 130

BIBL.
Chastel 1968, n° 971, repr. p. 368
Archives Maeght 1972, repr. p. 130, n° 90

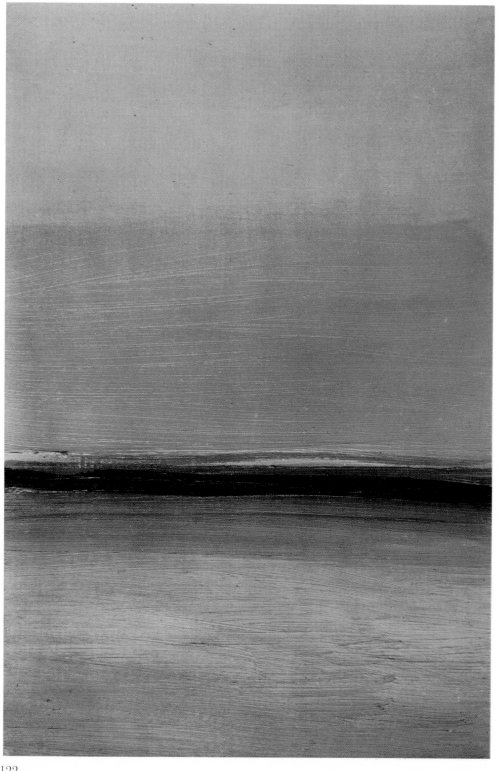

103 Marine foncée, 1955*

Huile sur toile
33 × 22
Collection particulière

Oil on canvas
33 × 22
Private collection

EXP.
Antibes 1955, n° 8
Saint Paul 1972, n° 91, repr. p. 131

BIBL.
Chastel 1968, n° 972, repr. p. 369
Archives Maeght 1972, repr. p. 131,
n° 91

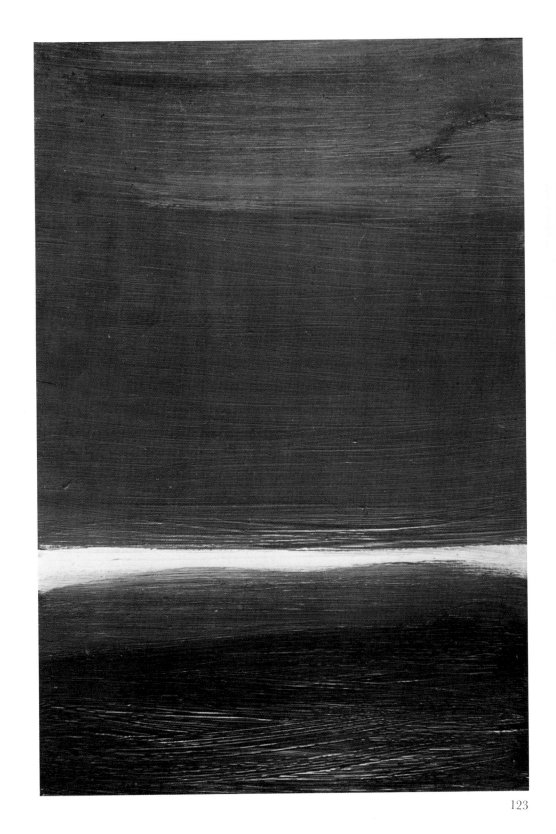

104 Nature morte au fond bleu, 1955*

Huile sur toile
89 × 130
s.b.g. : Staël
Musée Picasso, Antibes

Oil on canvas
89 × 130
s.l.l. : Staël
Musée Picasso, Antibes

EXP.
Antibes 1955, n° 7

BIBL.
Grenier 1955, repr. p. 48
Tudal 1958, repr. p. 53
Chastel 1968, n° 979, repr. p. 371

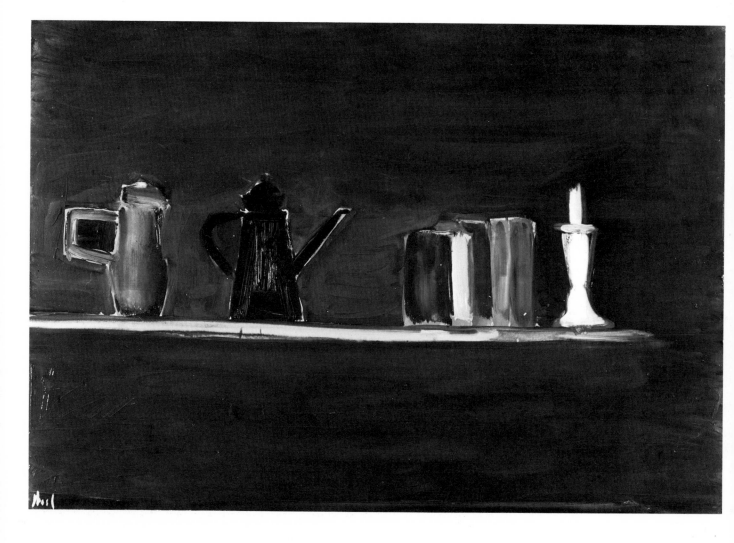

105 L'étagère, 1955*

Huile sur toile
88,5 × 116
s.b.d. : Staël
Museum Ludwig, Cologne

Oil on canvas
88,5 × 116
s.l.r. : Staël
Museum Ludwig, Köln

HIST.
Jacques Dubourg, Paris

EXP.
Antibes 1955
Paris 1956, n° 88
Hanovre/Hambourg 1959-1960, n° 70,
repr. p. 42
Turin 1960, n° 98, repr. p. 128
Saint Paul 1972, n° 94, repr. coul.
p. 136

BIBL.
Wescher 1956, p. 19
Cooper 1961, p. 74
Chastel 1968, n° 983, repr. p. 374
Archives Maeght 1972, repr. coul.
p. 136, n° 94

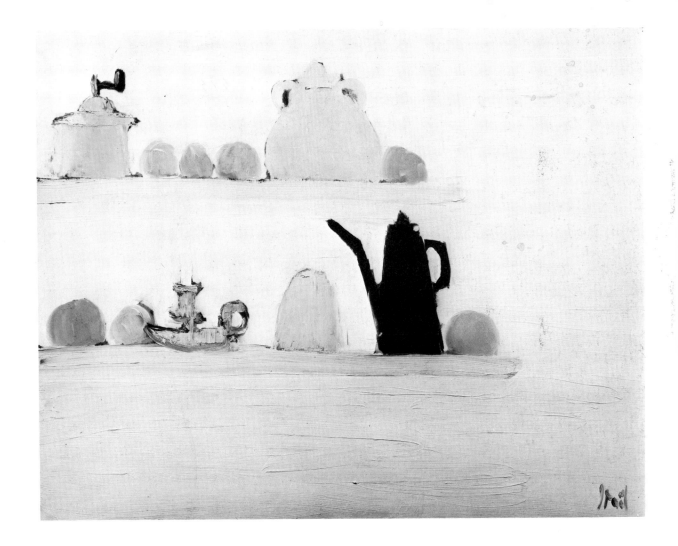

106 Nature morte au poêlon blanc, 1955*

Huile sur toile
60 × 81
s.b.d. : Staël
Collection particulière

Oil on canvas
60 × 81
s.l.r. : Staël
Private collection

HIST.
Jacques Dubourg, Paris

EXP.
Paris 1955, n° 169
Antibes 1955
Rotterdam/Zurich 1965, n° 85 repr.

BIBL.
Zervos 1955, repr. p. 268
Chastel 1968, n° 985, repr. p. 374

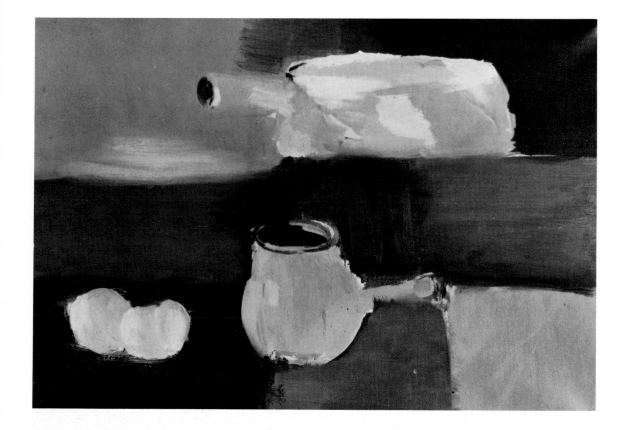

107 Le pain, 1955*

Huile sur toile
73 × 100
s.h.g. : Staël
Collection particulière

Oil on canvas
73 × 100
s.u.l. : Staël
Private collection

BIBL.
Chastel 1968, n° 988, repr. p. 374

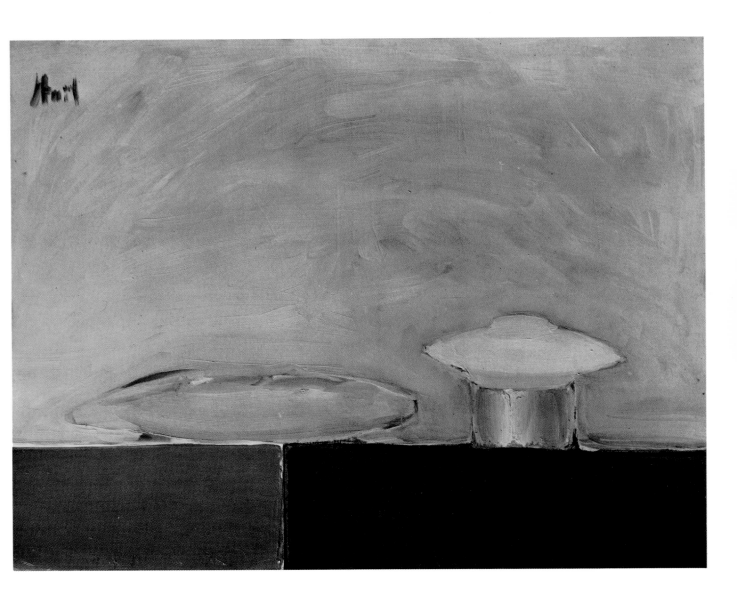

108 Cannes, 1955 *

Huile sur toile
89 × 116
Collection particulière, Lugano

Oil on canvas
89 × 116
Private collection, Lugano

BIBL.
Chastel 1968, n° 993, repr. p. 375

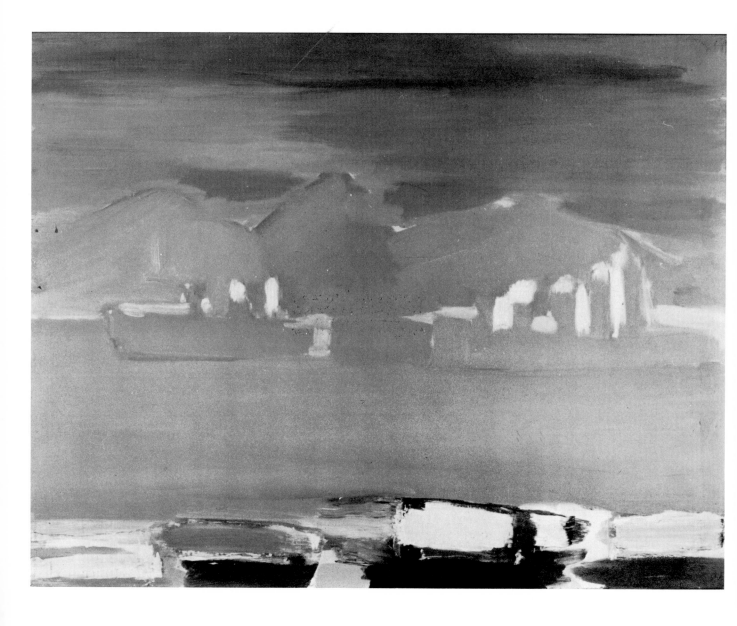

109 Chemin de fer au bord de la mer, soleil couchant, 1955

Huile sur toile
73 × 100
s.b.g. : Staël
M. et Mme Paul Dufrien, Londres

Oil on canvas
73 × 100
s.l.l. : Staël
Mr and Mrs Paul Dufrien, London

HIST.
Jacques Dubourg, Paris
Tooth, Londres

EXP.
Londres 1956, n° 2
Hanovre/Hambourg 1959-1960, n° 73
Edimbourg 1967, n° 30

BIBL.
Granville 1965, repr. coul. p. 97
Chastel 1968, n° 1008, repr. p. 379

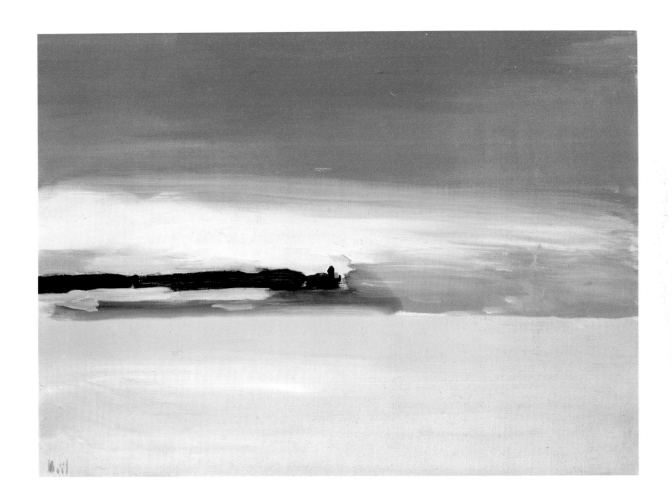

110 La bouteille noire, 1955

Huile sur toile
73 × 100
s.h.g. : Staël
Collection particulière, Zurich

Oil on canvas
73 × 100
s.u.l. : Staël
Private collection, Zurich

HIST.
Jacques Dubourg, Paris

EXP.
Antibes 1955, n° 1
Berne 1957, n° 84
Hanovre/Hambourg 1959-1960, n° 69,
repr. p. 45
Turin 1960, n° 95, repr. p. 125 et coul.
pl. IX
Rotterdam/Zurich 1965, n° 77, repr.
Boston/Chicago/New York 1965-1966,
n° 63, repr.
Zurich 1976, n° 22, repr. coul.

BIBL.
Zervos 1955, repr. p. 275
Cabanne 1962, repr. p. 6
Chastel 1968, n° 1016, repr. p. 380

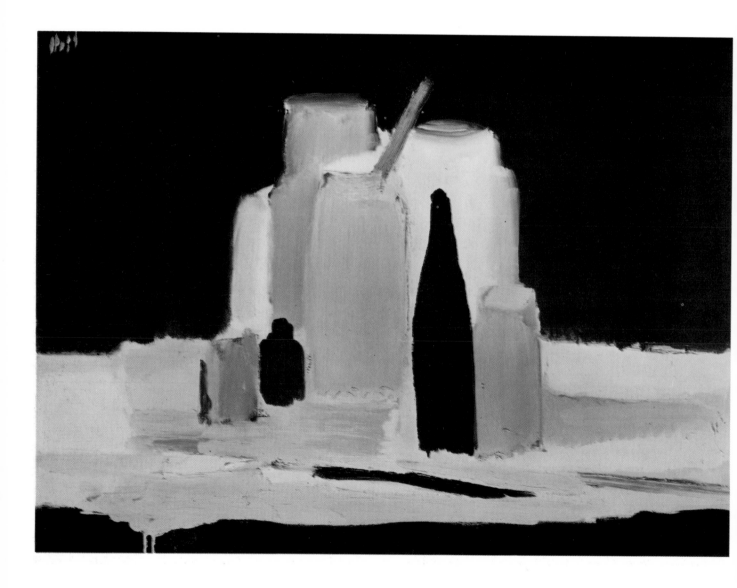

111 Bouteilles rouges, 1955

Huile sur toile
73 × 100
Collection particulière

Oil on canvas
73 × 100
Private collection

EXP.
Bâle 1964, n° 37, repr.

BIBL.
Chastel 1968, n° 1021, repr. p. 381 et
coul. p. 377

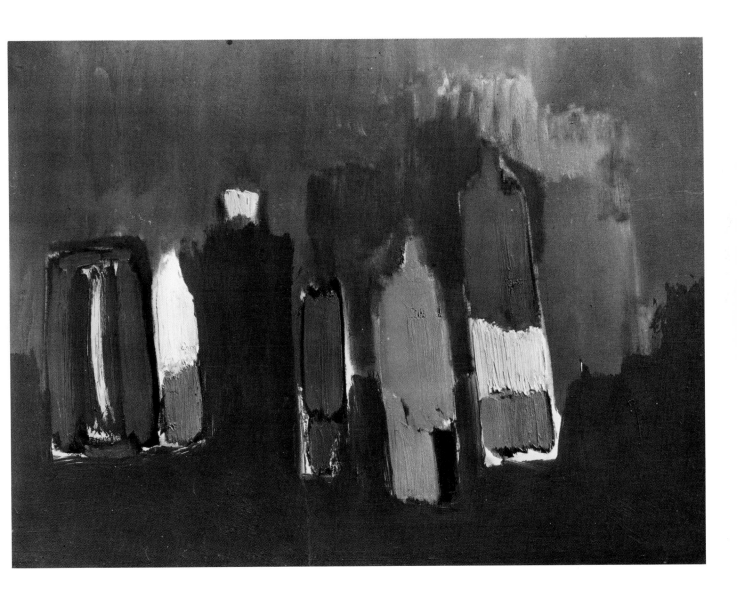

112 Barques dans le port, 1955

Huile sur toile
73 × 100
s.b.g. : Staël
Collection particulière, Zurich

Oil on canvas
73 × 100
s.l.l. : Staël
Private collection, Zurich

HIST.
Madame Jacques Dubourg, Paris

EXP.
Paris 1965, n° 87
Londres 1956, n° 42, repr.
Berne 1957, n° 79
Genève 1967, n° 41, repr. p. 29
Paris 1969, n° 20
Saint Paul 1972, n° 96, repr. coul.
p. 144

BIBL.
Zervos 1955, repr. p. 272
Granville 1965, repr. coul. p. 96
Chastel 1968, n° 1014, repr. p. 384
Archives Maeght 1972, repr. coul.
p. 144, n° 96
Dumur 1975, repr. coul. p. 82

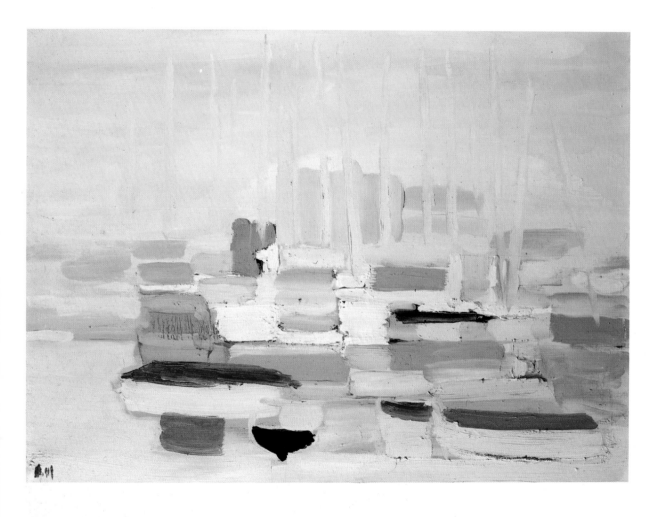

113 Bateaux, 1955*

Huile sur toile
116 × 89
s.b.d. : Staël
Collection particulière

Oil on canvas
116 × 89
s.l.r. : Staël
Private collection

EXP.
Antibes 1955
Paris 1956, n° 90
Turin 1960, n° 102, repr. p. 132
Bâle 1964, n° 35, repr. coul. couv.
Rotterdam/Zurich 1965, n° 94, repr.
Boston/Chicago/New York 1965-1966,
n° 77, repr.
Saint Paul 1972, n° 97, repr. p. 142

BIBL.
Tudal 1958, repr. coul. p. 51
Chastel 1968, n° 1044, repr. p. 385
Deschamps 1971, repr. coul. p. 15
Archives Maeght 1972, repr. p. 142,
n° 97

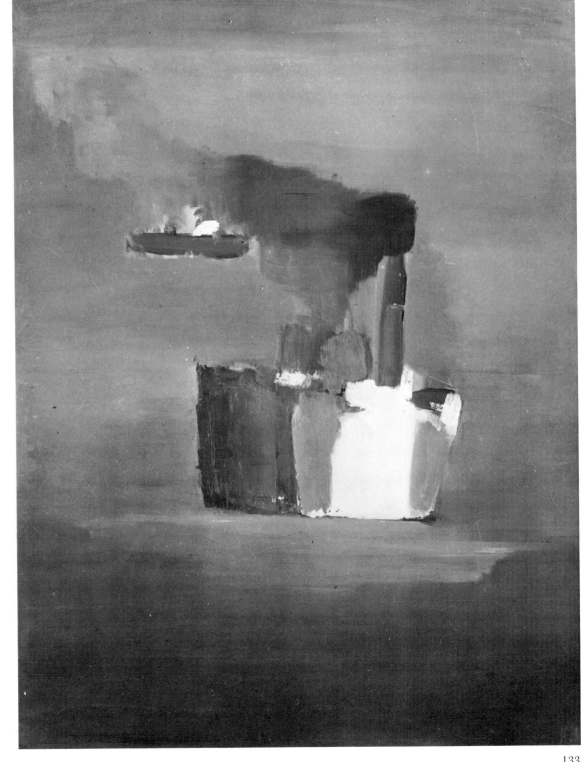

114 Coin d'atelier, fond bleu, 1955

Huile sur toile
195 × 114
s.b.g. : Staël
Collection particulière

Oil on canvas
195 × 114
s.l.l. : Staël
Private collection

EXP.
Paris 1955, n° 170
Antibes 1955, n° 9
Paris 1956, n° 95
Londres 1956, n° 48, repr. frontispice
Paris 1957, n° 20
Berne 1957, n° 82, repr.
Arles 1958, n° 63, repr. pl. XVI
Hanovre/Hambourg 1959-1960, n° 74,
repr. p. 47
Turin 1960, repr. coul. couv., n° 108,
repr. p. 138
Bâle 1964, n° 34, repr. coul.
Rotterdam/Zurich 1965, n° 87, repr.
coul.

Boston/Chicago/New York 1965-1966,
n° 72, repr. coul.
Saint Paul 1972, n° 98, repr. p. 134

BIBL.
Gindertaël 1955, repr. p. 8
Zervos 1955, repr. p. 267
Cooper 1956, p. 145, repr. p. 138
Gindertaël 1960, repr. coul. pl. 10
Cooper 1961, p. 74, repr. coul. pl. 68
Guichard-Meili 1966, repr. coul. pl. 15
Sutton 1966, repr. p. 3
Chastel 1968, n° 1045, repr. p. 386
Archives Maeght 1972, repr. p. 134,
n° 98

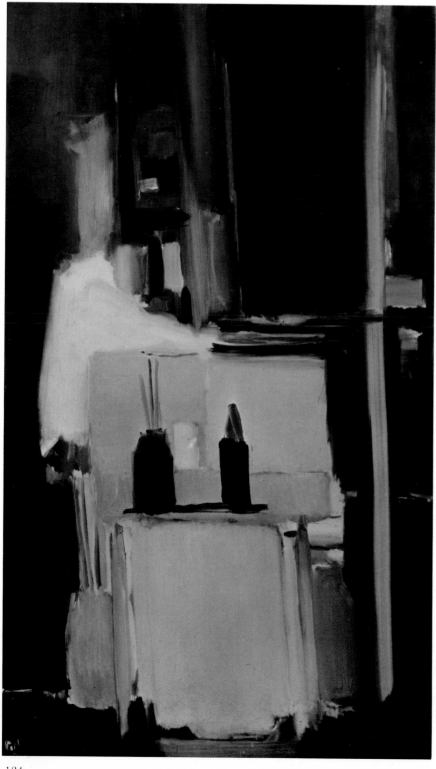

115 La cathédrale, 1955*

Huile sur toile
195 × 130
s.b.d. : Staël
Collection particulière

Oil on canvas
195 × 130
s.l.r. : Staël
Private collection

EXP.
Antibes 1955, n° 3
Berne 1957, N° 83
Arles 1958, n° 62, repr. p. XIV
Turin 1960, n° 106, repr. p. 136
Bâle 1964, n° 38, repr. coul.
Rotterdam/Zurich 1965, n° 90, repr.
coul.
Boston/Chicago/New York 1965-1966,
n° 74, repr. coul.
Saint Paul 1972, n° 99, repr. p. 137

BIBL.
Cooper 1956, p. 145
Cooper 1961, pp. 63-74, repr. coul.
pl. 67
Granville 1965, repr. coul. p. 96
Chastel 1968, n° 1047, repr. p. 390
Archives Maeght 1972, repr. p. 137,
n° 99

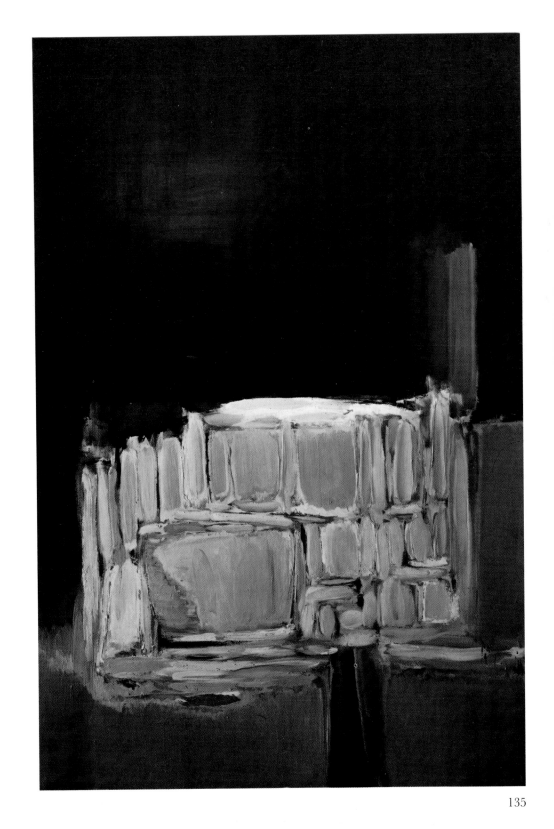

116 Nu couché, 1955

Huile sur toile
114 × 162
Collection particulière

Oil on canvas
114 × 162
Private collection

EXP.
Antibes 1955, n° 4
Paris 1956, n° 92
Turin 1960, n° 133, repr. p. 133
Rotterdam/Zurich 1965, n° 93, repr.
Saint Paul 1972, n° 100, repr. p. 138

BIBL.
Zervos 1955, repr. p. 268
Sutton 1966, repr. coul. pl. XVI
Chastel 1968, n° 1049, repr. pp. 392-
393
Archives Maeght 1972, repr. p. 138,
n° 100

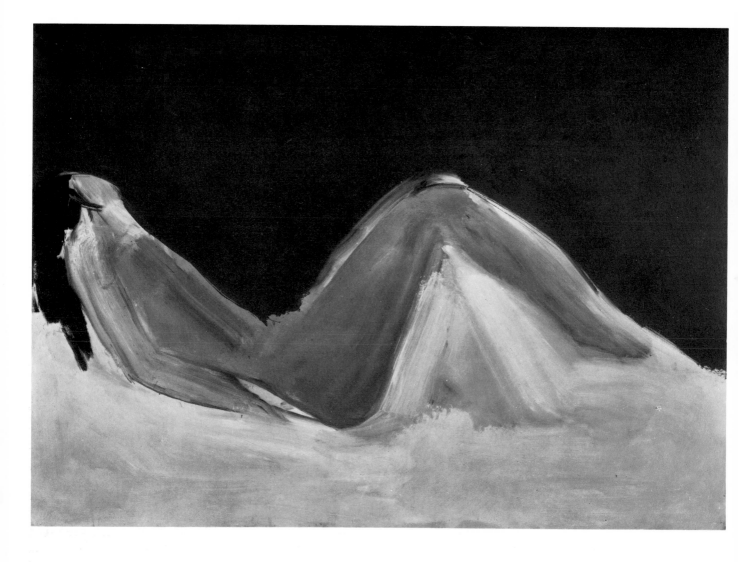

117 Le Fort d'Antibes, 1955

Huile sur toile
130 × 89
Madame Jacques Dubourg, Paris

Oil on canvas
130 × 89
Mrs Jacques Dubourg, Paris

EXP.
Rotterdam/Zurich 1965, n° 91, repr.
Boston/Chicago/New York 1965-1966,
n° 73, repr.
Paris 1969, n° 21
Saint Paul 1972, n° 102, repr. p. 145

BIBL.
Grenier 1955, repr. p. 51
Zervos 1955, repr. p. 273
Chastel 1968, n° 1053, repr. p. 395 et
coul. p. 387
Archives Maeght 1972, repr. coul.
p. 145, n° 102
Dumur 1975, repr. coul. p. 145, n° 102

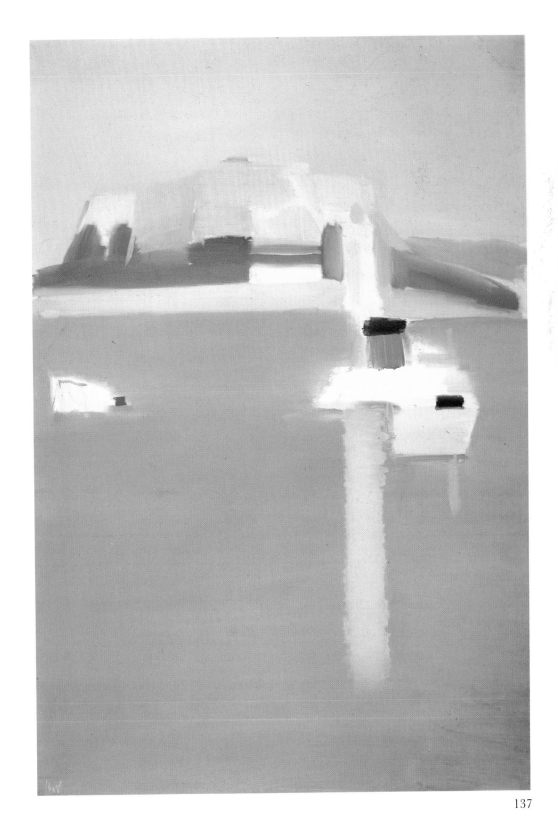

118 Les mouettes, 1955*

Huile sur toile
195 × 130
Collection particulière

Oil on canvas
195 × 130
Private collection

EXP.
Antibes 1955
Paris 1956, n° 89, repr. pl. XVIII
Londres 1956, n° 43, repr.
Arles 1958, n° 60
Turin 1960, n° 107, repr. p. 137
Rotterdam/Zurich 1965, n° 92, repr.
Boston/Chicago/New York 1965-1966,
n° 76, repr.
Saint Paul 1972, n° 101, repr. p. 147

BIBL.
Bigongiari 1960, repr. p. 23
Cooper 1961, pp. 63-74, repr. pl. 60
Grojnowski 1966, p. 949
Sutton 1966, repr. coul. pl. XIII
Chastel 1968, n° 1050, repr. p. 394
Archives Maeght 1972, repr. p. 147, n° 101
Dumur 1975, repr. coul. p. 85

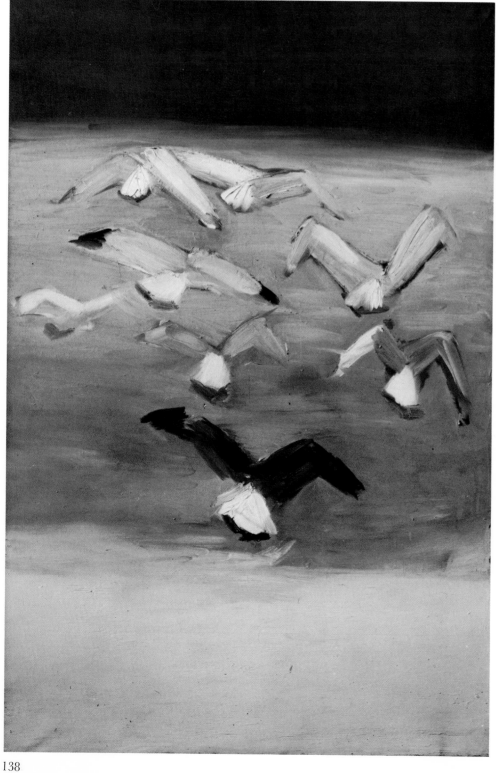

119 Poissons, 1955*

Huile sur toile
89 × 116
Collection particulière

Oil on canvas
89 × 116
Private collection

EXP.
Bâle 1964, n° 43, repr.

BIBL.
Grenier 1955, repr. p. 51
Chastel 1968, n° 1054, repr. p. 395 et
coul. p. 388

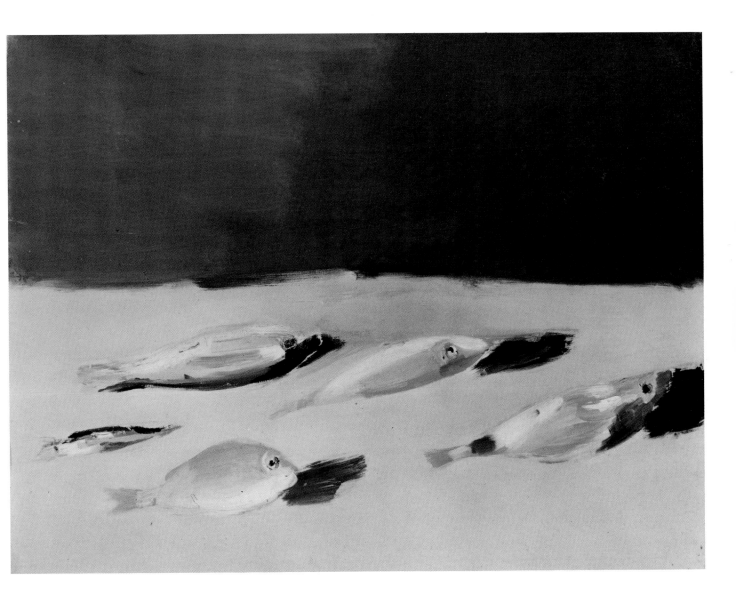

120 Le concert, 1955

Huile sur toile
350 × 600
Collection particulière
Dépôt au Musée National
d'Art Moderne, Paris

Oil on canvas
350 × 600
Private collection
On loan to Musée National d'Art
Mŏderne, Paris

BIBL.
Granville 1965, p. 88
Sutton 1966, p. 5
Chastel 1968, n° 1059, repr. p. 395 et
coul. p. 397
Archives Maeght 1972, repr. p. 148,
n° 104
Dumur 1975, repr. coul. p. 86-87

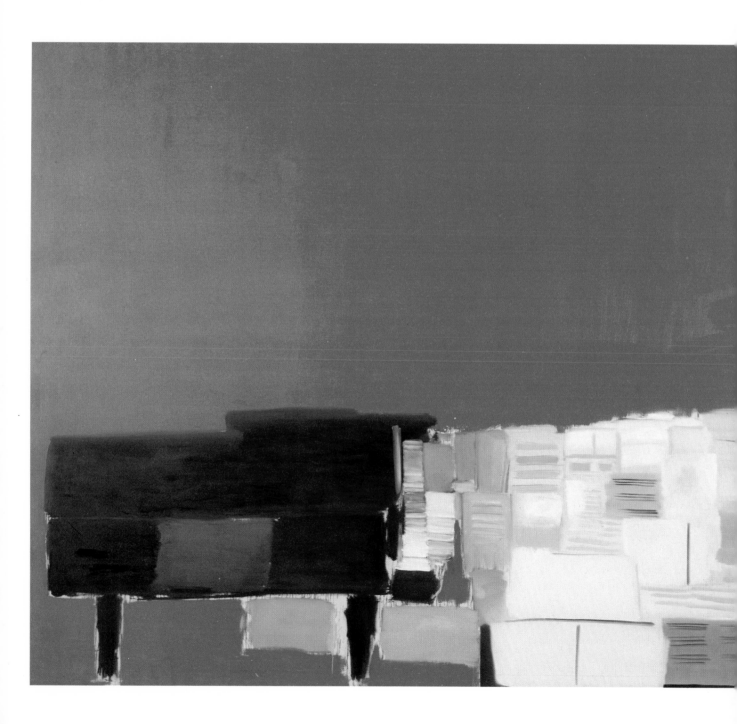

120a Marathon, 1948

Huile sur toile
81 × 65
s.b.g. Stael
Tate Gallery

Oil on canvas
81 × 65
signed bottom left 'Stael'
Tate Gallery

BIBL.
Chastel 1968, nº 134, repr. p. 99

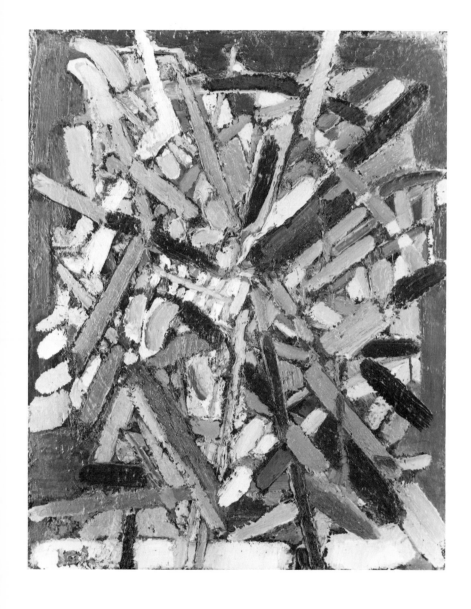

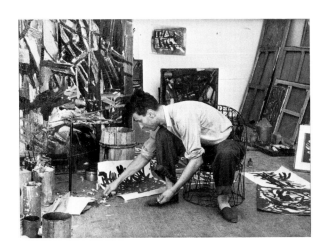

There is no danger of over-emphasising the need for enlargement and dramatisation that forms the basis of de Staël's artistic temperament. He prefers big formats because they retain a vertical essence, a quality of immense stillness; because they break and force out all superfluity, and hence attain monumental force. Though his manner of drawing is often delicate and refined, the result is unfailingly powerful. Let him once yield to his violence: it is seated at the nape of his neck: light tautens, space splits, and the artist's hand forcibly leads to its destiny a mysterious work of art, which he holds by its endlessly quivering strands. But although one can grasp the full richness of this art, we have no access to its intimacy. It would be useless to try and seize upon de Staël's work with hopes of unearthing its most disturbing qualities or extracting from it an account of modern man's spiritual experiences.

These drawings will never constitute a record of the qualities of three-dimensional art. For when we are on the point of believing that we have access to the painter, by means of a certain line, inflexion, or cipher, leading to a brief instant of intimacy with him, he suddenly throws us back into confusion by withdrawing all signs of this complicity: currents of air seem to descend upon us and bring us to the bedrock of new perspectives. The artist's individuality all but ceases to seem worth mentioning. For it is obliterated by the language he speaks, and the forms he displays: this enigma, this chiromancy, this graphology constitute in themselves the Language, the Form and the Word that a certain hand once traced according to the instructions of a mysterious decree once given. And though the force of this hand is individual, the sign obtained is transcendant. Subjective instinct twists, shatters, and knots these lines with its passionate invention, while the spirit endows the resulting structure with all the surging powers, logic, and certainty of nature herself.

Pierre Lecuire, Paris 1948
Extract translated from *L'Art qui vient à l'avant*

121 La presse à bras, 1946*

Pinceau, plume et encre de
chine sur papier
73 × 107
s.d.b.g. : Staël 1946
Musée des Beaux Arts, Dijon,
Donation Granville

*Brush, pen and indian ink on
paper*
73 × 107
s.d.l.l. : Staël 1946
*Beaux Arts Museum, Dijon, Donation
Granville*

HIST.
Atelier de l'artiste ; acquis en 1951

EXP.
Paris 1951
Paris 1956, n° 109
Paris 1958, n° 18, repr. pl. XI
Turin 1960, n° 18, repr. p. 48
Rotterdam/Zurich 1965, n° 114, repr.
Boston/Chicago/New York 1965-1966
n° 90
Saint Paul 1972, n° 107, repr. p. 14

BIBL.
Landini 1956, repr. fig. 40
Mock 1958, repr. p. 140
Cooper 1961, p. 23
Archives Maeght 1972, repr. p. 14,
n° 107
Lemoine 1976, p. 248, repr.

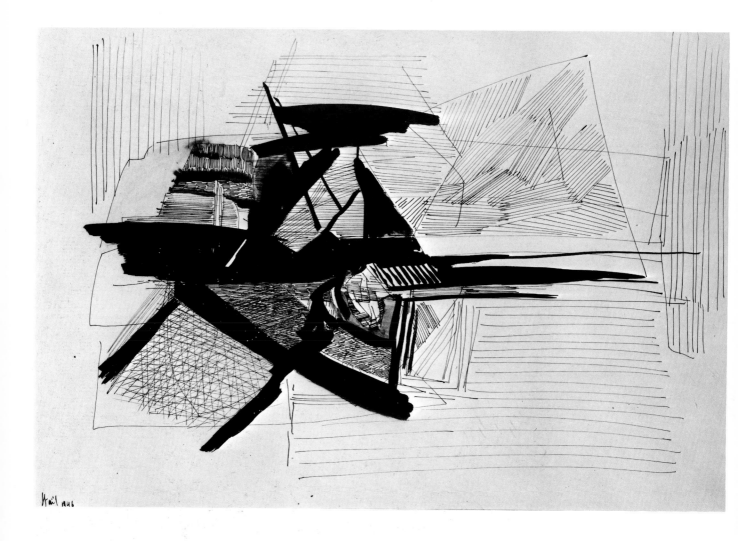

122 Composition, 1947*

Pinceau et encre de chine
sur papier
123 × 93
s.d.b.g. et déd. : Pour Madame
Poulain / bien amicalement / Staël 47
Collection particulière

Brush and indian ink on paper
123 × 93
s.d.l.l. and ded. : To Madame
Poulain / with very best wishes /
Staël 47
Private collection

EXP.
Saint Paul 1972, n° 109, repr. p. 18

BIBL.
Duthuit 1950, repr. p. 383
Archives Maeght 1972, repr. p. 18,
n° 109

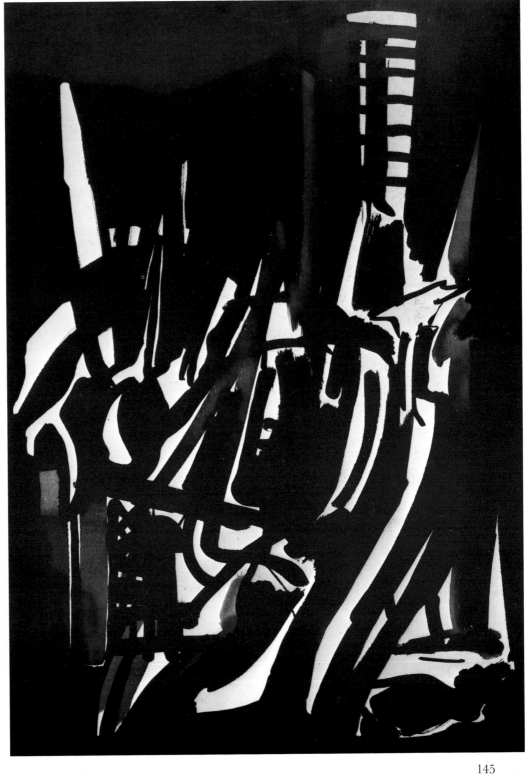

123 Composition, 1947*

Pinceau et encre de chine
sur papier
106 × 75
s.b.g. : Staël et déd. : A Fandre/
Staël 49
Hubert Fandre, Reims

Brush and indian ink on paper
106 × 75
s.l.l. : Staël and ded. : to Fandre/
Staël 49
Hubert Fandre, Reims

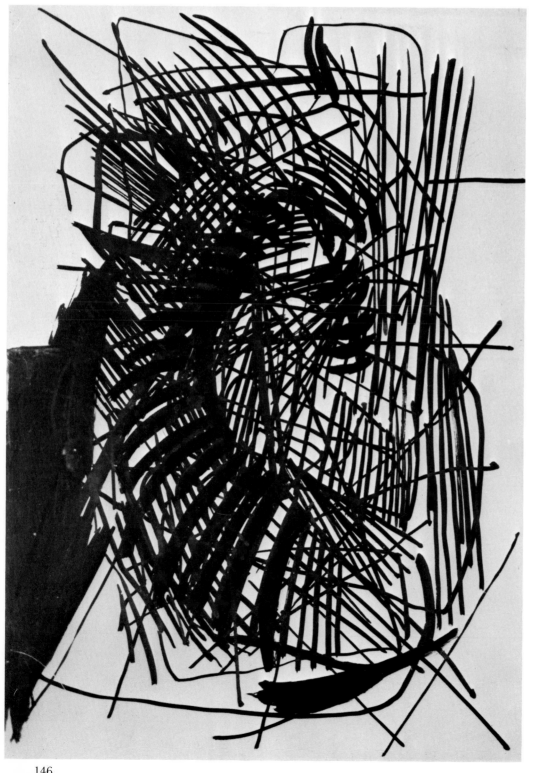

124 Composition, 1948*

Pinceau et encre de chine
sur papier
108 × 74
s.d.b.d. : Staël 48
Collection particulière, Paris

Brush, indian ink on paper
108 × 74
s.d.l.r. : Staël 48
Private collection, Paris

EXP.
Paris 1956, n° 118
Paris 1957, n° 93
Paris 1958, n° 33
Rotterdam/Zurich 1965, n° 119

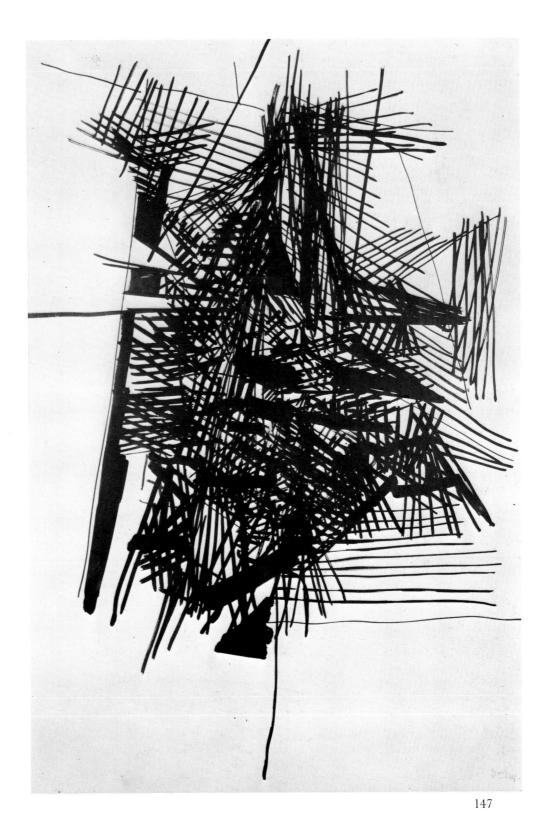

125 L'écorché, 1948*

Pinceau et encre de chine
sur papier
103 × 71
s.d.b.d. : Staël 48
Collection particulière

Brush and indian ink on paper
103 × 71
s.d.l.r. : Staël 48
Private collection

EXP.
Paris 1956, n° 117
Berne 1957, n° 92
Paris 1958, n° 32

BIBL.
Courthion 1952, repr. pl. LX
Art-Documents 1953, repr.

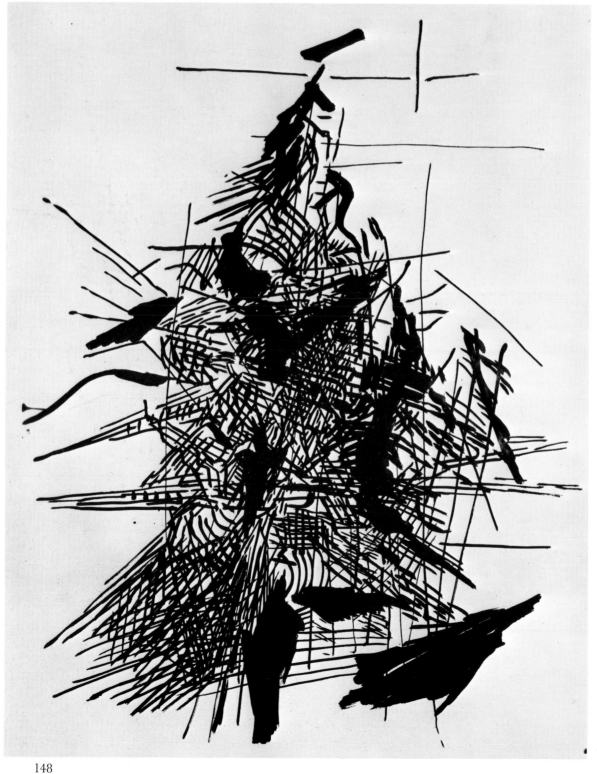

126 Composition, 1948*

Pinceau et encre de chine
sur papier
101 × 74
s.d.b.d. : Staël 48
Collection particulière, Paris

Brush and indian ink on paper
101 × 74
s.d.l.r. : Staël 48
Private collection, Paris

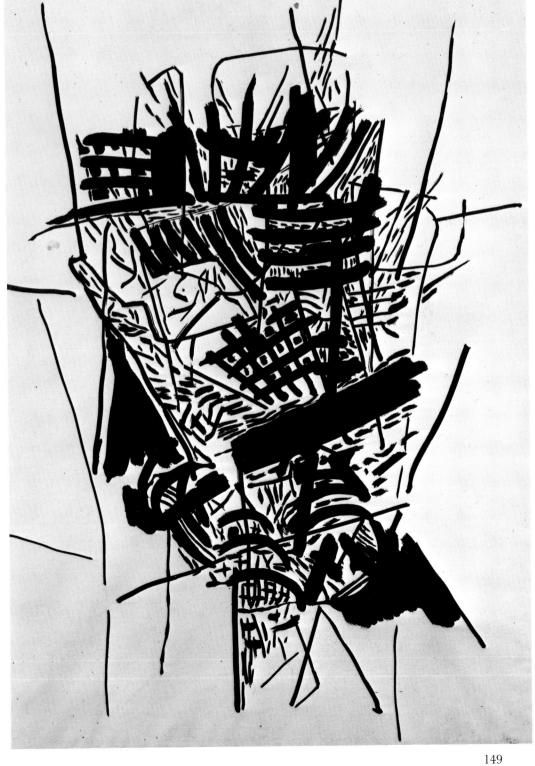

127 Composition, 1948*

Pinceau et encre de chine
sur papier
75 × 105
s.d.b.d. : Staël 48
Collection particulière

Brush and indian ink on paper
75 × 105
s.d.l.r. : Staël 48
Private collection

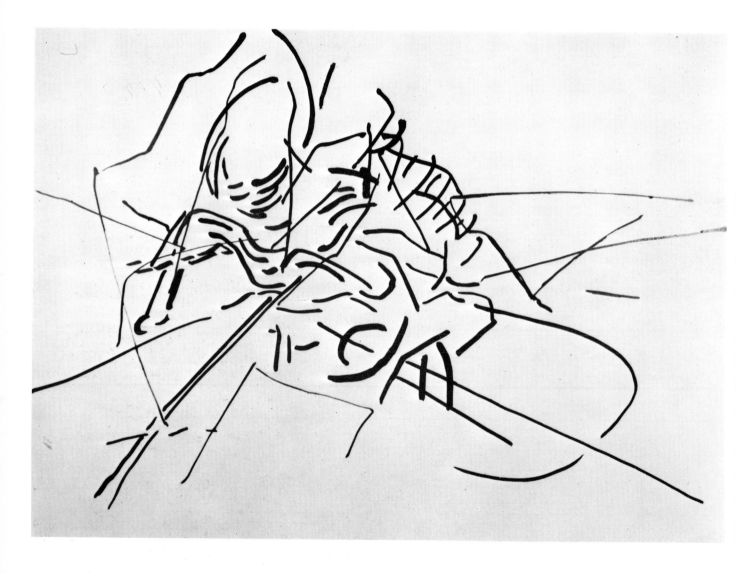

128 Composition, 1948*

Pinceau et encre de chine
sur papier
108 × 74
s.d.b.d. : Staël 49
Galerie Jeanne Bucher. Paris

Brush and indian ink on paper
108 × 74
s.d.l.r. : Staël 49
Jeanne Bucher Gallery, Paris

EXP.
Paris 1956, n° 116
Berne 1957, n° 97
Paris 1958, n° 26, repr.
Hanovre/Hambourg 1959-1960
Turin 1960, n° 20, repr.
Rotterdam/Zurich 1965, n° 121, repr.
Boston/Chicago/New York 1965-1966,
n° 95, repr.
Paris 1979, n° 6, repr.

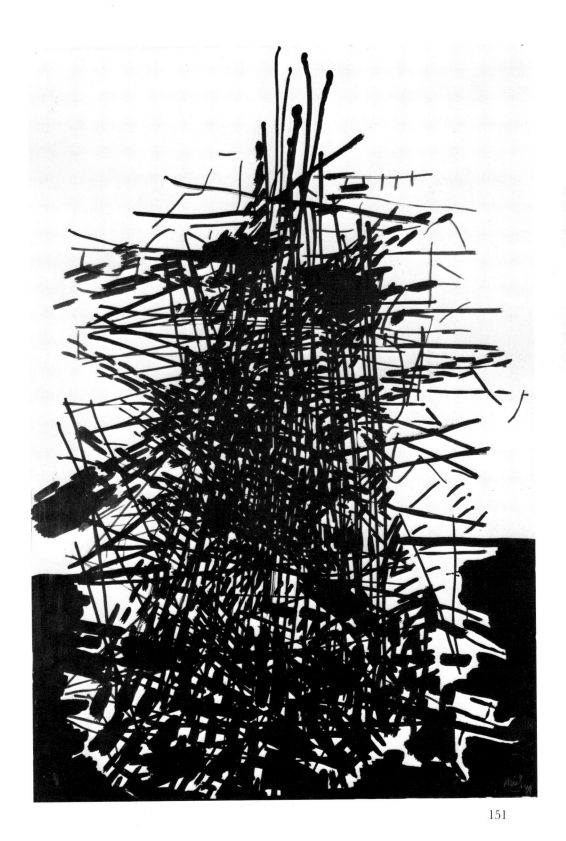

129 Composition, 1948*

Pinceau et encre de chine
sur papier
107 × 74
Collection particulière

Brush and indian ink on paper
107 × 74
Private collection

EXP.
Londres 1952, repr. couv.
Paris 1958, repr. pl. XII
Saint Paul 1972, n° 111, repr. p. 21

BIBL.
Gindertaël 1950, repr. p. 2
Courthion 1952, repr. pl. LIV (sous le
titre : Eclats)
Tudal 1958, repr. p. 35
Archives Maeght 1972, repr. p. 21,
n° 111

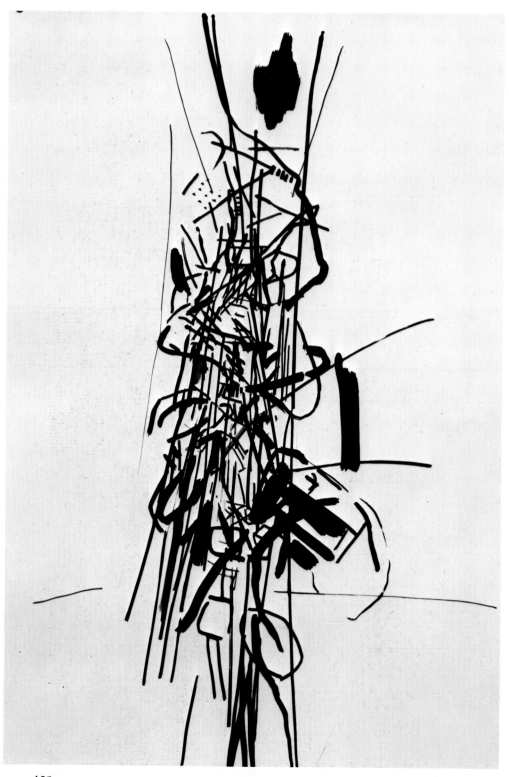

130 Composition, 1948*

Plume, pinceau et encre
de chine sur papier
100 × 70
s.b.d. : Staël
Michel Laval, Reims

*Pen, brush and indian ink on
paper
100 × 70
s.l.r. : Staël
Michel Laval, Reims*

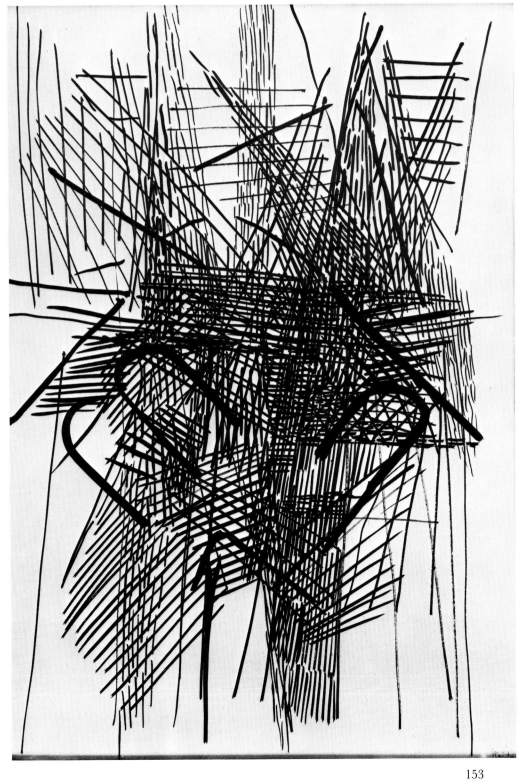

131 Paysage, 1951-1952*

Pinceau et encre de chine
sur papier
120 × 82
s.b.d.
Galerie Jacques Benador, Genève

Brush and indian ink on paper
120 × 82
s.l.r.
Jacques Benador Gallery, Geneva

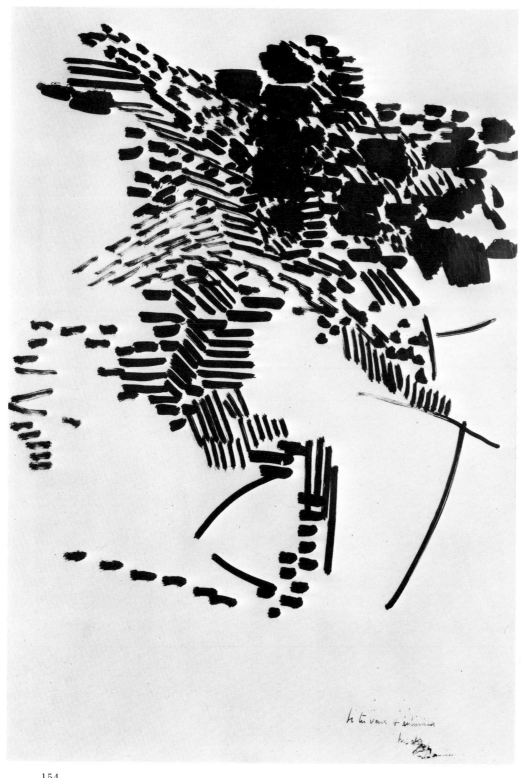

132 Paysage, 1952*

Encre de chine sur papier
107 × 74
s.d.b.d. : Staël 52 ; déd. b.g.
Suzanne Tezenas, Paris

Indian ink on paper
107 × 74
s.d.l.r. : Staël 52 ; ded. l.l.
Suzanne Tezenas, Paris

EXP.
Saint Paul 1972, n° 117, repr. p. 29
Paris 1979, n° 13

BIBL.
Archives Maeght 1972, repr. p. 29,
n° 117

133 La lune, 1952*

Plume et encre de chine
sur papier
100 × 75
s.d.b.d. : Staël 52
Musée des Beaux Arts, Dijon,
Donation Granville

Pen indian ink on paper
100 × 75
s.d.l.r. : Staël 52
Musée des Beaux Arts, Dijon,
Donation Granville

HIST.
Atelier de l'artiste ; acquis en 1952

EXP.
Berne 1957, n° 102
Paris 1958, n° 41
Turin 1960, n° 49, repr.
Rotterdam/Zurich 1965, n° 125, repr.
Saint Paul 1972, n° 118, repr. p. 31

BIBL.
Bigongiari 1960, repr. p. 9
Archives Maeght 1972, repr. p. 31,
n° 118
Lemoine 1976, p. 272, repr.

134 Arbre, 1954*

Pinceau et encre de chine
sur papier
108 × 75
s.d.b.g. : Staël 54
Collection particulière

Brush and indian ink on paper
108 × 75
s.d.l.l. : Staël 54
Private collection

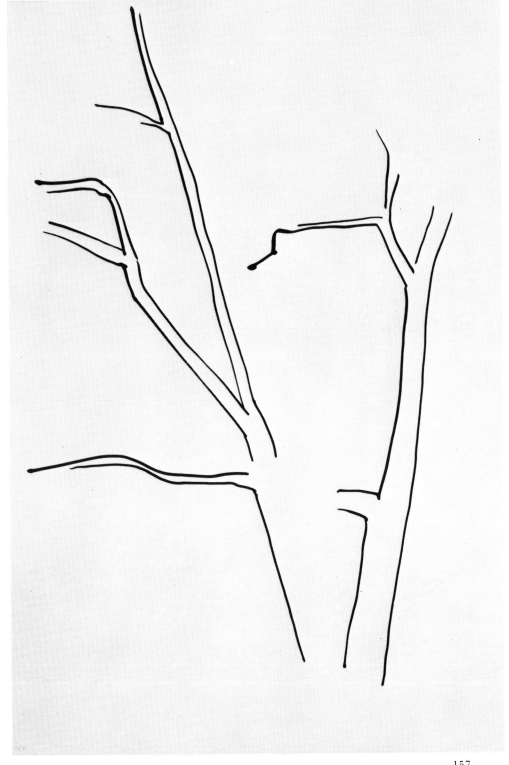

135 Arbre, 1954*

Pinceau et encre de chine
sur papier
108 × 75
s.d.b.g. : Staël 54
Collection particulière

Brush and indian ink on paper
108 × 75
s.d.l.l. : Staël 54
Private collection

136 Arbre, 1954*

Pinceau et encre de chine
sur papier
108 × 75
s.d.b.g. : Staël 54
Collection particulière

Brush and indian ink on paper
108 × 75
s.d.l.l. : Staël 54
Private collection

137 Etude de nu, 1954*

Fusain sur papier
150 × 92
Collection particulière

Charcoal on paper
150 × 92
Private collection

EXP.
Berne 1957, n° 101
Paris 1958, n° 40
Arles 1958, n° 89

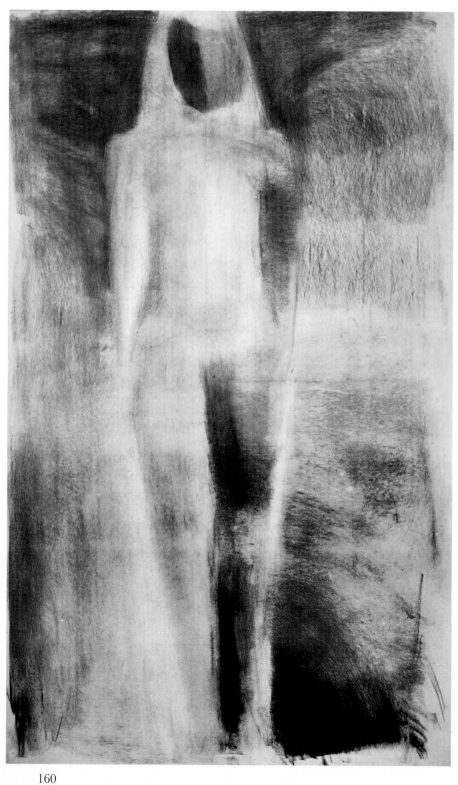

138 Table à palette, 1954*

Fusain sur papier
150 × 104
Collection particulière

Charcoal on paper
150 × 104
Private collection

EXP.
Paris 1956, n° 124
Paris 1958, n° 42
Bâle 1964, n° 67
Rotterdam/Zurich 1965, n° 140, repr.
Saint Paul 1972, n° 121, repr. p. 35
Paris 1979, n° 114, repr.

BIBL.
Guichard-Meili 1966, repr. p. 7
Archives Maeght 1972, repr. p. 35,
n° 121
Dumur 1975, repr. p. 71

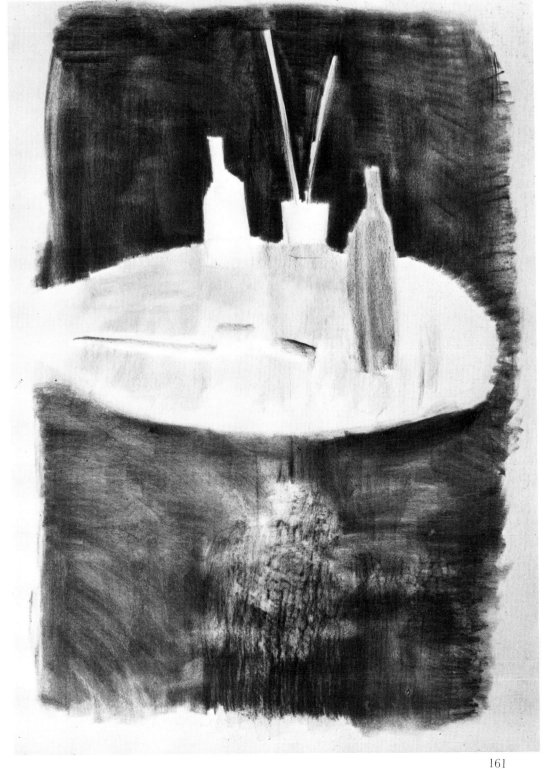

139 Nu couché, 1954-1955*

Fusain sur papier
106 × 149
Dr Peter Nathan, Zurich

Charcoal on paper
106 × 149
Dr. Peter Nathan, Zurich

EXP.
Zurich 1976-1977, n° 25, repr.

BIBL.
Dumur 1975, repr. p. 79

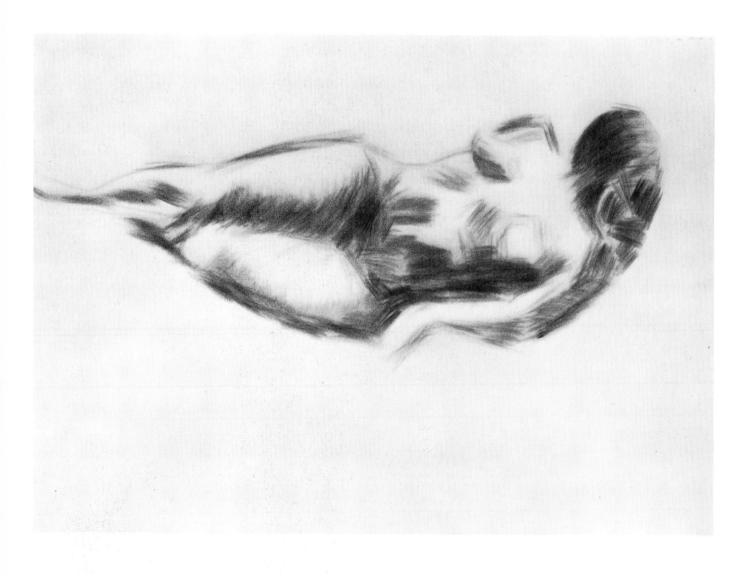

140 Etude de nu, 1955*

Fusain sur papier
150 × 100
Fondation Maeght, Saint Paul

Charcoal on paper
150 × 100
Fondation Maeght. Saint Paul

EXP.
Paris 1979, n° 123

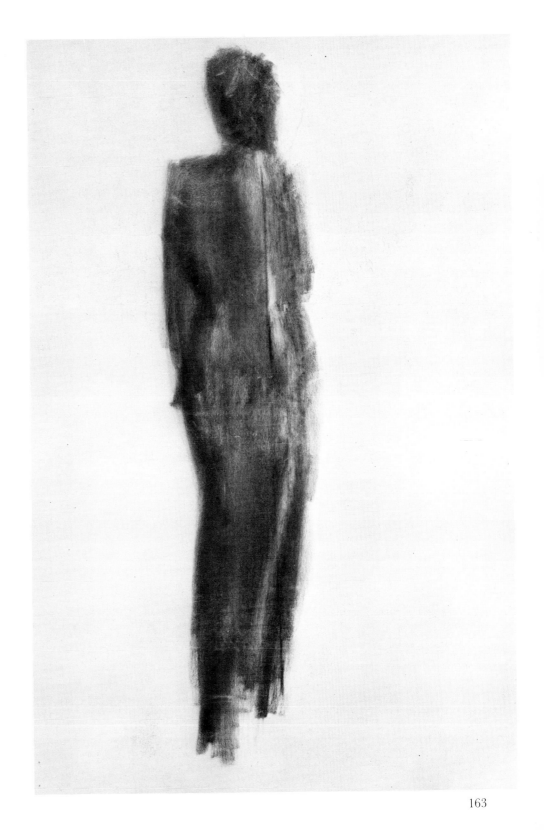

141 Etude de nu, 1955*

Fusain sur papier
150 × 100
Collection particulière

Charcoal on paper
100 × 100
Private collection

EXP.
Antibes 1955, n° 16
Paris 1956, n° 129
Arles 1958, n° 103
Turin 1960, n° 104, repr. p. 134
Rotterdam/Zurich 1965, n° 142, repr.
Boston/Chicago/New York 1965-1966,
n° 118, repr.

BIBL.
Zervos 1955, repr. p. 271
Tudal 1958, repr. p. 37

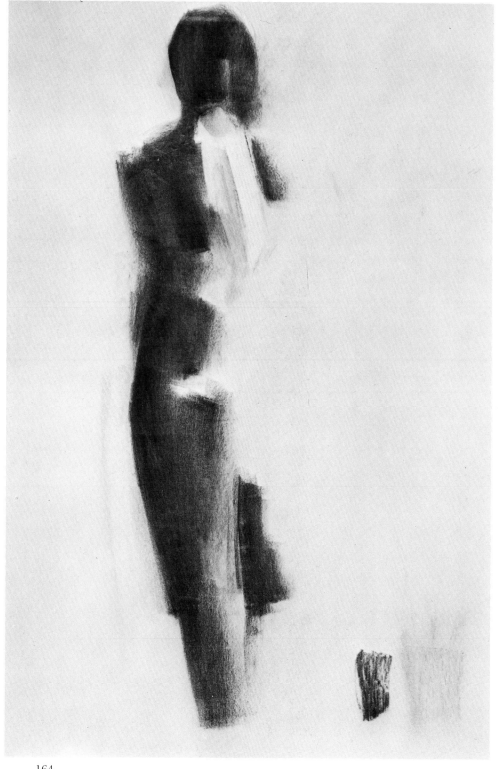

142 Etude de nu, 1955*

Fusain sur papier
150 × 100
Collection particulière

Charcoal on paper
150 × 100
Private collection

EXP.
Antibes 1955
Paris 1956, n° 127
Turin 1960, n° 105, repr. p. 135
Rotterdam/Zurich 1965, n° 141, repr.
Boston/Chicago/New York 1965-1966,
n° 117, repr.
Saint Paul 1972, n° 125, repr. p. 40

BIBL.
Tudal 1958, repr. p. 36
Cooper 1961, repr. pl. 69
Archives Maeght 1972, repr. p. 40,
n° 125
Chastel 1978, repr. p. 467

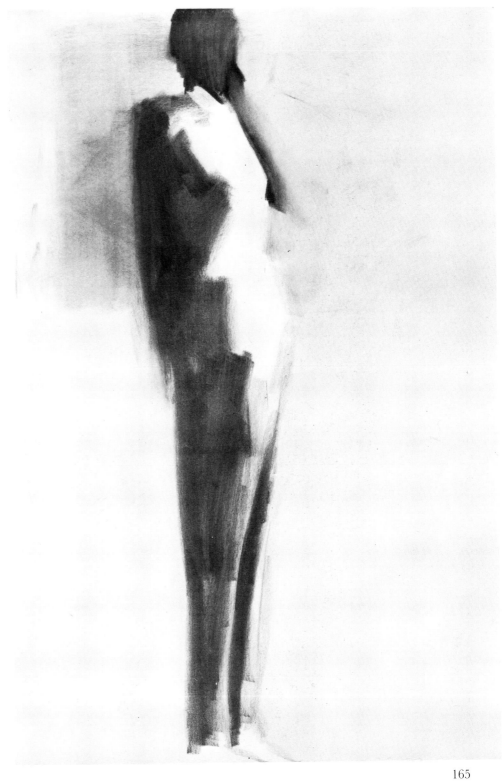

143 Etude de nu avec tête, 1955*

Fusain sur papier
150 × 90
Collection particulière

Charcoal on paper
150 × 90
Private collection

EXP.
Saint Paul 1972, n° 126, repr. p. 41

BIBL.
Archives Maeght 1972, repr. p. 41,
n° 126

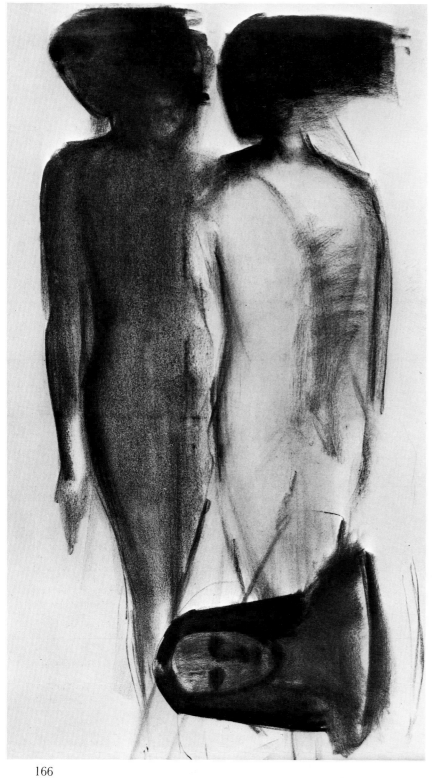

Biographical Notes

1914

Born 5 January, according to the Gregorian calendar (23 December 1913, according to the Julian calendar) at St Petersburg. Nicolas, like his elder sister, Marina, and younger sister, Olga, is the fruit of his father's second marriage late in life.

His father, the Baron Vladimir Ivanovitch de Staël-Holstein, was a major-general and deputy governor of the fortress of Peter and Paul; he came of a distinguished family of Baltic nobles with a long military tradition – the husband of the celebrated woman writer, Madame de Staël, was among his forebears. Staël's mother, Lioubov Berednikoff, came from a wealthy bourgeois family who owned a palace on the Nevsky Prospect. She was a Slav and passionately interested in painting and music; she played the piano and encouraged her son to share her interests and to paint and draw at an early age.

1916

Nicolas is appointed page at the imperial court of Nicolas II.

1917

His father is obliged to resign by the provisional government.

1919

The Soviet Revolution forces the Staël family to leave Russia. They emigrate to Poland; Nicolas' mother runs a home for refugee children and later a soup-kitchen.

1921

21 September: the death of Staël's father aged 68, at Ostrow. Staël's mother, much younger than her husband, becomes ill.

1922

20 August: Madame de Staël dies at Danzig, after entrusting her three children to the care of a friend. They are sent to Brussels where they are brought up by M. and Mme Fricero, rich and hospitable Russian expatriates. With this family Nicolas was to receive the same classical education and training in aristocratic sports that he would have had at the Royal Court.

1922–1930

At the Jesuit school of Saint-Michel in Brussels. Staël's adoptive father hopes to prepare him for a career in the Navy but his tastes tend towards the arts. He is greatly impressed by the Greek tragedies.

1930–1931

Continues his studies at the Cardinal Mercier College at Braine-L'Alleud, near Brussels. Although not particularly intellectual he enjoys Greek and Latin. He has a strong poetic gift and was later to number many writers and poets among his close friends. He is first in French and receives prizes in fencing, swimming and tennis.

1932

October: he enrols in the architecture course at the Académie Saint-Gilles-les-Bruxelles.

1933

June: a trip to Holland where he sees Rembrandts and Philip de Konincks and paints his first watercolours.
October: he begins a course in decoration at the Saint-Gilles Academy and, concurrently, a course in drawing from the antique at the Académie Royale des Beaux-Arts in Brussels.

1934

June: Staël goes to France with a friend from the Beaux-Arts, Alain Haustrate. Discovers Provence and the Midi; then Paris where he is greatly impressed by the painters that are to remain the great exemplars for him: Cézanne, Matisse, Soutine and Braque.

1935

Receives his first commissions and also earns his living as assistant to a mural painter. Collaborates with his teacher, G. de Vlamynck, on murals for the Agriculture and Glass Pavilions at the 1935 International Exhibition in Brussels. The summer and early autumn are spent in Spain and the Balearic Islands; the discovery of El Greco remains an important one for Staël and is clearly manifested in the 'Portrait of Jeannine' 1942 (Cat. 1, Chastel 2).
November: he enters his third and final year at the Beaux-Arts.

1936

February: exhibits icons painted in the Byzantine tradition and watercolours of Spain at the Dietrich Gallery.
June: departs for a long stay in Morocco where he lives among the local people. He visits Fez, Rabat, Casablanca, Kenitra and Marrakesh, but

although he paints many portraits and landscapes he seems to have destroyed most of the work of this period; it is a period of apprenticeship and his thoughts revolve almost entirely around painting.

'One has to find some explanation for *why* one finds beautiful that which is beautiful – a technical explanation. One absolutely must know the laws of colour, know exactly why Van Gogh's apples at the Hague, painted in decidedly foul local colours, seem so splendid, why Delacroix slashed his decorative ceiling nudes with rays of green and yet these nudes seem perfect and the flesh tones brilliant, why Veronese, Velasquez, Franz Hals all used more than 27 blacks and as many whites, why Van Gogh committed suicide, Delacroix died hating himself and Hals became a drunkard in despair – why? What were the reasons? For one small canvas of Van Gogh's in the Hague Museum we have *two* pages of his notes on its orchestration. Each colour has its reason . . .'
(letter to Madame Fricero, 30 November 1936)

Subsequent critics have often remarked on the similarities in development and temperament between Van Gogh and Staël and Staël himself was aware of the parallels.

1937

Marrakesh, Mogador, Si Adallah Riat. Paints assiduously; on the wall of his room in Mogador he pins a Hokusai print:

'It bestows on the room not only the joyfulness of its colours but also the mood for a regulated life, for study'.
(letter to Emmanuel Fricero, Mogador, 24 April 1937)

August: meets Jeannine Guillou, also a painter. They go to Algeria together.

1938

January: the couple go to Italy; Naples, Frascati, Pompei, Paestum, Sorrento and Capri.

'. . . after spending a year trying to paint in that marvellous Morocco – and not coming out of it famously – I am now getting to know, seeing and copying, Titian, El Greco, the beautiful Primitives, the last of the Bellinis, Mantegna, Antonella da Messina, all of them; and even though these paintings are not always as close to my heart as the old Flemish painters, the Dutch, Vermeer, Rembrandt, Van der Meer, I'm learning an enormous amount from them and wish for only one thing: to be able to study them for as long as possible'
(letter to Emmanuel Fricero, Naples, 15 February 1938)

May: they return to France. Staël works in Fernand Léger's atelier for three weeks. The summer is spent with Jeannine's family at Concarneau. Here Staël meets Jeannine's cousin, Jean Deyrolle; a friend of Sérusier, he was at this time questioning the validity of traditional representation and painted in a cubist mode.
September: on their return to Paris they live in a studio at 124, rue du Cherche-Midi. Staël studies and draws at the Louvre; copies of Chardin and Delacroix; reads with interest J. W. Power's theories of pictorial construction. They spend a very difficult winter.

1939

May: at the request of Lucien Fontanarosa, he executes a fresco for the Pavillon de l'Eau at the Liège International Exhibition. Summer at Concarneau.
November: upon the declaration of war, he enlists in the Foreign Legion but receives his mobilisation papers only the following January. During the winter Staël forms a friendship with Hector Sgarbi, a Uruguayan painter who was later to organise a Staël exhibition in Montevideo. He meets Pierre Chareau and the dealer, Jeanne Bucher.

Jeanne Bucher played a central role in the artistic avant garde between the wars; her tastes were discerning and eclectic and at her small gallery she exhibited such artists as Pascin, Lipchitz, Picasso, Braque, Ernst, Mondrian, Kandinsky, Arp, Mirò.

1940

January: Staël is mobilised and sent to Tunisia where he works on ordnance survey maps.
19 September: demobilised at Sousse, he rejoins Jeannine in Nice. Here they become friendly with the painters, Magnelli, Sonia Delaunay, Jean Arp, Le Corbusier; it is a new and stimulating milieu for Staël; they meet frequently to talk about painting and the problems of artistic expression. A friend, Felix Aublet, obtains some decorative work for Staël and Jeannine manages to sell a few paintings but things are still extremely difficult for them materially.

1942

24 February: birth of Anne. Staël finishes the 'Portrait of Jeannine' (Cat. 1, Chastel No. 2). Hereafter Staël turns towards abstraction.

'When I was young, for years I painted Jeannine's portrait. There's no denying that a portrait, a real portrait is a high point in art. So I painted two paintings, two portraits – Looking at them I would ask myself: what have I painted? A living dead being, a dead living being? . . . Then little by little I began to feel ill at ease painting an object

realistically, because in relation to any one object I felt bothered by the infinite number of other coexisting objects. One absolutely can't think about any one object whatsoever as there exist so many objects at the same time that the ability to take them in falters and fades. I have therefore sought a freer form of expression'
(Nicolas de Staël 1949)

Staël did not 'evolve' towards abstraction. The step to abandon figuration was taken with great deliberation and, more than anyone else, it was Magnelli who acted as intermediary in Staël's adoption of a new abstract language which he approached from a theoretical aspect. He was acutely aware of the dangers, artistic and emotional, engendered by this freedom of expression and of the rigorous personal discipline it necessitated.

1943

September: they return to Paris and settle in a large family house at 54 rue Nollet. Staël draws and paints a great deal, producing large canvases. Work of this period has its origins in the experience of the formal rhythms of real objects: hammers, pincers, trees, roots, meat etc., executed with the palette knife, a tool he continues to use for many years.

'I need to feel the presence of life in front of me, and to seize it whole, just as it penetrates through my eyes and skin'
(cit. Gindertaël, 1966)

1944

February: Jeanne Bucher includes some of Staël's work in a small exhibition of Domela and Kandinsky.
7 April – 7 May: he again participates with them and Magnelli in an exhibition called 'Abstract Painters' organised by the Galerie L'Esquisse.
12 May – 3 June: Staël has his first one-man show at the Galerie L'Esquisse.

Besides the valuable esteem and friendship of Jeanne Bucher Staël makes three all-important friendships during this year: that of Georges Braque (whom he gets to know in connection with a lithograph Braque executes to illustrate a book of poems by the 12 year old Antoine Tudal, Jeannine's son); that of the Russian abstract painter Lanskoy and that of Jean Bauret, an industrialist and collector, who was to remain one of Staël's closest friends throughout his career.

Braque was for Staël the master of modern art, he represented 'la vraie peinture' and his friendship gave Staël much needed spiritual support, helping to shape his vision and confirm his sense of the 'metier' of painting. Braque's overriding preoccupation with space, 'visual space, tactile space, manual space'[1] was clearly an important influence on Staël's painting.

Through the Galerie Jeanne Bucher Staël got to know Kandinsky before the latter's death in December 1944 and at the same time struck up a friendship with the Russian emigré and abstract painter, Lanskoy, who encouraged, both in their prolonged discussions and by the example of his own work, Staël's use of thick paint, a rich and textured surface, and sombre tones lit by vibrant accents. Staël also found himself in sympathy with certain qualities of mood and atmosphere, specifically Russian in character, which he recognised in the painting of Kandinsky and Lanskoy.

Jean Bauret was gifted with an exceptionally good eye and by the 1950s Staël came to rely on his critical judgement almost exclusively. The beginning of their close and fruitful friendship was marked by a letter from Bauret: 'I think of you and of your adventure with rectangles. I am convinced that you will discover a universe where I should be most happy.'[2]

[1] *Cahier de Georges Braque:* 1917–1947, Paris 1948.
[2] Jean Bauret, 17 January 1945. Cit. Germain Viatte 1968.

1945

5–28 April: at the Galerie Jeanne Bucher, Staël's second one-man exhibition.
May: he participates in the first Salon de Mai.
June: he leaves the rue Nollet for an attic room in the rue Campagne Première which does not, however, prevent him painting large canvases, and by October he settles in a studio at 83 Boulevard du Montparnasse. Staël makes two further important friendships: with the poet, Pierre Lecuire and with the engineer and collector, Jean Adrian.

'I admit that I'm not very clear on the role of the unconscious, particularly when reason acts as a filter one day only to push forth the next day all the rubbish that we believe it is there to stop. I find it very difficult to grasp the truth . . . On the subject of instinct we must have different ideas; for me instinct is unconscious perfection and yet my paintings live by conscious imperfection. I have confidence in myself only because I have confidence in no one else, and in any case, I cannot know myself what a painting is or isn't, or establish new precepts, before actually painting. One must work constantly – with a ton of passion and a few ounces of patience'
(letter to Jean Adrian, March 1945)

All his biographers have emphasised the extreme poverty and material pressures Staël and his family suffered during this formative period for the painter. Staël was constantly prey to anxiety and depression and his moods oscillated between exaltation and utter despair; his work of this period attests to his disturbed state.

1946

February: the death of Jeannine Guillou. In the spring Staël visits the major exhibition of French tapestries (From the Middle Ages to the twentieth century) at the Musée Nationale d'Art Moderne.

Staël's painting was rarely influenced immediately by the art of the past that interested him. Although passionate in his responses Staël would assimilate the lessons learnt and they can sometimes by discerned in his work of a later date. It was this year also, that he expressed his admiration for Gustave Moreau, in whose paintings he admired the low foreground tones and the sumptuousness of the paint.

22 May: Staël marries Françoise Chapouton, a distant relative of Jeannine Guillou.
7 June–7 July: The Salon de Mai. Staël is a member of the organising committee (a duty he hastily abandons) and also submits two paintings only one of which is exhibited. The rejected work is probably the large 'Composition en Noir' 1946 (Cat. 10, Chastel 61) which he was later to regard as the culmination of several years' work:

'No one would have been disappointed if in all those years I had painted only that one picture'.
(letter to Roger van Gindertaël, cit. Gindertaël, 1966)

October: Staël's material difficulties are somewhat alleviated – he signs a contract with the dealer, Louis Carré, and Jacques Dubourg, former associate of the Galeries Georges Petit, becomes interested in his work. Having just opened his own gallery he becomes Staël's main dealer from 1947 on.
 At about this time he receives a friendly visit (without sequel) from André Breton.
 Commissioned by Jean Bauret, Staël, among other artists, works on fabric designs.
 At the end of the year stays with his wife's family in the Savoie.

'Softly the snow covers all the rooves casting into my room a light which allows me to work until half past five; it cleaves the landscape apart'
(letter to Humbert Stragiotti, end of 1946)

At this time Staël rarely painted 'sur le motif', but the linear, angular formations of trees sometimes drew his attention and he would note them down in rapid sketches.

1947

January: he moves into an immense studio at 7 rue Gauguet. As it is near Braque's studio they spend long hours in discussion together.

Staël's profound admiration for Braque is evidenced in such paintings as 'Brises-Lames' 1947 (Cat. 19, Chastel 116) which can be compared, in its use of black and sombre tones and compressed rhythmical construction, with Braque's 'Woman at a Mirror' 1946.

6 April: the birth of a daughter, Laurence.
June: stays at Carry-le-Rouet, near Marseilles. On the way he visits one of the first major exhibitions of contemporary art since the war, organised by Christian and Yvonne Zervos at the Palais des Papes in Avignon. A huge and varied exhibition it includes work by Picasso, Matisse, Braque, Léger, Masson, Klee, Kandinsky, Mirò, Balthus, Ernst, Giacometti, Mondrian; it makes a strong impression on Staël.
 He gets to know the painter, Lapicque, through the Louis Carré Gallery; Staël finds much in common with Lapicque's explorations in the expressive use of colour and the ambiguities of pictorial space and is fascinated by the latter's theories.
 Towards the end of the year, after a chance meeting, he strikes up a friendship with his neighbour, Theodore Schempp, an American dealer who gradually, over the next few years, opens the American market to him.

1948

February: Staël exhibits at the Dominican convent of Saulchoir with Braque, Lanskoy, and the sculptors, Laurens and Adam.
April: obtains French nationality. 13 April: the birth of Jérôme.
 The first articles on Staël appear, for example Roger van Gindertaël in the *Journal des poètes de Bruxelles*:

'... I don't think I risk too much in claiming the work of Nicolas de Staël to be the most important new discovery in the art of today since Picasso, and one of the things determining the "raison d'être" of contemporary painting'
(May 1948. Cit. Germain Viatte, 1968 p. 110)

October: an exhibition of Staël's paintings and drawings organised by the painter Hector Sgarbi in Montevideo; the catalogue preface is by Pierre Courthion, a painter himself, and a recent and enthusiastic admirer of Staël's work; the tone of the preface is elegiac, redolent with hyperbole and mysticism – the first of many that pay tribute to the sense of myth and awe Staël inspires. Courthion's description of the artist's palette is evocative:

'It ranges from the most fresh and silvery greys to the deepest of blacks and pure milky whites ... from old gold and earthy bronze to a rosy brown ... this palette is one of autumn colours, the nuances of a carpet of dead leaves on the damp earth'
(extract from 'Bonjour Nicolas de Staël', 1948)

Staël's painting of this period has an architectonic quality. 'Hommage à Piranèse' 1948 (Cat. 23, Chastel 120) testifies to his enthusiasm for Piranesi's engravings (Staël later acquired an album of the Carceri*) and the tight architectural blocks and creamy whites and ochres of the best Utrillo have been compared to such paintings as 'Harmonie grise, beige, taches rouges' 1948 (Cat. 25, Chastel 130). But it is interesting to note that Staël also around this time enjoyed drawing in the dark of a cinema, evoking the rhythms suggested to him by Soviet war films. Towards the end of the year his painting attains a certain calm and throughout the following year the bars that seem to tear across his canvases become increasingly less dominant and the areas of colour larger.*

1949

At the beginning of the year a brief trip to Amsterdam, The Hague and Brussels where Staël rediscovers the vivid impressions of his first visit in 1933; he also now discovers the work of the Dutch artist, Hercules Seghers (1589?–1640?); Staël's enthusiasm for his art was to increase over the years and Seghers is one of the few artists to inspire him directly, in the engravings he later does for Pierre Lecuire's book, *Ballets-Minute* (1954).
July: stays at Carry-le-Rouet and Grignan.
 Schempp succeeds in arousing the interest of several American collectors in Staël's work: Duncan Phillips acquires 'Nord' 1949 (Cat. 30, Chastel 166) for the Phillips Collection, Washington.

Towards the end of the year Staël was seeing a great deal of Braque and his painting of this year in some measure bears witness to his influence in their new sense of space. The constricted space and tangled bars of the previous year have been renounced for simpler, open planes of colour that allow the canvases to breathe more freely; a softer palette also, with rose-greys and a rich variety of blues often set against a warm yellow or ochre.

1950

During the early months of the year Staël prepares for his first important exhibition.
March: the Musée Nationale d'Art Moderne buys a canvas.
1–15 June: exhibition consisting of 12 paintings at Jacques Dubourg's gallery. The exhibition is not a success with the public but receives much critical attention and stimulates substantial articles from Patrick Waldberg, André Chastel, René de Solier, Charles Etienne and Bernard Dorival. Shortly afterwards Georges Duthuit publishes an important essay on Staël (Transition Press, 1950) parts of which are republished in *Cahiers d'Art* (1950, No. 2, pp. 383–6).
July: after a brief visit to Braque at Varengeville, Staël goes to London where Denys Sutton is in the process of organising a Staël exhibition at the Matthieson Gallery.

'. . . the Royal Palace is like everywhere else, a crowd of nit-wits gawping at those famous fellows in red; it's very pretty, really pretty. There's also Westminster Abbey, an enormous grey mass with a stunning lawn of unprecedented green . . .'
(letter to his wife, July 1950)

The visit was an important one for Staël; like Monet and Derain before him he loved the soft London light and the play of bright colours against grey façades; he spent some time in the British Museum and walked around the docks '. . . as if intoxicated by a new found reality; this visit seems to have led Staël to consider his painting more in relation to the rhythms of colour and visual shocks that life itself offered him' (Germain Viatte, Chastel 1968). He admired Turner and Constable and Douglas Cooper mentions his liking for Bonnington and Corot, adding that Staël was evolving towards a greater concern with light through direct observation. (Cooper, 1961, p. 49).

August: stays in Antibes and Aix-en-Provence.
September: participates in an exhibition of French painting in Copenhagen.

'Thank you for having separated me from the 'Gang de l'abstraction avant'[1]. Thank you for your text[2] ... I could write you any number of pages to help you place me more precisely, a real treatise of moral dynamic with a whole anthology of space, movement, light, order and disorder from which one day I think I'll be able to sort out my position – with your help perhaps – but let's leave the painting to explain itself'
(letter to Bernard Dorival, September 1950)

Staël made no secret of his lack of esteem for the work of certain of his contemporaries, in particular the lyrical abstract painters such as Soulages, Schneider and Hartung and the Tachism of Wols or Mathieu. Staël was concerned to identify himself with the central traditions of painting; in his view the issues of contemporary painting were very secondary to the perennial problems of pictorial creation itself and to a great extent he saw himself as his critics portrayed him: alone, locked in a kind of mortal combat with his art. In this sense he did not define himself as an abstract painter.

Théodore Schempp, Nicolas de Staël, Georges Braque, Varengeville, 1950.

'. . . by starting with his own experience and through the very act of creating the painting, Staël strives to abolish the distinction between the natural phenomena which inspired its creation and the finished work itself . . . For Staël, painting is essentially a vital medium in which the life of forms is captured and embodied. The elements of these forms . . . the contours, surfaces, colour planes, . . . are simultaneously the materials of his craft and its very spirit: in a word, its "poetics". In these poetics the problems of representation and those of abstraction are not contradictory'
(Roger van Gindertaël, 1950, cit. Gindertaël 1966)

October: Jean Leymarie seeks to purchase the large canvas, 'La Rue Gauguet' 1949 (Chastel 174) having seen it hung at Georges Duthuit's house. It is finally bought by the Museum of Fine Arts, Boston.
Staël is very aware of the importance of the right painting for a particular place:

'. . . The important thing for museums (which as you know I dislike) is to create air. A museum painting must dominate and bring the other paintings to life. Then it has a reason for being there, despite the pervasive smell of the laboratory'
(letter to Theodore Schempp, October 1950)

November: Staël meets Suzanne Tézenas who invites him to her salon, the birthplace of the Domaine Musical; here he was to meet musicians, writers and poets, among them Messiaen, Stravinsky, Boulez, Dora Maar, Jean Paulhan. Throughout the year Staël also corresponds with a number of friends discussing his own and others' painting.

'. . . Braque came yesterday. He is very pleased with what I'm doing – it was a long, excellent visit . . . Ted, I think one can say that my way of suggesting pictorial space is completely new; I spoke with Braque for a long time about this article that I am sending you[3] and about the paintings there, before our eyes . . .'
(letter to Theodore Schempp, December 1950)

[1] 'Gang de l'abstraction avant' (Forward Abstraction gang) parodies the nickname, 'gang de la traction avant', given to a band of criminals who were in the news at that time; it also contains a pun on 'traction-avant' which means front-wheel drive.
[2] Bernard Dorival's review of Staël's exhibition in June, which was published in *La Table Ronde*, July 1950, pp. 162, 163.
[3] Article by René de Solier, *Cahiers de la Pléade*, Spring 1950, pp. 59–61.

1951

January: exhibition at Theodore Schempp's in New York and the publication of Roger van Gindertaël's monograph, *Nicolas de Staël*.
February: he meets the poet, René Char. It is the beginning of a close friendship and gives rise to the project of doing a book together, *Poèmes*, the woodcuts for which occupy Staël almost exclusively during this year; it is the first engraving work he has done.
March: a Staël painting ('Composition' 1947 Chastel 99) is donated to the Museum of Modern Art, New York and the painter is requested to complete a questionnaire sent by the museum:
Asked for a general account of his artistic philosophy Staël writes:

'I want to achieve a harmony; the material I use is painting. My ideal is determined by my individuality and the individual that I am is made up of all the impressions received from the exterior world since and before my birth'

His notes concerning this question contain the remarks:
'. . . For the most part I paint without a concept, without any literary conception. I also sometimes start from a clear image. In both cases the perception must not be fragmented'

To the question, 'Does the subject hold any special significance, personal or symbolic', he replies 'There is no subject', but his notes contain the following: 'Special significance? In relation to what? Personal – naturally; symbolic – I am unaware of it. I simply wanted to paint a brown canvas; begun in the garden of a house in the rue Nollet. All I know is that things are communicating constantly with the artist while he is painting'
(cit. Germain Viatte, Chastel 1968)

17 April – 2 May: exhibition of drawings at the Galerie Jacques Dubourg. From April to June there is an exhibition of mosaics from Ravenna at the Musée des Monuments français; it makes a strong impression on Staël and, unusually, seems to affect his work directly in his use of small juxtaposed bricks of colour eg. 'Composition' 1951 (Cat. 51, Chastel 294). He also visits the large retrospective of Fauvism at the Musée Nationale d'Art Moderne.
August: is spent in the Savoie and at Grignan in the South.
12 December: *Poèmes* by René Char with 14 wood engravings by Staël is exhibited at Jacques Dubourg's; it is well received by the critics.

'. . . I will never be able to say enough how much I gained from working with you. You made me rediscover directly the passion I had as a child for vast skies, autumn leaves and all the nostalgia for a direct language, without precedent, that this brings'
(letter to René Char, 8 November 1951)

1952

21 February – 15 March: Staël's first exhibition in England, at the Matthiesen Gallery. It receives a great deal of attention in the British art world and several enthusiastic reviews both in the art and national press;[1] some of the avant-garde critics however, are disconcerted by the fact that several of the 26 canvases shown are explicitly representational; the first of Staël's series of paintings of bottles, apples and landscapes seem an extraordinary anachronism, a betrayal of abstraction just when it is receiving world wide recognition.

Unlike his earlier sudden move to abstraction in 1942 and his involvement in its theoretical side, Staël's evolution towards figuration in the 50s was gradual and based on observation and natural phenomena. He is said to have claimed 'One does not begin with nothing; when Nature is not the starting point the picture is inevitably bad' (Cit. Gindertaël, 1966) and Germain Viatte in his commentary describes his development as 'a progressive convergence of the abstract elements of his own vocabulary and certain identifiable characteristics from reality' (Chastel, 1968).

In the Spring Staël paints directly from nature near Jean Bauret's home at Mantes, at Chevreuse and at Gentilly. As always he subjects his canvases to a variety of different lights (daylight, studio, artificial light and the filtered light of Jean Bauret's orchard) and to the precise and enlightening judgements of his friend.

26 March: he attends the floodlit football match between France and Sweden at the Parc des Princes; he is bowled over by the spectacle and immediately undertakes several paintings on the subject, of which the 'Parc des Princes' 1952 (Cat. 56, Chastel 386) is the most ambitious.

'Between sky and earth, on grass which is red or blue, there whirls a ton of muscle in complete oblivion of self with, against all semblances, a great sense of presence . . . So I've set to work on the entire teams of France and Sweden alike and even in this short time it's beginning to move. If I found premises as big as at rue Gauget I'd start off two hundred small paintings so that the colour would ring out like the posters on the motorway out of Paris'
(letter to René Char, 10 April 1952)

Germain Viatte has pointed out that the suppressed energy and jostling, rhythmical forms of these paintings reminds one of Staël's interest in the work of Paolo Ucello whose 'Battle of San Romano' at the National Gallery he had recently seen again. (Germain Viatte, Chastel 1968, p. 188)

'Une Nuit au Parc des Princes' is shown at the Salon de Mai where Matisse also exhibits his spectacular paper cutout, 'La Tristesse du Roi'; the influence of Matisse's découpages was to manifest itself in Staël's collages of 1953, made however, from torn, rather than cut, paper.

May and June: Staël stays at Bormes-les-Pins in the Var and Le Lavandou on the Côte d'Azur; the experience is a crucial one, he paints in a state of great exaltation, discovering the brilliance of the Mediterranean light as if for the first time.

'The light is simply devastating here . . . the contrasts are . . . violent . . . colour is literally consumed . . . I am getting through quantities of colour . . . by dint of burning up the retina of one's eye on the "shattering blue", as Char puts it, one ends up seeing the sea red and the sand violet'
(letters to Jaques Dubourg, June 1952)

Also during the summer, under the instruction of the sculptor, Vitullo, he carves two blocks of marble, only completing one.

July and August: he paints in Paris and does some lithography.

October: he goes to Aubusson to see the making of his tapestries at the Picaud studio and late in the year discusses with René Char, then Pierre Lecuire, a project for a ballet which however was not to materialise.

Staël had long wanted to create the décor for a ballet and 'Les Indes Galantes' 1953 (Cat. 73 and 74, Chastel 550 and 545) were inspired by the opera of the same name by the seventeenth-century French composer, Jean-Philippe Rameau.

[1] Reviews of Staël's exhibition at the Matthieson Gallery: *Apollo*, March 1952; *Manchester Guardian*, 25.2.52; *Sunday Times*, 24.2.52; *New Statesman*, 1.3.52; *Art News and Review*, 8.3.52; *The Listener*, 13.3.52.

1953

February: in connection with their projects for décor and choreography Staël, his wife and Pierre Lecuire make a rapid trip to Italy; Ferrara, Venice, Bologna, Milan and Ravenna in the snow. At the end of February, to New York for his exhibition at Knoedler (10–28 March); the catalogue is prefaced by a short text by Staël:

'All my life I have needed to think painting, to see paintings, to make paintings to help myself live, to free myself from all the impressions, all the sensations, all the anxieties to which I have never found any other issue than painting. Today I am showing a group of paintings which, in all modesty, mean more to me than any I have done before'

The exhibition is a great success but apart from the museums – MoMA, the Metropolitan, the Philadelphia Museum and the Barnes foundation – Staël does not like America. He profits from the visit to do some research into the graphic work of Hercules Seghers and goes to a concert of Stravinsky.

Pierre Lecuire publishes *Voir Nicolas de Staël*. In a well known passage from this descriptive litany on Staël and his painting the poet writes of the painter's greys:

'His greys. There would be no light in the paintings, no atmosphere, no transparency . . . if it were not for the famous greys. These greys are quite unique in the painting of today; unique in their refinement and variety, unique in substance and depth, and unique also in the multiple ways the painter combines them'

Staël exhibits 'Bouteilles dans l'Atelier' 1953 (Cat. 76, Chastel 570) at the Salon de Mai.

June: he receives a visit from the American dealer, Paul Rosenberg, who offers him an exclusive contract for the sale of his paintings in America, declaring to a journalist that for Staël, and only for him, he is prepared to take all the risks he had taken with the masters of Cubism; Staël is stunned by these promises of prosperity. In the summer he visits the large, important exhibition of French stained glass in Paris.

'One day he held up a piece of wax so that it stood out against the bright sky . . . "you see", he said, "this is the art of painting, nothing but this. But it is just *this* which is most difficult . . . almost impossible"'
(Cit. Gindertaël, 1955)

The exhibition acts perhaps as both stimulus and confirmation of Staël's gradual use of thinner paint and sheer expanses of translucent colour.

A brief visit to London to see the Hercules Seghers exhibition.

July: a short stay at Lagnes in the Midi; he has developed a firm attachment to the light of the Mediterranean and begins to paint figures and portraits.

August: he leaves with his family for Italy and Sicily: Florence, Rome, Naples, Pompei, Agrigento, Syracuse; then returns to Lagnes.

'I already paint ten times too much, and more as one who crushes the grapes then he who drinks the wine . . .'
(letter to Jacques Dubourg, 12 October 1953)

23 November: buys Le Castellet at Ménerbes, an old fortified house at the end of the village; he was to live there until the summer of 1954. Staël's painting techniques change: he uses brushes rather than a palette knife. He meets Douglas Cooper, and visits his chateau at Castille with its magnificent collection of Cubist paintings.

'. . . But the point when history becomes thrilling, really thrilling, is the moment when one grasps the Braques in the light in which they were painted, that kind of diffuse and violent light that the painting receives all the better for having all the ability to resist it . . . These Braques are great painting just as Uccello made great painting and they acquire a mystery, a simplicity, an unprecedented strength from their kinship with painting from Corot to Cézanne . . .'
(letter to Denys Sutton, November 1953)

1954

8 February – 6 March: exhibition of recent paintings at Rosenberg's in New York; well received by critics and collectors.

During the Spring he goes often to draw and paint in Marseilles and at Martigues, and, despite the lengthy journeys, often by sea, he continues to show his paintings to Jean Bauret, regularly packing up still damp canvases to travel the several hundred kilometres to Bauret's home at Erquinghem; despite his solitude and pride he has total confidence in his friend's judgement and is quick to make changes to a painting on his advice. His painting becomes progressively more figurative; still lifes, figures and many landscapes. Concerning the importance of Nature for him he is quoted as saying:

'"When it is cold in winter one doesn't feel at ease; the same is true when it is too hot in summer. We are continually influenced and penetrated by nature." Nature was thus both a milieu and a point of reference for Staël. "I want my painting . . . to be like a tree, like a forest. One moves from a line, from a delicate stroke, to a point, to a patch . . . just as one moves from a twig to a trunk of a tree. But everything must hold together, everything must be in place"'
(Roger van Gindertaël, 1955)

April: after the abandonment of several other common projects, the publication of *Ballets-Minute* by Pierre Lecuire with 20 etchings and a cover in colour by Staël.

The etchings owe a great deal to his study of the engravings of Hercules Seghers; indeed one of the original projects was to have been a hommage to the Dutch artist and Staël had already made a series of etchings that are in effect purified abstractions of certain of Seghers' engravings (see Chastel 1968, pp. 275–9).

5 April: the birth of Gustave.

11–25 June: exhibition at Jacques Dubourg's; very controversial due to Staël's 'return to figuration'. Roger van Gindertaël defends Staël's new paintings:

'. . . which reconcile the double reality of being and the world. . . .Staël shows himself capable of taking up the wager and achieving a new figuration, or rather figuration once more transcended'
(Cimaise, July – August 1954, pp. 9–10)

Staël spends the summer in Paris where he paints bridges, the *quais*, Notre Dame and also on the coast of the North Sea at Gravelines; later at Cannes.

September: he moves to a studio at Antibes; his paint becomes progressively more fluid, often diluted with turpentine on pads of gauze; he seeks to paint with more flexibility and immediacy but with the same intensity.

October: he leaves for Spain with Pierre Lecuire; Barcelona, Valencia, Grenada and Madrid. He has not seen the Prado since his trip in 1935 and is now particularly moved by the Velazquez:

'Solid, calm, unshakeably rooted, painter of painters who keeps an equal distance from kings and dwarfs, and between himself and others. He creates a miracle at each touch, without hesitation yet tentative . . . reserved yet outside of himself and there on the canvas. He gives the clear impression of being the first unshakeable pillar of free painting, genuinely free . . .'
(letter to Jacques Dubourg, 29 October 1954)

November: visits the Courbet exhibition at Lyons, commenting that he is a 'titan, immense'. Then settles for the winter in Antibes to paint; he is very solitary and troubled.

'I always try to make a more or less decisive action from my possibilities as a painter and when I attack a large canvas, when it begins to be good, I always become painfully aware of how too much is owing to chance and I feel dizzy; it is a chance born of strength but it still looks like chance, like a sort of backhanded virtuosity, and this throws me into the most pitiful state of discouragement. I lose my grasp and even the three metre canvases I begin – on which I just put a few well thought out touches each day – always end up in bewilderment. I can't master it – in the real sense of the word, if there is a sense; I would like to manage to strike with full deliberation, fully conscious, even if I strike fast or with force. The important thing is to keep as calm as one can, right to the end. I am at Antibes trying precisely to change fundamentally in this way . . . I know that my solitude is inhuman; I can't see any way out of it but I can see a means to progress seriously . . .'
(letter to Jacques Dubourg, end of December 1954)

1955

Antibes: continues painting intensely and alone in preparation for an exhibition at Jacques Dubourg's planned for June and another in August at the Museum of Antibes.

'I don't want to be systematically either too close or too far from the subject – neither one nor the other – but I believe in obsession because without obsession I would do nothing; whether fantasy obsession or direct obsession is more valuable I don't know, and all being said, I don't care, provided it all balances out as best it can, preferably without equilibrium. I lose contact with the canvas at each instant, find it again, lose it again . . . This is necessary because I believe in the adventitious, I can only proceed from incident to incident. As soon as I sense too much logic I become irritated and swing naturally over to the illogical . . .'
(letter to Douglas Cooper, January 1955)

5 March: goes to Paris, to two concerts held by the Domaine Musical at the Petit Marigny theatre: Schoenberg and Webern. On his return he starts two large canvases: 'Le Piano' 1955 (Chastel 1058) and 'Le Concert' 1955 (Cat. 120, Chastel 1059).

'One never paints what one sees or thinks one sees; rather one records, with a thousand vibrations, the shock one has received, or will receive it'
(Staël, cit. Gindertaël, 1966, extracted from letter to Pierre Lecuire, 3 December 1949, Paris 1966)

16 March: Nicolas de Staël commits suicide at Antibes.

I am much indebted to the excellent Catalogue Raisonné and annotated letters of Nicolas de Staël compiled by André Chastel, Germain Viatte, Jacques Dubourg and Françoise de Staël (Editions du Temps, 1968).

Hetty Einzig

One Man Exhibitions

Paris 1944 Nicolas de Staël, Paris, Galerie l'Esquisse, 12 May–3 June 1944.

Paris 1945 Nicolas de Staël, Paris, Galerie Jeanne Bucher, 5–28 April 1945.

Montevideo 1948 Nicolas de Staël, Montevideo, October 1948, preface by Pierre Courthion.

Paris 1950 Nicolas de Staël, Paris, Galerie Jacques Dubourg, June 1950.

New York 1951 Nicolas de Staël, New York, Theodore Schempp Gallery, January 1951.

Paris 1951 Nicolas de Staël, dessins, Paris, Galerie Jacques Dubourg, 17 April–2 May 1951.

Paris 1951 Poèmes de René Char, bois de Nicolas de Staël, Paris, Galerie Jacques Dubourg, 12–27 December 1951. Text by René Char, woodcuts by Nicolas de Staël.

London 1952 Nicolas de Staël, London, Matthiesen Gallery. Text by Denys Sutton.

New York 1953 Nicolas de Staël, New York, Knoedler Gallery, 10–28 March 1953.

Washington 1953 An Exhibition of Paintings by Nicolas de Staël, Washington, The Phillips Gallery, 12 April–4 May 1953.

New York 1954 Recent Paintings by Nicolas de Staël, New York, Paul Rosenberg Gallery, 8 February–6 March 1953.

Paris 1954 Nicolas de Staël, Paris, Galerie Jacques Dubourg, June 1954.

Antibes 1955 Nicolas de Staël, Antibes, Musée Grimaldi, 1 July–1 August 1955.

New York 1955 Loan Exhibition of Paintings by Nicolas de Staël, New York, Paul Rosenberg Gallery, 31 October–26 November 1955.

U.S.A. 1955/56 Nicolas de Staël, travelling exhibition organised by the American Federation of Arts. Introduction by Theodore Schempp.

Edinburgh 1956 Nicolas de Staël, Edinburgh, Royal Scottish Academy Galleries, 6 October–11 November 1956. Preface by Denys Sutton.

Fort Worth 1956 The Paintings of Nicolas de Staël, Fort Worth Art Centre, 6 August–9 September 1956.

London 1956 Hommage à Nicolas de Staël, London, Arthur Tooth & Sons Ltd, 6–31 March 1956.

London 1956 Nicolas de Staël (1914–1955), London. The Whitechapel Art Gallery, May–June 1956.

Paris 1956 Nicolas de Staël (1914–1955), Paris, Musée national d'art moderne, 22 February–8 April 1956. Preface by Jean Cassou.

Washington 1956 Paintings by Nicolas de Staël, Washington, The Phillips Gallery, 13 May–4 June 1956.

Berne 1957 Nicolas de Staël, Berne, Kunsthalle, 13 September–20 October 1957. Preface by Franz Meyer.

Paris 1957 Hommage à Nicolas de Staël, Paris, Galerie Jacques Dubourg, 4–28 June 1958.

Arles 1958 Nicolas de Staël, Arles, Musée Réattu, 28 June–8 September 1958. Preface by Douglas Cooper.

Geneva 1958 Nicolas de Staël, peintures, dessins, collages, aquarelles, tapisseries, Geneva, Galerie Jacques Benador, 26 September–18 October 1958. Selected by Jean Leymarie.

New York 1958 Loan Exhibition of Paintings by Nicolas de Staël, New York, Paul Rosenberg Gallery, 6 October–1 November 1958.

Paris 1958 43 dessins de Nicolas de Staël, Paris, Galerie Jeanne Bucher, 21 February–22 March 1958. Preface by Roger Van Gindertaël.

Paris 1958 Nicolas de Staël: Collages, Paris, Jacques Dubourg, June 1958. Preface by Roger Van Gindertaël.

Hanover 1959/60 Nicolas de Staël, Hanover, Kestner-Gesellschaft, 18 December–24 January 1960. Preface by Werner Schmalenbach.

Hamburg 1960 Nicolas de Staël, Hamburg, Kunstverein, 7 February–13 March 1960. Preface by Werner Schmalenbach.

Turin 1960 Nicolas de Staël, Turin, Galleria Civica d'Arte Moderna, 3 May–12 June 1960. Text by Franco Rusoli and Lando Landini.

New York 1961 Nicolas de Staël, New York, Stephen Hahn Gallery, 7 February–14 March 1961.

Zurich 1961 Nicolas de Staël (Collages), Zurich, Galerie Charles Lienhard, May 1961. Text by Roger Van Gindertaël.

New York 1962 Nicolas de Staël, Galerie Chalette, May 1962. Preface by Herta Wescher.

Zurich 1963 De Staël, Zurich, Gimpel-Hanover Galerie, 19 April–18 May 1963.

London 1963 De Staël, London, Gimpel fils, June–August 1963.

New York 1963 Nicolas de Staël, New York, Paul Rosenberg Gallery, 5–30 November 1963.

Basle 1964 Nicolas de Staël, Basle, Galerie Beyeler, August–October 1964. Text by Nicolas de Staël and Georges Braque.

Paris 1964 Nicolas de Staël, Paris, Galerie Louis Carré, 8–31 December 1964.

Rotterdam 1965 Nicolas de Staël, Rotterdam, Museum Boymans Van Beuningen, 17 May–11 July 1965. Preface by J. C. Ebbinge Wubben and R. Hammacher van den Brande. Text by Roger Van Gindertaël.

Zurich 1965 Nicolas de Staël, Zurich, Kunsthaus, 21 July–5 September 1965. Preface by J. C. Ebbinge Wubben and R. Hammacher van den Brande. Text by Roger Van Gindertaël.

Paris 1965 Lithographies et gravures de Nicolas de Staël, Paris, Galerie de Messine. Text by Antoine Tudal.

Boston 1965 Nicolas de Staël, Boston, Museum of Fine Arts. Text by R. Van Gindertaël.

Chicago 1965/66 Nicolas de Staël, Chicago, The Art Institute. Text by R. Van Gindertaël.

New York 1966 Nicolas de Staël, New York, The Solomon R. Guggenheim Museum. Text by R. Van Gindertaël.

Geneva 1967 Nicolas de Staël, (1914–55), Peintures et dessins, July–August 1967. Preface by Roger Van Gindertaël.

Edinburgh 1967 Nicolas de Staël, Edinburgh, Scottish National Gallery of Modern Art, 12 August–10 September 1967.

Paris 1969 Nicolas de Staël, Paris, Galerie Jacques Dubourg, 28 May–21 June 1969.

Saint Paul 1972 Staël, Saint Paul de Vence, Fondation Maeght, 11 July–24 December 1972. Introduction by Jean-Louis Prat. Text by André Chastel.

Zurich 1977 Nicolas de Staël, Gemälde und Zeichnungen, Zurich, Galerie Nathan, 4 November 1976–5 February 1977. Preface by Bernard Dorival.

Paris 1979 123 Dessins de Nicolas de Staël 19 April–26 May 1979, Galerie Jeanne Bucher.

Paris 1980 Nicolas de Staël, 7 tableaux, Paris, Galerie Alex Maguy, 7 October–25 December 1980.

Paris 1981 Revoir Nicolas de Staël 21 May–12 July 1981, Galerie Jeanne Bucher. Introduction by Jean-Luc Daval.

Group Exhibitions

This list of mixed exhibitions includes only the Salon d'Automne, the Salon de Mai and some exhibitions up to 1950. A more complete list can be found in *Nicolas de Staël* by André Chastel, Jacques Dubourg, Françoise de Staël and Germain Viatte, Paris, Editions du Temps, 1968.

Salon d'Automne, Paris, 1944 (No. 1241), 1946 (No. 1294), 1951 (No. 1561), 1952 (No. 1151).

Salon de Mai, Paris, 1945 (No. 109), 1946 (No. 207), 1947 (No. 71), 1949 (No. 222, 223), 1950 (No. 181), 1951 (No. 126), 1952 (No. 170), 1953 (No. 183 a), 1954 (No. 145), 1955 (No. 168, 169, 170).

Paris 1944 Peintures abstraites, compositions de matières, Paris, Galerie l'Esquisse, 7 April–7 May 1944 (works by Domela, Kandinsky, Magnelli, Staël).

La Haye 1947 Fransche Kunst, van Bonnard tot Heden, La Haye, Gemeente Museum, 8 February–7 March 1947.

Etiolles 1948	Etiolles, Couvent des Dominicains, February 1948 (works by Adam, Lanskoy, Laurens, Staël).
Lyon 1949	**Les grands courants de la peinture contemporaine (de Manet à nos jours)**, Lyon, Musée des Beaux Arts.
Charlottenborg	**Foreningen Fransk Kunst: Levende Farver, Udvalgte Malerei og Billedtoepper af Nulevende Franske Kunstnere**, Charlottenborg, Kunstakademie, September 1950.
Berlin 1950	**Französische Malerei und Plastik 1938–1948**, May–June 1950. Text by Jacques Lassaigne.
New York 1950	**Advancing French Art**, New York, Galerie Louis Carré. Preface by C. Estienne (works by Bazaine, Estève, Hartung, Lanskoy, Lapicque, Staël).
New York 1950	**Modern Art to live with**, New York, Galerie Louis Carré, 28 November–30 December 1950.
Bergame 1950	**Mostra Internazionale del Disegno Moderno**, Bergame, Palazzo della Ragione, 20 September–22 October 1950.

Bibliography

1948

Courthion	Pierre Courthion, 'Bonjour à Nicolas de Staël', preface to the catalogue of the Nicolas de Staël exhibition at Montevideo 1948 (reprinted in Pierre Courthion, *L'Art Indépendant*, Albin Michel, Paris 1948).
Gindertaël	Roger Van Gindertaël, 'Nicolas de Staël', *Le Journal des Poètes*, May 1948.
Lecuire	Pierre Lecuire, *L'Art qui vient à l'avant*, text written in 1948 for the exhibition at Montevideo, published by the author in 1965.

1950

Chastel	André Chastel 'Deux peintres et un lithographe', *Le Monde*, No. 1665, 3 June 1950 p. 7.
Dorival	Bernard Dorival, 'Tal-Coat, Singier, Nicolas de Staël', *La Table Ronde*, No. 31, July 1950, pp. 160–163.
Duthuit	Georges Duthuit, *Nicolas de Staël*, Transition Press, Paris 1950 (extracts reprinted in *Cahiers d'art*, 25 année, No. II, 1950, pp. 383–386).
Estienne	Charles Estienne, 'Nicolas de Staël', *l'Observateur*, 22 June 1950.
Gindertaël	Roger Van Gindertaël, *Nicolas de Staël*, Peintres et sculpteurs d'aujourd'hui No. 3, Collection signe, R. V. Gindertaël Editeur, Paris, 1950.
Solier	René de Solier, 'Germaine Richier, de Staël, Bazaine, Chagall', *Les cahiers de la Pléiade*, Spring 1950, pp. 58–63.
Waldberg	Patrick Waldberg, 'Nicolas de Staël', *Monde nouveau paru*, May 1950, No. 60, pp. 142–143 (reprinted in *Transition Fifty*, No. 6, pp. 66–67).

1951

Hess	Thomas B. Hess, 'Nicolas de Staël', *Art News*, January 1951, p. 49.

1952

Alvard et Gindertaël	*Témoignages pour l'art abstrait, 1952* (Introduction by Léon Degand, research by Julien Alvard and R. V. Gindertaël), Editions Art d'Aujourd'hui, Paris, 1952.
Courthion	Pierre Courthion, *Nicolas de Staël*, Peintres d'aujourd'hui, Editions Pierre Cailler, Geneva, 1952.
Dumur	Guy Dumur, 'Nicolas de Staël', *Cahiers d'Art*, XXVII année, No. II, December 1952, pp. 211–218.
Russell	John Russell, 'Risk all', *Sunday Times*, 25 February 1952.

1953

Art-Documents	'Nicolas de Staël', *Art-Documents*, No. 28, January 1953.
Chastel	André Chastel, 'Succès de Manessier et N. de Staël à New York', *Le Monde*, 10 April 1953, p. 7.
Fitzsimmons	James Fitzsimmons, 'In Love with paint', *The Art Digest*, 15 March 1953.
Hess	Thomas B. Hess, 'Nicolas de Staël', *Art News*, March 1953, pp. 34–35.
Sutton	Denys Sutton, 'Nicolas de Staël', *Signature*, No. 17, 1953, pp. 23–28.

1954

Berne-Joffroy	André Berne-Joffroy, 'Staël', *La nouvelle Revue Française*, vol. 2, No. 20, August 1954, pp. 335–336.
Chastel	André Chastel, 'La peinture de Nicolas de Staël', *Le Monde*, 16 June 1954.
Dorival	Bernard Dorival, 'Nicolas de Staël et Léon Gischia', *La Table Ronde*, August, 1954, pp. 172–176.

1955

Dumur	Guy Dumur, 'Hommage à Nicolas de Staël', *Combat*, 12 April 1955, p. 3.
Gindertaël	Roger Van Gindertaël, 'Nicolas de Staël 1914–55', *Cimaise*, No. 7, June 1955, pp. 3–8.
Grenier	Jean Grenier, 'Portrait posthume de Nicolas de Staël', *L'Oeil*, Christmas 1955, pp. 46–53.
Limbour	Georges Limbour, 'Nicolas de Staël', *France Obervateur*, 24 March 1955.
Malraux	Clara Malraux, 'Nicolas de Staël 1944–1955', *Monde Nouveau paru*, vol. 10, No. 91, July 1955, pp. 168–170.
Solier	René de Solier, 'Nicolas de Staël', *La Nouvelle Revue Française*, May 1955, pp. 923–926.
Zervos	Christian Zervos, 'Nicolas de Staël', *Cahiers d'Art*, XXX année, pp. 265–276.

1956

Arland	Marcel Arland, 'Nicolas de Staël', *La Nouvelle Revue Française*, vol. 4, No. 41, May 1956, pp. 904–908.
Cooper	Douglas Cooper, 'Nicolas de Staël: In Memoriam', *The Burlington Magazine*, No. 638, May 1956, pp. 140–146.
Degand	Léon Degand, 'Nicolas de Staël', *Aujourd'hui Art et Architecture*, vol. 2, No. 7, March 1958, p. 14.
Landini	Lando Landini, 'La Mostra di de Staël a Parigi', *Paragone*, No. 79, July 1956, pp. 70–78.
Limbour	Georges Limbour, 'Nicolas de Staël', *France Observateur*, 8 March 1956.
Schneider	Pierre Schneider, 'De Staël's Quest', *Art News*, vol. 55, No. 3, May 1956, p. 16.
Ulatowski	Jean Ulatowski, 'L'impossible retour', *Preuves*, Paris, May 1956, pp. 76–78.
Wescher	Herta Wescher, 'Nicolas de Staël', *Cimaise*, April 1956, pp. 15–19.

1958

Aublet	Félix Aublet et Michel Françoise Braive, 'Entretiens sur Nicolas de Staël', *L'Arc*, Autumn 1958, pp. 50–52.
Guttuso	Renato Guttuso, 'Pagine di diario: Nicolas de Staël 1914–1955', *Il Contemporaneo*, October/November 1958, pp. 43–47.
Jacobs	Rachel Jacobs, 'Nicolas de Staël en dehors de la pré-histoire', *Aujourd'hui Art et Architecture*, September 1958, No. 19, pp. 42–43.
Jouffroy	Alain Jouffroy, 'Dessins de Nicolas de Staël', *Arts*, No. 659, 25 February 1958, p. 15.
Mock	Jean Yves Mock, 'De Staël at the Galerie Jeanne Bucher', *Apollo*, April 1958, p. 141.
Raillard	Georges Raillard, 'Nicolas de Staël à Arles', *L'Arc*, Autumn 1958, pp. 51–56.
Tudal	Antoine Tudal, *Nicolas de Staël*, Le Musée de Poche, Georges Fall editor, Paris 1958.

1959

Cahiers du Musée de Poche	'Carnet de dessins: de Staël 1945–1948', *Cahiers du Musée de Poche*, No. 1, March 1959, pp. 21–27.
Brion	Marcel Brion 'L'aventure dramatique de Nicolas de Staël', *XXe siècle*, vol. 21, No. 12, May–June 1959, pp. 35–40.
Dorival	Bernard Dorival, 'Nouvelles acquisitions du Musée national d'art moderne', *La Revue des Arts*, vol. 9, No. 4–5, 1959, pp. 228–229.
Grenier	Jean Grenier, 'Profil de Nicolas de Staël', dans *Essais sur la Peinture Contemporaine*, Gallimard, Paris, 1959.

Kramer Hilton Kramer, 'Jackson Pollock and Nicolas de Staël, two painters and their myths', *Arts Yearbook*, No. 3, 1959, pp. 52–60.

Sutton Denys Sutton, *Nicolas de Staël*, Georges Fall, Paris, 1959, (Grove Press, New York).

1960

Bigongiari Piero Bigongiari, 'Nicolas de Staël, il pittore del primo giorno della creazione', *La Biennale di Venezia*, vol. 10, No. 41, October–December 1960, pp. 9–23.

Gindertaël Roger Van Gindertaël, *Nicolas de Staël*, Peintres d'Aujourd'hui, Fernand Hazan, editor, Paris, 1960.

1961

Chastel André Chastel, 'Nicolas de Staël à Ménerbes', *Art de France*, 1961, pp. 211–228.

Cooper Douglas Cooper, *Nicolas de Staël*, Weidenfeld and Nicholson, London 1961 (W. W. Norton and Co, New York, 1961).

1962

Cabanne Pierre Cabanne, 'Nicolas de Staël', *Jardin des Arts*, October 1962, pp. 22–29.

1963

Eisler Colin Eisler, 'Nicolas de Staël à Londres', *Art de France* IV, 1963.

Hugler Max Hugler, 'Nicolas de Staël', *Werk*, 8 August 1963, pp. 332–337.

1964

Courthion Pierre Courthion, 'De Staël reste le peintre capital de sa génération', *Arts*, No. 984, 9 December 1964, p. 27.

Dumur Guy Dumur, 'Il y a dix ans mourait le meilleur peintre de sa génération, Nicolas de Staël', *Gazette de Lausanne*, 5 October 1964.

1965

Char René Char, 'Hommage à Nicolas de Staël', *Le Nouvel Observateur*, 18 March 1965.

Granville Pierre Granville, 'Nicolas de Staël, le déroulement de son œuvre témoigne d'un destin libre et nécessaire', *Connaissance des Arts*, No. 160, pp. 84–97.

Jouffroy Jean-Pierre Jouffroy, 'Nicolas de Staël', *La Nouvelle Critique*, March 1965, pp. 116–123.

Sutton Denys Sutton, 'Editorial, Nicolas de Staël', *Apollo*, November 1965, pp. 354–359.

Tossi Roberto Tossi, 'La maggiore chiarezza di Nicolas de Staël', *Paragone*, November 1965, pp. 50–65.

1966

Grojnowski Daniel Grojnowski, 'Nicolas de Staël, description d'un itinéraire', *Critique*, No. 234, November 1966, pp. 940–949.

Guichard-Meili Jean Guichard Meili, *Nicolas de Staël, peintures*, Fernand Hazan, Paris, 1966.

Sutton Denys Sutton, *De Staël*, Fratelli Fabbri Editori, Milan, 1966.

1968

Chastel *Nicolas de Staël*, Introduction by André Chastel, letters annotated by Germain Viatte, catalogue raisonné of paintings by Jacques Dubourg et Françoise de Staël, Le Temps, Paris 1968.

1971

Deschamps Madeleine Deschamps, 'Le temps chez Nicolas de Staël', *Plaisir de France*, July–August 1971, pp. 8–15.

Granville Pierre Granville, 'De deux colonnes érigées', preface to exhibition catalogue by René Char.

1972

Archives Maeght *Staël, l'artiste et l'œuvre*, Archives Maeght 3, Maeght éditeur, Paris, 1972. Preface by André Chastel.

1975

Dumur Guy Dumur, *Nicolas de Staël*, Editions Flammarion, Paris.

1976

Lemoine Serge Lemoine, *Staël au Musée des Beaux-Arts de Dijon*, (Catalogue de la Donation Granville), Dijon, 1976.

1978

Chastel André Chastel, *Fables, Formes, Figures*, Paris, Editions Flammarion, 1978.

1981

Jouffroy Jean-Pierre Jouffroy, *La Mesure de Nicolas de Staël*, Ides et Calendes, Neûchatel, 1981 (sous presse).

Writings by Nicolas de Staël

Lettres de Nicolas de Staël à Pierre Lecuire, Paris 1966 – 100 unedited letters with a chronology and notes by Pierre Lecuire – 250 copies.
Lettres de Nicolas de Staël à Jacques Dubourg, Taranman, London 1981. 75 letters (published in French with an introduction and notes).
(Numerous letters from Nicolas de Staël, annotated by Germain Viatte, are reproduced in *Nicolas de Staël*, Paris, Editions du Temps, 1968.)

Illustrated books

René Char, *Poèmes*, Paris, Jacques Dubourg, 1952.
Pierre Lecuire, *Voir Nicolas de Staël*, Paris, 1953. Limited edition, two prints and cover in colour (lithograph) 210 copies.
René Char, *Arrière-histoire du poème pulvérisé*, Paris, Jean Hugues, 1953.
Pierre Lecuire, *Ballets-Minute*, Paris, 1954. Limited edition, 20 etchings and cover in colour, 50 copies.
Pierre Lecuire, *Maximes*, Paris, 1955. Limited edition, 1 lithograph on cover, 210 copies.

Photographic credits

Victor Amato, Washington.
Art Gallery of Ontario, Toronto.
Atelier 80, Paris.
J.F. Bauret.
Brunel, Lugano.
Cauvin, Paris.
Geoffreys Clement, New York.
Prudence Cummings Associates, Londres.
Documentation photographique du Musée national d'art moderne.
Documentation photographique de la Réunion des Musées Nationaux.
Walter Dräyer, Zurich.
Jacques Dubourg, Paris.
Hubert Fandre, Reims.
Jacques Faujour, Paris.
Claude Gaspari, Paris.
Hélène Hoppenot, Paris.
Walter Klein, Dusseldorf.
Kleinhempel Fotowerkstätten, Hambourg.
Knoedler, New York.
Kunsthaus, Berne.
Kunsthaus Zurich.
Mariette Lachaud, Paris.
Edith Michaïlis, Paris.
Phillips Collection, Washington.
Jacques Pugin, Genève.
Rheinisches Bildarchiv, Kölnisches Stadtmuseum.
Adriano Ribolzi, Lugano.
Rodney Todd-White and Sons, Londres.
Jérôme de Staël
Tate Gallery, Londres.
J. Vaering.
O. Zimmerman, Colmar.